BOXED SETS

TELEVISION REPRESENTATIONS
OF THEATRE

EDITED BY JEREMY RIDGMAN

THE **ARTS COUNCIL** OF ENGLAND

UNIVERSITY
UP of
JL
LUTON PRESS

British Library Cataloguing in Publication Data

A catalogue record for this page is available from the British Library

ISBN: 1 86020 519 4

ACKNOWLEDGEMENTS

Thanks are due to all the individuals and organisations
who kindly supplied photographs.
Of those whose assistance has made the task of editing this book easier and more
of a pleasure than otherwise it might have been, particular thanks are due to Bobby
Mitchell, to Jolè Cosgrove and, for her unfailing perspicacity, to Verity Ridgman.
Finally, I would like to express my gratitude to Will Bell of the Arts Council of England
for his advice and encouragement, and for the enthusiasm with which he has seen this
project through to completion.

Published by
John Libbey Media
Faculty of Humanities
University of Luton
75 Castle Street,
Luton, Bedfordshire LU1 3AJ
England

Book designed by Design & Art, London
Printed in Great Britain by Bookcraft, Midsomer Norton, Bath, Avon, UK

CONTENTS

PREFACE

WILL BELL

It was Bertolt Brecht who said that 'the old forms of communication are not unaffected by the development of new ones, nor do they survive alongside them. The filmgoer develops a different way of reading stories. But the man who writes the stories is a filmgoer too'.[1] That theatre and television have had an uneasy relationship is not the question. The question is the extent to which a technology develops an aesthetic that has a symbiotic relationship to its, sometimes, reluctant partner. In truth, television has had a tremendous affect on writing for the theatre as well as directing and acting. The theatre has returned these creative encroachments with equal verve. *Boxed Sets* looks at this relationship and shows that both theatre and television are better for it.

This is the eighth volume in a series of books on the way the media has transformed our understanding of the arts. The first volume, *Picture This: Media representations of visual art and artists* (ed. Philip Hayward), deals with a range of topics, including the representation of visual art in popular cinema, and how broadcast television has revolutionised our relationship to culture and cultural practices. The second volume, *Culture, Technology and Creativity in the Late Twentieth Century* (ed. Philip Hayward), addresses various aspects of how technology and culture inter-relate. Topics covered include digital technologies, computers and cyberspace. Volume three *Parallel Lines: Media representations of dance* (ed. Stephanie Jordan and Dave Allen) collects together accounts of how dance and dancing have been represented on public television in Britain. The book considers the role of dance in a variety of television practices including pop-videos, popular dance programmes, and experimental and contemporary dance. Volume four *Arts TV: A history of arts television in Britain* (ed. John A. Walker) is the first general, systematic history of the various types of genres of arts programmes – review programmes, strand series, drama documentaries, artists profiles, etc. – and gives a chronological account of their evolution from 1936 to the 1990s. Volume five, *A Night in at the Opera: Media Representations of Opera* (ed. Jeremy Tambling), offers an arresting range of accounts of how the popular arts have represented this high art form written by specialists in music, media and popular culture. It raises issues which have bearings on the sociology of music and about its implications for

television and video culture. Volumes six and seven *Diverse Practices: A critical reader on British video art* (ed. Julia Knight) and *The British Avant-Garde Film 1926-1995* (ed. Michael O'Pray) highlight the rich practice of artists working with film and video.

We would like to take this opportunity to thank Jeremy Ridgman for editing this book and the publishers John Libbey Media at the University of Luton who joined with us in its production. We are grateful to them for the untiring and thoughtful way in which they approached the task.

Finally, the views expressed herein are those of the authors and should not be taken as a statement of Arts Council of England policy.

Will Bell
Policy Officer: Arts & the Media

1. Bertold Brecht, 'The Film, the Novel and Epic Theatre',
 from *Brecht on Theatre*, Eyre Methuen, London (1975).

INTRODUCTION

JEREMY RIDGMAN

There are two competing popular images of the relationship between television and theatre. The first might be characterised as the discourse of deference, in which a brash but bright youngster rather guiltily pays respect to an impoverished but venerated parent. As the press release for *Blow Your Mind* – a week of theatre-based programming mounted by Channel 4 in 1995 – maintained, the task of television was to celebrate 'one of our greatest cultural assets' and 'the contribution that theatre makes to both the large and small screen.' Such is the iconic status of theatre in Britain, enshrined in the familiar trinity of actor, author and architecture, the television's role appears all too often to have been that of media slave, a cultural messenger dutifully bearing news of Olympian achievements from beyond the terrestrial confines of studio, screen and living-room.

Below the deference, meanwhile, lurks the sense of debt. A somewhat embarrassed relationship between the industries of television and theatre has been sharpened during the 1980s and 1990s by the increasing struggle – if not competition – for dwindling public subsidy. Debate on the theme of 'cultural obligation' has bubbled away, most noticeably in the arts pages of *The Guardian*, since the Arts Council Conference on Broadcasting and the Arts in 1992. The keynote address to the conference – reprinted in this volume – was given by Richard Eyre, then Artistic Director of the Royal National Theatre and formerly producer in charge of the BBC *Play for Today*. Eyre's concern with what he saw as a crisis of confidence at the BBC was endorsed by the Guardian's theatre critic, Michael Billington: 'But there is one area Eyre didn't, as far as I know, touch on; the deeply ambivalent attitude of television to the theatre from which it sucks the blood as vampirically as Count Dracula from any white-necked virgin' (Billington, 1992, p.28). At the same time, Billington rounded on an erstwhile colleague on the arts page, Waldemar Januszczak, who in defending television's status as art form rather than medium had poured scorn on 'those aging Hamlets who service the kingdom of theatre'. A year later, Billington was writing the 'mutual wariness' between the two industries: 'Many TV executives see theatre as old hat; theatre people are also guilty of an aesthetic snobbery that regards live drama as the ultimate art experience' (Billington, 1993, p.26).

Ambivalence and wariness finally crystallised into a more hard-headed polarisation over cultural economics when the theatre director Michael Bogdanov and the Head of Drama at Channel 4, David Aukin, met to debate whether 'Television Lives Off Theatre' at the Theatre Museum in 1994. predictably, perhaps, proceedings were coloured once again by the vampire motif. The television industry, maintained Bogdanov, 'drains the live theatre of its life blood in every single area'. Dependent for its actors, writers and directors on the training ground and pool of talent provided by the drama schools and theatre companies, with the exception of a handful of schemes to fund assistant directors and new writers it put 'virtually nothing back into the discipline that it sucks dry' (Bogdanov and Aukin, 1994, pp. 4-5)[1]. Aukin, previously Executive Director of the National Theatre and director at the Leicester Haymarket and the Hampstead Theatre, responded in a spirit of collaboration and co-operation. Ever a 'convenient scapegoat for most of the ills prevalent in society today', television was now being blamed for the underfunding of theatre brought about by declines in subsidy. The medium had developed 'its own language and grammar' and simply placing cameras in front of a stage performance would result in 'bad television and bad representation of theatre'. The two industries, he maintained, could work together, the stage generating productions which could be reconceived for film or studio recording, television providing the imaginative critical coverage which might encourage greater theatre attendance.

Television has often been able to rely on theatre as a means of endorsing its own cultural aspirations. It is worth noting that the death of Dennis Potter in 1995 was marked not by a major retrospective of his work on television (though plans did go ahead for the posthumous co-production by the BBC and Channel 4 of his two final works) but by stage versions of two earlier pieces, *Son of Man* and *Blue Remembered Hills*, at the Royal Shakespeare Company and the Royal National Theatre. The ritual of television's deference to theatre, moreover, is firmly written into the history of television drama itself. There is special resonance in the part played by the work of a dramatist such as Pirandello in the emergence of televised drama, first with the experimental transmission in 1930 of his one-act play *The Man With a Flower in His Mouth* – 'probably the first play to have been televised anywhere' (Brandt, p.8) – and with a production of *Henry IV* in 1938 that launched what was to become an institutionalised tradition of Sunday evening classic drama. One could also be forgiven for forgetting that *Armchair Theatre*, *Thirty Minute Theatre* and *Theatre 625* were series dedicated to the commissioning of new work written specifically for television. Paradoxically, such sobriquets, in their very claim for parity of esteem with the stage, fly in the face of television drama's radical rejection of conservative West End and Loamshire theatre culture in the 1950s and 1960s. 'Not only does television drama grow out of radio drama,' remarks John Caughie, 'it also develops with a strong respect for theatre at its most culturally prestigious cognate form' (p. 14). The new wave of televised theatre in the eighties and nineties may reflect a parallel confidence in the medium's own dramatic aesthetic, as specifically televisual drama turns towards filmic production values and serial narrative rather than the spatial and temporal unities inherited from the stage. Nevertheless, as Jason Jacobs' research here

demonstrates, that early respect for theatre should not be confused with subservience to its form. Beneath the surface of television's negotiation of theatrical texts in the 1930s and 40s, the seeds of its own dramatic aesthetic were already beginning to germinate.

It should be clear that when we speak of the representation of theatre on television, we are concerned with more than the re-encoding of a body of literature according to the conventions of the small screen. What is at stake in much of this practice is the relationship between two distinct but historically intertwined cultural forms. In terms of institutional structure, production practice and audience composition, they may be miles apart. And yet, the proximity of the narrative and dramatic discourses of television fiction to those of theatre (compared, say, with those of dance, opera or painting) poses a particular conundrum for the cultural critic – not least for Paul Kerr, who, faced with preparations for the screening of the Royal Shakespeare Company's *Nicholas Nickleby* in 1982, confronted the spectre of 'serialised theatre – a project which would do little to dissipate the continuing confusion of "television culture" with television's transmission of non-televisual culture' (p. 19).

Within the debate on the politics of cultural form, television and theatre have frequently been characterised as dialectical opposites. At the top of the radical interventionist agenda set in the 1970s by dramatists such as David Edgar, Trevor Griffiths and John McGrath was the strategic question of whether it was the duty of the socialist playwright to work within the mass medium of television, accepting its institutional and formal structures for the sake of addressing the popular imagination (Griffiths' theory of 'strategic penetration'), or to embrace the greater freedoms, the immediacy and the tangible sense of the audience as a specific community that were seen as peculiar to the live stage. Yet it was often at the intersection of these differentiated practices and ideologies that the most interesting and challenging work was done. Griffiths' two most operatic stage plays, *The Party* and *Comedians*, are imbued with the politics of television culture, while some of his most intricate works for the screen, from the parliamentary serial *Bill Brand* to the single play *Country*, unfold by means of a dramaturgy borrowed unashamedly from the theatrical literary tradition: the long address, rhetorical debate, the *scène à faire*. In John McGrath's still remarkable reworking for television of his 7:84 play *The Cheviot, the Stage and the Black, Black Oil*, we move through an ever more challenging spiral of recorded stage performance, historical reconstruction and vox pop-based documentary, and finally into an analysis of the dialectics of metropolitan and local culture, community and technology, that makes it one of the most purposeful explorations of the formal and ideological relationship between theatre and television.

This book brings together a number of different investigations into the relationship between theatre or dramatic performance and the medium of television. Its aim is to consider the diverse ways in which theatre, both as an institution and as text, is represented on and through television. How is our understanding of theatre, its histories, its textual canon, its processes and practices, mediated through the agency of television

in Britain? What, furthermore, do those acts of representation tell us about television itself? As the title is intended to indicate, television is defined here as broadcast television – a particular nexus of production, scheduling and viewing practices. Of video itself – both the contemporary experiment with this technology within live performance and its increasing use as a means of documentation and preservation – other volumes must speak.

If, as Raymond Williams tells us, we live in a dramatised society, there can be no doubting television's pre-eminent role in that definition of the contemporary condition. Television has revolutionised our relationship with the process of dramatic representation, not only in terms of extended access but in establishing dramatised fiction as an essential element of quotidian culture. Drama is no longer the 'occasional' event of the Athenian or medieval religious festivals or even the focus of the theatregoing activities of urban and provincial audiences in the eighteenth and nineteenth centuries, it is now 'habitual experience… the flow of action and acting, or representation and performance, raised to a new convention, that of a basic need' (Williams, p. 4). That flow, of course, is far from the relentlessly homogenous torrent that many see in television and the slice of life naturalism long associated with the medium may no longer necessarily be its single most powerful genre. Television is nothing if not a plurality of voices, and dramatic representation now occupies a wide range of spaces both within the medium and within its social use. As indigenous television drama moves increasingly towards serial structure and is absorbed into the schedules and formats of popular broadcasting, might it not be televised theatre that acts as a specific mode of heightened representation and which returns us to the experience of drama as event – a disorientation, in Potter's words, 'smack in the middle of the orienting process which television perpetually uses'? (p.30).

Clearly, one of our areas of interest must thus be the literal act of *re-presentation*, the transposition of the stage play itself. However, this practice cannot be divorced from the institutional imperatives of television as public service. Driven by the Reithian injunction to educate and inform as well as entertain, the televised play has enjoyed a privileged, if unsteady, position in the schedules since the beginning of television in Britain. Indeed, early television drama consisted substantially of such productions, sometimes reconstructed from existing West End productions to be relayed live from the studio. One of the functions of this tradition, as in the parallel institution of novel serialisation, has been to reinforce – perhaps even determine – a canon of acceptable or esteemed texts as well as a sense of how those texts should be read. Neil Taylor's survey of the history of the stage play on television not only charts changes in the proportion of broadcast time given over to drama but raises questions about the repertoire itself, as particular writers and texts jostle for position in that cultural league table. Carol Banks and Graham Holderness develop the discussion of the place occupied by Shakespeare in the construction of a national culture by identifying the critical role of television's predominantly serial form in the ordering of the history plays back into the ideologically convenient package of chronological sequence.

As far as the actual performance of stage plays on television is concerned, we can distinguish between three basic models of production practice. The most common of these is the studio production, specifically mounted for television and traditionally (though no longer exclusively) shot on video rather than film. The action here is rarely opened out in the way familiar from cinematic adaptations. Indeed, such productions will often exploit the closed form of the studio, replicating if not necessarily imitating the fictional conventions of stage space that govern theatrical representation. Such practice forms the backbone of the tradition of classical theatre production on BBC television, particularly that associated with series such as *Play of the Month* in the 1970s and *Performance* in the 1990s. It may be contrasted with the more experimental – and hence occasional – reconfiguration of the stage play as telefilm or television drama. Here location or multi-set shooting may be a means of resituating action and expanding beyond the spatial confines encoded in the stage script, or reorganising the duration and sequence of scenes to take account of the temporal conventions of screen narrative.

Elements of the second of these processes inevitably creep into the first. Openings, closings or act divisions may be signalled by the insertion of location footage, communicating essential information about time and setting or suggesting atmosphere and other connotative values. Of more complex dramaturgical significance, even the most studio-bound production may balance the dramatic demands of closed fictional space with the potential for expanded movement and a more varied sense of place that is occasioned by camera mobility and studio layout. Action confined in the stage text to a single room may now move between rooms in the same house; voices to be heard off-stage may be re-embodied, by means of a suitable cut-away shot, as fully performed, visual action. In such cases, the entire syntax of the dramatic narrative, centred around the clear, punctuating polarities of 'off' and 'on', entrance and exit, is subtly but assuredly reconstituted. Val Taylor's analysis of the studio production of *Top Girls* and Derek Paget's study of the late Alan Clarke's location-based reworking of *Road* address the implications of these different practices. As both writers demonstrate, the critical issue here is not merely a formalistic one. The visual and spatial re-encoding of dramatic design, action and dialogue, Taylor argues, significantly and critically repositions the spectator in relation to the ideas embodied in the narrative, while Paget's discussion of another transposed Court play homes in on the power of television's inescapable intertextuality to amplify the poetic, sociological and ideological resonances of Cartwright's troubling text.

A third model of television production is concerned with recapturing the experience of the stage play as live, public performance. There was a clear resurgence in this area during the 1980s, fostered particularly under the public service remit of the new Channel 4. Most significant in this development were the broadcasts – usually from their original performance spaces – of large-scale productions such as the Royal Shakespeare Company's *Life and Adventures of Nicholas Nickleby*, Bill Bryden's promenade productions of *The Mysteries* at the National Theatre and *The Ship* at the Harland and Wolff shipyard, and John McGrath's Scottish history work with Wildcat at the Glasgow

Tramway. Even the series of annual Amnesty International 'Secret Policeman...' comedy and rock galas may be seen as companion events. Often adopting the complex logistics of outside broadcasting, these productions are firmly rooted in the principle of television as relay – the time-honoured cultural function of bringing into the domestic space the nationally significant public or ceremonial event. Such productions, however, are rarely recorded continuously but are, to varying degrees, reconstructed by the logistics of television coverage itself. The final transmitted version may, for example, be a compilation of material shot over several live performances; elements of the staging may be modified to allow for different lighting and sound conditions, camera positions and recording breaks; and it may be necessary to edit in the audience presence from a collection of shots or a soundtrack gathered separately. Thus, the Channel 4 *Nicholas Nickleby* was recorded over a number of weeks, in an empty theatre (not the Aldwych, where it had been staged, but the Old Vic, which was conveniently dark at the time), and with audience reactions and a chase into the auditorium dropped in later from footage shot during one of the original public performances. We might argue that such work is not merely concerned with reproducing the presence of a live theatre audience in order to capture the mood and atmosphere of a specific event or to make sense of the non-televisual rhetoric of stage performance, but goes a long way towards enhancing – one might say dramatising – that presence as part of the new, orchestrated television experience. The audience's arrival in the theatre space may form part of the broadcast, as a background to the opening titles perhaps or, as in the case of *Nicholas Nickleby*, stylised into a time-lapse sequence showing the auditorium gradually filling up. Shots may be favoured which have 'accidentally' caught a certain reaction from a spectator, a particularly 'photogenic' face or a telling configuration in the crowd. The dramatised *idea* of an audience thus begins to function as an enabling fiction, a dynamic but far from neutral component in the mediation of theatre as popular experience. Olga Taxidou's discussion of McGrath's work at the Tramway and Susanne Greenhalgh's study of *The Mysteries* develop this debate, examining its implications for the perception of contemporary political and economic conditions.

Television's fascination with theatre culture, of course, is not confined to the transposition of texts and productions. John Barton's *Playing Shakespeare* workshops, commissioned by Melvyn Bragg at London Weekend Television and broadcast on Channel 4 in 1984, heralded a wave of televised acting masterclasses and demonstrations, which, alongside profiles and documentaries on actors and acting (and, thanks to Nigel Planer's Nicholas Craig, the occasional generic spoof), have participated in the mobilisation of an entire mythology to do with the theatre profession and the status of the actor in contemporary culture. Whether such representations are more concerned with critical clarity than with the perpetuation of mystique (the titles for a recent series of acting workshops on BBC2, for example, scrolled over the menacing image of an empty chair lit as if from above by a circling light bulb) is the starting point for Peter Reynolds' investigation into television's view of the world and work of the stage actor. Bob Millington identifies a similar mythologising process in the obsession of the arts documentary with the ideal of

individual creativity in an industry far more frequently governed by economic and organizational considerations.

In schools and universities, it is now increasingly common to use video recordings of performance, whether off-air or drawn from commercial and archival sources, in the study of theatre and dramatic literature, and there is every indication that the CD-ROM will introduce new levels of accuracy and interactivity to performance analysis. In 1990 the National Video Archive of Stage Performance was established at the Theatre Museum in London, experimenting across a number of trial recordings with a variety of methods and formats. Dedicated educational television broadcasts are widely available for classroom use, from grainy repeats of John Russell Brown's Open University Shakespeare workshops to a glossy studio production of *Romeo and Juliet* lit, shot and 'letter-boxed' to evoke as closely as possible the romantic production values of a feature film. The educational and documentary uses of video are not the specific concern of a book whose principal frame of reference is broadcast television. However, the pedagogic pitfalls of television's representation of theatre have never been more evident than in an edition of the Channel 4 programme *J'accuse* which, as part of a demolition job on the myth of Olivier's greatness, showed a group of A Level English pupils earnestly dismissing his Othello as an example of mannered overacting – the evidence before them the film version of the 1964 production, seen on video playback via a 22-inch TV monitor.

Television will always have the potential to make theatre 'look' ridiculous. The televisual gaze may approximate in some ways to the cinematic but, assisted by increasing viewer control and situated in the private domestic space or the confines of the classroom, it can never deliver the first-hand, subjective experience of space and place that are unique to theatre. And yet, so frequently does television insist upon its own transparency that we may not even recognise the theatrical values of heightened performance or deliberate artifice when we see them. A television designer told me ruefully of the occasion on which her lovingly produced, two-dimensional, picture-book sets for a screened opera had been praised by an admiring friend: but where, came the follow-up question, had she found such extraordinary locations? Ironically, of course, overt, unabashed performance is no stranger to television but is more likely to be found among the vaudevillian and melodramatic scenarios of the television game show – with its sense of public event, its informality, its gestural and expressive range and its highly charged emotion, even its ironic self-reflexivity – than in much that advertises itself as television drama (see Docker, p.53). John Adams digs beneath the surface of television drama's insistent and habituated realism to identify some of the elements that have contributed to the development of a performance aesthetic in British television production.

Compared with work elsewhere in Europe, contemporary performance is 'poorly served by British television', declared John Wyver at the Broadcasting and Arts conference in 1992. The 'visual quality … precision and … engagement with the camera' to be found in the dance work of Wim Vanderkus and in an opera by Jan Fabre and Jef Cornelis were

rare on this side of the channel. Wyver may in fact be pointing to the absence of an avant-garde tradition in televised theatre. Work in the field may indeed by boxed in by a predominantly literary deference to our theatrical heritage as a package of approved texts. Yet, in the same year, Michael Billington could celebrate the freshness of vision brought to the experimental space of the television studio by the theatre designer Bob Crowley, in the *Performance* production of *Tales From Hollywood*:

> Homage is paid to Edward Hopper and David Hockney as frozen-frame
> long-windowed bars and azure pools spring to life. The dialectical set-to
> between Ödön von Horváth and Bertolt Brecht takes place in a *trompe l'oeil*
> setting with Brecht exiting into the Californian landscape. Design is not just a
> backdrop: it is brilliantly used to make a point about the tension between
> Horváth's European origins and fictive American acclimatization.
> (Billington 1992, p. 28)

Amid such competing aesthetic claims, the time is surely ripe for the creative and critical implications of television's representation of theatre and theatrical performance to be put under the spotlight. Yet we must also reconsider the developing relationship between these two industries as agents of cultural production. As actors, writers, directors and administrators commute between the media, so the textual traffic proliferates. In the 1990s, a figure such as writer-director Patrick Marber moves with seemingly effortless ease from fringe revue through television comedy to National Theatre and West End hit, back again to an updated television version of *Miss Julie* and on to a staging of the classic TV play, *Blue Remembered Hills*. In the process – as texts are reconfigured, acting styles transposed and orthodoxies challenged – complex shifts in meaning and in the pleasure of drama itself are taking place. Self-evidently, television is in a multiplicity of ways conditioning not only our understanding but the very character and future both of theatre as an institution and of dramatic performance as a human activity. And it may now be as partner in the cultural process rather than as mere media slave that it is doing it.

NOTES

1. The debate, chaired by Michael Billington, took place at the
 Theatre Museum, London, on 7 April 1994. A third participant was
 the playwright Doug Lucie. *The Guardian* subsequently published
 articles by Aukin and Bogdanov summarising their views.
 Quotations are from this publication.

REFERENCES

Billington, M. (1992) 'Blood brothers under the skin'
The Guardian, 21 Oct. 1992, p. 28.
Billington, M (1993) 'Why television should tune into theatre'
The Guardian, 7 Aug. 1993, p. 26.
Bogdanov, M. and D. Aukin (1994) 'Who Gives a Bugger?'
The Guardian, 20 April 1994, pp. 4-5.
Brandt, G. (ed) (1981) *British Television Drama*. Cambridge:
Cambridge University Press.
Caughie, J. (1981) 'Rhetoric, Pleasure and "Art Television": *Dreams of
Leaving.*' *Screen*, Vol. 22, No. 4, pp. 9-31.
Docker, J. (1983) 'Unprecedented in history: drama and the dramatic in
television' *Australasian Drama Studies*, Vol.1, No.2, pp. 47-61.
Kerr, P. (1982) 'Classic Serials – To Be Continued'. *Screen*,
Vol.23, No.1, pp. 6-19.
Potter, D. (1984) *Waiting for the Boat*. London: Faber.
Williams, R.(1974) "Drama in a Dramatised Society". In O'Connor, A.
(ed.) (1989) *Raymond Williams on Television*. London: Routledge.

THE ODD COUPLE?

RICHARD EYRE

One of the more enduring and unpleasant legacies of the Thatcher Years is the coinage of the phrase 'the chattering classes' to describe anyone who talks about broadcasting, or art, or politics, and who is not fortunate enough to work for a right-wing newspaper, or sit on the board of a merchant bank or the benches of the House of Commons. They 'make statements' while we 'chatter'; they 'assert' while we 'witter'; they are serious while we are frivolous. I'm an unrepentant chatterer and am proud to have been asked to speak at what is, in effect, a sort of Pentecostal rally for the chattering classes.'

I hope, therefore, it won't be construed as churlish if I say that the title of the conference, *The Odd Couple?*, strikes me as diffident, defensive, and defeatist – in spite of the coy question mark tagged on the end. To imply that broadcasting and the arts are essentially poor bedfellows is to concede the argument before a question has been put. There are – it seems to me – two questions to be asked. The first is this: can television be art? Or, put a different way, what can art do for broadcasting? And the second: what can broadcasting do for the arts?

Before either question can be asked, I'd like to ask what broadcasting can do for broadcasting, and peer at the existing institutions. Like many British institutions, their shape reflects their origins, in all cases a combination of principle and confusion, and if their output reflects their constitutions perhaps it's a rare occasion when Marshall McLuhan, the chatterers' prophet, has been proved right. In the world of British broadcasting the doubtful truism, 'the medium is the message' has the ring of truth.

I was recently away from the country, for a shortish time. If you take a keen interest in the media it is unwise to do so without a briefing on re-entry at Heathrow. In recent years, after an absence of three weeks, I overheard so much talk of character assassination that I imagined there had been a mass murder on the scale of the Reverend Jim Jones in Guyana. Only the intervention of a friend of the management prevented me from being barred from the Groucho Club for life, for committing the

grave solecism of asking, 'But who is Lynn Barber?'. I had a similar experience over the matter of the man who drank bourbon while wearing red braces. It seemed an inoffensive social sin, until I became aware that the poor man was being castigated not for his dress sense but for criticising the BBC. It was then that the smile commuted rapidly across my face. I felt a surge of indignation compounded with acute depression when I realised that the only response that an informed, articulate, even affectionate, critique on the BBC would get was an insult that belonged to a sixth-former studying the history of the nineteenth century. A Bourbon is said to be someone who learns nothing and forgets nothing, and I wonder who that might apply to at the BBC?

I only read Michael Grade's Edinburgh festival speech in synopsis, but I was very affected by his phrase that, '... the BBC exists to keep us all honest'. It was an expression which belonged not to the language of sociology, semiotics, or economics, that is normally employed by broadcasters, but to the language of the heart and, coming from a man who dearly had some misgivings about accepting a substantial golden sweetener to continue running a public service broadcasting company, it had a singular poignancy. It was like a rather wistful compliment that might be paid by a philandering husband to his long-suffering wife. It dramatised for me that the debate about the BBC and the struggle for its preservation is not about the abolition of bureaucracy, or even about the pressure of market forces, it is about an emotional and cultural heartland.

Commercial television exists to make money. This is not incompatible with making good programmes, but the first obligation is to the shareholders, the second is to the advertisers, and the third is to the audience. The BBC exists to serve its audience: to educate it, to inform it, and to entertain it. It is − and forgive me for stating the obvious − a public broadcasting service independent of government control, which has, however risible and antique this may sound now, a duty to serve the public. The notion of 'duty' has in the past given the Corporation a self-importance that has sanctified the growth of an overweening bureaucracy, allowing it a status somewhere between the Church and the Post Office. But the existence of an inert and supine bureaucracy, and the need for it to be reformed, shouldn't be used as an excuse to abandon a philosophy that asserts that the public is best served by making the best programme, not by trying to second guess the audience and mimic the competition.

The commitment to 'quality'− however loaded and subjective an aspiration − was the fuel which drove the BBC throughout what is now regarded as its golden age. It infected *The Morecambe and Wise Show* every bit as much as *Play for Today*; people were willing to work for less pay and lower conditions than 'outside' because they believed in a collective endeavour, that the sum was greater than the parts, and that they were a part of an entire vision. It was a state of mind that was often irritating to the outsider, often seemed blinkered and insular, but it was a faith, a belief that there was more to making programmes for television than picking up a pay packet.

A few years ago I was filming *Tumbledown* on a cold hill in Wales, at night, in the pouring rain, and talking to a prop man. 'I like working here', he said, 'you get to make good programmes.' 'Here?', I said. 'Here? In Wales? In the Black Hills?' ' 'No, no', he said, 'I mean at the BBC.' 'Here' was a territory of the mind – a heartland, if you like and it's one that has been systematically eroded over the past few years by the reductive logic of market economies.

You may say that this is mere nostalgia for a supposed golden age. You might think I'm saying, 'Oh, they don't write 'em like that now'. And you might be right to say, 'Well, that's because we aren't like that now'. But I am not so sure. I work in a building – the National Theatre – with people who are there for reasons that can be loftily dismissed as sentimental: a sense of community, a sense of 'family', a desire to share a common purpose. Many of them – as at the BBC – could be much more highly paid in the commercial theatre, but they prefer to work in a climate where it is thought important to be good before you are successful. I know that what I am saying will seem Pollyanna-ish, priggish or just plain daft to someone in ITV who feels that it is acceptable to be paid huge sums of money in order to remain with a company that they have been part of for many years. However, unless those who manage the BBC are prepared to demonstrate their admiration – and affection – for the ideals of public broadcasting and their loyalty to those who work by those ideals, then they are doomed to a bitter purgatory.

Mrs – sorry, Lady – Thatcher observed in the 1980s that there was no such thing as society, and she set about making this assertion come true. Television was an irresistible target – all those opinionated dissenting voices having unhealthy access to the minds of the nation. No one has described what happened better than Alan Bennett:

> With a limited number of channels television is a topic for discussion – a play or a documentary talked about the morning after at work or whenever. But the more channels there are, the less this is going to be the case. Of course, if there's no such thing as society, then this is of no consequence. But the very people who fuss about the nation losing its identity in Europe are quite happy to see national television lose its identity and go the European way, so that we end up with a diet of pay and crap. One wants to ask such people: what is it that helps to hold the nation together? A shared interest in the novels of Jeffrey Archer?

The majority of the press, having a vested interest in satellite television, have acted as footmen for the government policy of destroying the duopoly of the BBC and ITV, and being temperamentally opposed, in the case of the BBC, to a news organisation that doesn't rely on deriving half their revenue from advertising cars, condoms and cellphones, they have lost no opportunity to belittle an already beleaguered and confused management.

Market forces have been invoked by the Government, like the Code of Moses, to justify the deconstruction of obstructive anomalies like the public utilities, the Health Service, and the BBC. The fiasco of the attempt to delete the coal industry is a perfect example of the myopia of a government which seems determined to prove that there is no such thing as society by eliminating all evidence of its existence. They wilfully refuse to see that all things connect, and end up behaving like the Devil: 'I cannot read, therefore I wish all books were burnt'.

The BBC has tried to stay one jump ahead of government. They have espoused producer choice – a policy of chaos couched in confusion. They have urged producers to seek co-production to the extent that a programme that does not manage to raise co-production money is regarded as suspect and vulnerable; they have taken on a quota of 'independent' programmes often to the damage of their internal resources and morale, and the ceaseless craving for ratings has resulted in an ideology that, as Roger Woddis has written, should oblige them to change their motto to: 'Nation shall speak of Ratings unto Nation'. The consequence of all this loss of nerve in the management is a loss of vision. No one knows what the objective is, so instead of programmes being made because people think they are good and may therefore attract an audience, programmes are conceived by market researchers to fit the shape of the required ratings.

The BBC crisis is a crisis of faith, and there are no clearer examples of working in good faith and working in bad than *EastEnders* and *Eldorado*. The first was made in a spirit of innocence, enthusiasm and energetic commitment; the second was mired in cynicism, and the torpor of disaffection. We've all heard people say, after reading a Jackie Collins novel or seeing a West End musical, 'Oh, I think I could turn my hand to that, and make a lot of money'. This misses a crucial point about popular culture. However it may appear, popular novels, films, musicals, and television shows, are not cynically constructed. Their makers, the writers, directors and producers believe in them. If you try to manufacture popular culture synthetically, it will not work. You cannot fake it, your bad faith will always betray you. There is no clearer indication of this than a story that a publisher told me about Jeffrey Archer. Archer asked him to lunch and, after some idle political gossip, he said to the publisher 'I'm thinking of writing a novel'. 'Ah,' said the publisher expectantly. 'Do you think', said Archer, 'do you think that after writing several novels I might …' And here he paused. There was an awkward silence as the publisher waited for the inevitable request not only to read the novel but to publish it. 'Do you think', said Archer, and the publisher nodded, 'that I might ever win the Nobel Prize for Literature?'.

The BBC has to decide what to do and decide to do it well. At the moment they are behaving like Dean Acheson's description of Britain after the War: 'They have lost an Empire and have yet to find a role'. There are, apparently, three strategies on offer for the BBC. The first is, apparently, known as the 'Himalaya' strategy and it describes the intention to occupy the cultural high ground becoming – and I don't know whether to

be flattered or appalled – the National Theatre of the Airwaves. To give, and I quote, '…religion a prominent place in the schedule …'. The second strategy may well be called 'The Vale of Evesham', or 'The Sunlit Uplands' , dedicated to a middle-brow pastoralism – classic serials, and nature programmes. And the third strategy, 'The Sewage Farm', would, I suppose, be dedicated to game shows, sex shows, sport, sitcoms, and Esther Rantzen.

In my view, if the BBC continues to take the licence fee, there is only one strategy possible. It has a dual responsibility: to address a mass audience and to address a minority audience. I believe it should continue to discharge both responsibilities. It is all too easy to legislate for other people's problems, and since I haven't hesitated to do so up till now, I will suggest a strategy. The BBC should cut Breakfast Television and local radio, stop trying to mimic the competition from ITV, stop follies such as a 24 hour news channel, stop engineers determining how programmes are made and stop politicians determining where they are made. The cultural obligation of the BBC is to continue to display a commitment to the forms that they have invented. These are: the serious documentary, the television and radio serial, the television play and film, and radio drama. In addition they should show a commitment to preserving and strengthening the world service and continue to demonstrate a commitment to training.

They should offer a catholic range of programmes, *Blackadder* before a documentary on the prison service, or a prom after a sitcom. It is precisely the chance of an audience spilling over from one programme to another, the chance exposure to something that you haven't chosen to watch, that has made, and should continue to make, the service that the BBC provides so extraordinary. It seems ironic now that there was a time when the BBC served as a model not only for public service broadcasting all over the world, but in this country for commercial broadcasting as well. There is a story – possibly apocryphal – that the Japanese television service were so impressed by the BBC that they built their television centre in the shape of a circle.

It must seem several centuries ago that I posed the question: what can art do for broadcasting? Or to put the same question differently: can a television programme be a work of art? In the past it would have been possible to point to a continuously growing body of work which had a singularity, a confidence in itself, and in its relationship to its audience, and a degree of 'excellence' that marked it out as 'art'. Programmes were created to the highest possible level and they influenced the way we thought, and spoke, and felt. They defined the way we looked at the world. If such programmes are more rare nowadays it is not only the fault of the television institutions, or even of the programme makers themselves, but of a wholesale special revolution. There's been a flight from the idea of a regimented culture where we sit down in front of the television at a particular time, or turn up at a theatre, or put ourselves passively in the hands of the artist.

While the writer, or film-maker, or composer becomes increasingly concerned about controlling the conditions in which their work is displayed, the audience becomes

increasingly reluctant to concede this control. If you make a film for television you are powerless to do anything but deliver the film to the best of your ability, and nothing in the world will prevent your audience from answering the phone, attending to the baby, kicking the cat, or talking loudly during what you regard as the crucial and indispensable scene. After years of this attritional drizzle, the programme maker – consciously or not – becomes worn down, and as the audience relies more and more on videos and watching bite-sized fragments on time shift recording, what used to be the EVENT of television – the big documentary or television film or variety show or rock concert which happened once or twice a week, happens instead once a year.

Making good television used to be much easier. Expectations were low, and there was an amiable chaos which made for a warm relationship between the presenter, as it were, and the public. There was an energy drawn from knowing that if you were on television, you were addressing the nation as a whole. Television was a newish medium populated by a newly emancipated group of male, middle-class university graduates whose energies in an earlier age might have been diverted to the Church, or the Army, or the Civil Service. There was a homogenous culture, largely imposed from above. You could say you knew where you were then. If Huw Wheldon, or even Melvyn Bragg, told you it was good art, then it was. And it was good for you.

There is now, thankfully, a growing plurality of voices in our culture and if we are to have good television, it is important that these voices are heard. 'Art' is the expression of the voice of gifted individuals with a point of view. It used to be easier to identify these voices when there was universal agreement that, for instance, Keats was better then Bob Dylan. It's not quite the point to say that Keats is the better poet – after all, Chuck Berry's a better poet than Bob Dylan – the point is that it's no longer possible, or desirable, for television to dispense cultural directives and expect an audience to follow them. There's been something of a revolution against prescriptive culture, and while you may lament some of the territory that has been annexed for art, you can't ignore the fact that it has been occupied. I am entertained by programmes about the design of the tail fin of the Ford Cortina as much as by programmes about the brushwork of a Rembrandt, and I really don't see any harm in thinking that all forms of individual self-expression and aspirations to excellence are forms of art. According to Madonna, even sex is art, which makes us all artists – like Molière's *bourgeois gentilhomme* who discovers with delight that he's been speaking prose all his life.

Of course you have to make critical distinctions between art that is well achieved in its own terms and art that is not, but I would make a further distinction – and it's one that will probably mark me out as an unreconstructed fogey – I believe art should possess a moral dimension. If you ask me what I think of *Bladerunner* I would say I admire it, I enjoy it, and I love the fact that it's as stuffed with cultural references as the Museum of Modern Art. But if you ask me if it's art, then I would have to say no, it lacks an implicit moral sense. It is nihilistic and mechanistic and therefore – to me – depressing and

inhumane in a way that Bergman's films, for all their bleakness, are not. And if you say –
well, what does that matter if millions of people enjoy *Bladerunner*, and millions of people
don't enjoy Bergman – I would have to say, you must have both. But if you don't nurture
the spiritual side of humanity through art, then in some way, you are not encouraging
humanity to flourish. I know it can be argued that art didn't help the victims of the death
camps whose executioners played Schubert, but you will never be able to make an
argument for the conviction that the arts should be for everyone. We'd like art and
popular entertainment to be the same thing, but in practice they're not. We wish it to be
true, but wishing doesn't make it happen – any more than it does in politics, in
economics, or in social matters.

However, there is an overlap. And the greatest opportunity for the convergence – at least
in this country – is in broadcasting. There are many obstacles, but the greatest enemy to
better broadcasting is ourselves. If those of us who do care about broadcasting, and
those who are in a position to change it, take the view that it's not worth bothering
about, or it will all be swilled away in the wash of the marketplace, then we will only have
ourselves to blame. The enemy of good television and radio, of good art, is self-
censorship and inertia, every bit as much as the implicit censorship imposed by the
ratings war. Television will only be good if those who are making it have a respect for it,
and have a determination to make it work in its own terms. Not as a surrogate for any
other form of art or journalism, but as itself: confident, imaginative and – in the words of
Michael Checkland – distinctive.

Which brings me to the explicit agenda of this conference: what is the relationship of the
arts to broadcasting? To the Arts Council, broadcasting appears to offer a paradigm. It
offers access to all, and so it is hardly surprising that they are so keen to urge what they
call their 'clients' – in the language of the caring professions – to transfer their work to
television. It's a cruel parody of their view, but I can't help thinking that, like the Judge in
the Chatterly case, they think that there are the 'arts', which we enjoy, and there is
'television', which the servants watch, so they see it as the obligation of television to serve
the arts. I believe that the only obligation of television is to provide good programmes
and to show, in spite of the difficulty for the programme maker to legislate for the
conditions in which their programmes are viewed, that the medium is no less resistant to
art than a piece of canvas of an empty stage.

Subsidised theatre, opera and ballet companies are, quite rightly, under pressure to justify
their subsidies by increasing the availability of their productions, but to advocate that they
should do this by getting their work on television is to entirely miss the point of the
unique nature of a live performance. If you merely put a camera in front of a stage
performance, you destroy the conceit on which is stands. When you're inside a theatre, a
good stage performance doesn't seem either absurd or untruthful. On television, the
same performance, without the nourishment of distance and space and real time, can
merely seem vulnerable, and even silly. Those who run opera houses have to pretend

that it works on television, and that it spreads the experience. It doesn't. What does work, indisputably, are opera recitals and arias sung out of context. The *Three Tenors' Concert* and *Pavarotti In The Park* won huge audiences, sold a vast number of records, and may even have persuaded some people to visit an opera house. These concerts will have achieved far more in that sense, than a thousand relays from opera houses shot on four cameras with lighting that makes everything look like a staff panto in the works canteen. If you try to show a live opera performance on television to an audience which has a hugely sophisticated expectation of visual images, you mustn't be surprised if they think it's like *It's a Knockout* but without the excitement. Whole swathes of the population have been deterred from opera and theatre by the miserably inert attempts to translate performances to television that are inherently untranslatable. What is needed is the widespread opportunity to see the thing itself, and that means sustaining touring venues, giving the larger permanent companies the resources and encouragement to tour, and adequately funding those companies for whom touring is their reason for existence.

Only by recreating live theatre for television, only by reconceiving it, can it be translated – which means carried across – from one medium to another. When we translate theatre performances to television, we measure our standards by the best of television drama and feature films; in opera, by films such as Bergman's *Magic Flute*, and Losey's *Don Giovanni*. There are few exemplary dance films outside *The Red Shoes*, but when ballet or modern dance is filmed well for television it has the force and the beauty of living sculpture. When it is submitted to the outside broadcast technique, it becomes disastrously risible.

There are many art forms that do transfer effectively from one medium to another. Music of all sorts, of course, is pre-eminently a radio medium but on television concerts, both popular and classical, respond well to the outside broadcast technique. Discussion and illustration is often brilliantly done through master classes and through the odd documentary that escapes the prison of the hagiographic personality profile. Likewise, paintings are often wonderfully well dealt with on television, and the context, technique, and content of the visual arts is often treated with immense care and imagination.

When Channel 4 started, every night, just before closedown, a poem was read and the text of the poem was shown on the screen. It was a marvellously surprising and inventive piece of television, which demonstrated – at least for me – how effectively poetry could be presented on television. No babbling brooks, no waving cherry blossoms, just the voice and the words on the page. The programme perished, presumably because advertisers avoided the slot as if it were emanating poison fumes. I'm astonished how little poetry reaches the screen, given that poets work for notoriously little money, and the production resources are, to say the least, modest.

I realise that I am not talking about minorities, but if there is one thing that is clear about our society, it is that we are all minorities of one sort or another. If it is proper – as of

course I believe it is – to provide money for opera and theatre, which by their nature play to small numbers of people, why is it not proper for a public broadcasting service to provide poetry on television? Or show paintings, or to make radio drama, or arts discussion programmes, for audiences of several hundred thousand people? Figures that are considered derisory in the macho culture of the ratings where four million is regarded as a poor showing in the pissing competition.

Television may be said to have an obligation to bring information and illumination about art in that, like a newspaper, it can be said to have a duty to deal with the pre-occupations or pastimes of some of its audience as news. To analyse, comment, and criticise with a commitment equivalent to that shown for sport and politics. The arts in this respect are short-changed. Listings programmes have an essential function, but they shouldn't be seen by the television companies as acting as a sort of penance for the shedulers absolving them of the duty, in the case of public broadcasters – to present programmes which celebrate the arts, discuss them, and place them in some sort of context. It is, however, no service to anyone if these programmes are not, in themselves, good television. I can't believe it is beyond the wit of British television to devise a decent programme which discusses books, let alone a programme which discusses films in a way that is not either sneering, sycophantic, or just plain silly. On the occasions – such as the recent interviews with Billy Wilder by Volker Schloendorf – where films are discussed and analysed, it seems as if television was invented for this very purpose. For the arts programmes that do exist, such as *The Late Show* and *The South Bank Show*, the problem is how to steer a course through the dangers of canonisation of the artist, earnest evangelism, gratuitous iconoclasm, and a decent critical distance. Given this, it's hardly surprising that a recent Channel 4 arts programme dealt with whether Shakespeare was gay and Brigitte Bardot sexy, in the same edition. A friend of mine was asked if he would appear on *Wogan*. 'Why me?' he said. 'Oh,' responded the guileless researcher, 'we've run out of famous people'. This is self-evidently a problem for *The South Bank Show*, but is endemic to arts programmes that insist on viewing the arts only through the prism of personalities. In the end, after you have exhausted the conventional examination of the personalities of a finite number of living celebrities, you are left, as with the 'posh' Sunday's, only with their sex lives as objects of exploration. We await further developments with interest.

It's hard for the presenters on arts programmes to avoid appearing something like a combination between a seer, a priest and a judge, superior to the art they are presenting. As a corollary an often spurious authority is conferred on an artist merely by appearing on a television arts programme. On radio, as on the excellent *Kaleidoscope,* this unwitting aggrandisement is absent. Perhaps the difference dramatises what John Updike said about television, 'Appearing on television is like living, only more so'.

There is an uneasy, rather than odd, partnership between the arts and broadcasting. It's not disinterested on either side, and on the whole it supports the artists who are already

established in their respective fields. The programme maker is often keen to exploit the celebrity of the artist, and the artist to manipulate the wider exposure to publicity that is offered. Arts organisations tend to view the 'media' as a promotional tool to be employed at the appropriate time to plug their play, book, record, exhibition, opera or film. I heard an executive from a record company say the other day that, 'It's the marketing machine that gets music on television …', and I've often heard plaintive complaints from arts organisations that the same isn't true of what they produce. It does little for the cause of the arts to treat those in broadcasting as their servants. It is in the interest of all of us that there is mutual respect and mutual co-operation. Good broadcasting depends on good faith, no less than good art does.

Our vulnerability in the world of arts and broadcasting makes us all propagandists. We spend so much time talking up the importance of what we do for funding bodies, channel controllers, sponsors, and audiences, that it is little wonder that we sometimes become the victims of our own propaganda and act as if we believed, with Shelley, that we were the ' …unacknowledged legislators of the world …'. We're not. We may be the teachers, the jesters, or even the prophets, but our power is only through the power of our work, and that work is felt to be inaccessible to large numbers of people. We should never underestimate the effects that our education system and our class system have had on disenfranchising millions from a culture that should be their birthright, and we should never underestimate the importance of television and radio as a means of helping to rectify this.

It's hard not to be affected by a feeling of millennial despair: so much seems to be wrong, and so little seems to get better. It's hard not to think that we all have to make a choice between bread and circuses, between the hardness of fact and the luxury of fiction. It's no wonder in this context that we're being offered the possibility of a 24 hour news service; it can be justified on the grounds of being serious, respectable, quantifiable, essentially unfrivolous. Art can't be justified, except by what it is. It's its own justification: either you get it or you don't. But without it as a society, we would lack a soul and we would lack a voice. Throughout the Gulf War, we had a diet of unremitting news broadcasts. I searched in vain for a voice which questioned the wisdom and conduct of the war. The morality and philosophy remained unexamined, drowned in the wash of 'expert' voices discussing the efficacy of SCUD missiles, Challenger tanks, F111's, and desert strategy, with all the enthusiasm of small boys deploying their tin toy soldiers. Only when I saw a photograph of a dead Iraqi soldier in his armoured car, charred beyond recognition into a grinning skeletal death mask, and heard Tony Harrison read his poem about him, did I find a voice that echoed the outrage, confusion and despair that I felt about the whole event. This is what art does and journalism doesn't. Balance is the enemy of art but is the essential premise of news broadcasting, and that is precisely why it is so difficult for those who run television companies to allow the artists to flourish. And precisely why it is so important that they do.

If there is a crisis in the arts and broadcasting, it is a crisis of confidence in ourselves. If we seek to improve our lot, we must not look to the Governors, the controllers, the managers, the administrators, or the legislators to find solutions to our problems. If things are to change, we must force the changes ourselves. It was Keats who said, 'That which is creative must create itself', and I think we should try and prove him right.

NOTES

1. This chapter is the text of a speech delivered to the Arts Council Brighton Conference on Broadcasting and the Arts, 27-29 October 1992.

A HISTORY OF THE STAGE PLAY ON BBC TELEVISION

NEIL TAYLOR

Writing in 1974, Raymond Williams marvelled at the extent to which the television of his day exposed its audience to drama in one form or another: 'there has never been a time, until the last fifty years, when a majority of any population had regular and constant access to drama, and used this access'.[1] If anything, the picture he described has intensified since the 1970s. With the advent of satellite and cable, the sit-com, the soap and the film have taken over, with sport and news increasingly relegated to specialist channels.

But if drama is defined as *plays* rather than dramatised fictions, the history of television drama has been one in which the significance of the genre has long been in decline. And when one turns to my subject here, the history of the *stage* play on television, that pattern of decline has been even more marked.

I have restricted myself in this essay to a consideration of BBC television, and my analysis of data covers the period 1936, the first year of regular broadcasting, to 1994. During this period three factors have determined the history of the televised stage play. Two of these factors operated from the very beginning. The first was television's perceived need to establish itself as a medium distinctly different from theatre, cinema and newspapers. The second factor was television's voracious appetite for new material – a characteristic which is no longer universal, now that cable and satellite have begun to provide some channels dedicated largely to repeats. A third factor emerged in the early 1950s: the gradual but relentless decline in television's interest in plays as providing that new material.

In the earliest days of radio, and then television, the BBC was trying to define its identity and its cultural role. In respect of drama, it had the technology to provide the service of bringing into people's homes experiences from the world of entertainment which many people were denied. At the same time it had to compete with the other existing news, arts, entertainment and educational media, for an audience, for material and for status.

A great deal of what was broadcast on radio and television before 1950 was imported from pre-existing sources of entertainment, and in particular from music hall, cabaret and theatre. Occasionally since then the relationship goes the other way: of the 36 new plays specially written for television in 1954, four were subsequently bought for theatre production. But while television stars have frequently become a draw for audiences in the commercial theatre, theatre has almost always been the exporter rather than the importer of plays. And there have been two kinds of import from the theatre – direct (the relay or transfer) and indirect (the revival).

The direct import was a common feature in the first years of broadcasting. The BBC's *Annual Report* for 1946-47 refers to the 'numerous transmissions direct from theatres, such as had become a feature of television programmes before the war'.[2] This practice of relaying productions live to the television screen had begun in 1938 and continued sporadically well into the 1960s, when Brian Rix starred in a number of farces televised from the Whitehall Theatre.[3] Nowadays such outside broadcasts are restricted to visits to the great opera houses, to concert halls and to such events as the annual Royal Variety Performance. But in the early days of both radio and television, there was also another way in which commercial theatre directly provided the BBC with material – the casts of current runs of plays in the commercial theatre visited the BBC studios to give further performances before the microphone or television cameras.

The indirect import, which has lasted to the present day, has taken the form either of new television productions of plays originally performed on the stage or else of broadcasts of commercial films based on plays originally performed on the stage. The latter only became a possibility in the mid-1950s, and grew to proportions of some significance for many years.

The former, on the other hand, became an important feature of both radio and television from their very earliest days. In 1937, for example, there were 46 television broadcasts of excerpts from stage plays and 56 broadcasts of complete state plays. Two facts need to be appreciated before these figures can be properly understood. Firstly, many of these broadcasts were repeats (*live* repeats, of course, with the actors performing again either later on the same day or later in the week). Secondly, in order to fit into the very restricted daily schedule, the broadcasts were usually very short (the average over the year is only 34 minutes). Hence, broadcasts could usually only be of one-acters or excerpts.

The length of imported stage plays continued to be a problem after the war. The scheduling framework did not suit full-length theatre plays – the evening session was only 90 minutes and the afternoon session often only 60 minutes. In 1946, classics such as *St Joan* and *Mourning Becomes Electra* had each to be broadcast in two parts. Faced with such formal problems, television was keen to define and publicise its own formal strengths and achievements.

In the spring of 1937 an article appeared in *Radio Times* entitled 'The Televising of Drama'. It was written by a television producer, G. More O'Ferrall, who was looking back on the experience of televised broadcasts of T.S. Eliot's *Murder in the Cathedral* and Lady Gregory's one-act play, *Workhouse Ward*. O'Ferrall concluded that television drama was 'a medium of its own', different from and in certain ways superior to both the theatre and the cinema (22-27 March, 'Television Supplement', p. 4). His genuinely illuminating argument was about the quality of experience afforded by televised drama, whatever the play's origins. For him television scored over film in that, like theatre, it was live. It scored over theatre in its filmic ability to employ close-up and semi-close-up (providing psychological insights by examining intensely a character's face, or directing attention to small significant details, such as a cartridge being inserted in the revolver) and in tricks such as superimposing one image on another. It scored over both film and theatre in the degree to which the producer was an 'actor' in the play, responding in the real time performance to contingent realities in the studio by delaying or accelerating or amending the planned sequence of shots according to the actors' departures from the rehearsed sequence of events. O'Ferrall's article is a wonderful record of the excitement which the new medium provoked and the intelligence which it attracted. Within a few years live drama programmes died, and much of his argument with them. But by then, other forces had begun to gang up on the televised stage play.

The stage play was a very attractive option: classics like Shakespeare were self-validating while new West End plays had the attraction of topicality. But the BBC very much wanted to develop its own material. By 1931 it had been able to boast that, for the first time, there were 'more original wireless plays than stage plays'.[4] It took almost another 30 years before it could announce that 'Television drama made history this year in that over 50 percent of its material was specially written for the television screen'.[5] By the 1990s, however, the original picture had reversed. Where once imported stage plays provided the bulk of televised drama, now they are rarely broadcast at all, and even the number of feature films based on stage plays has dwindled into insignificance.

Immediately after the war, BBC television ran into difficulties over the supply of good theatre plays and good stage actors (always limited commodities at the best of times). Outside broadcasts of successful current shows in the London theatre (valued reportage and actuality as much as tested quality-goods) were hard to secure 'owing to the opposition of some theatrical managements',[6] and 'Television variety has been handicapped by the unavailability of artists who are under contract to the big music-hall combines'.[7] As a result those few performers who were available (people like Richard Hearn, who played the clownish character 'Mr Pastry') came to be established television personalities and developed new careers. It also explains how the resultant need for new revues written specially for television led to the employment of entertainers newly returned from the services and not yet under contract to theatre managers (as well as the reconstruction of wartime troop shows in which members of the television staff had recently appeared).

Struggles with the unions, the British Actors Equity Association and the Variety Artistes' Federation, led to bans on simultaneous radio and television broadcasts and all relays of public performances from theatres. Meanwhile the film industry was proving uncooperative – a deal had been proposed that cinemas should show television programmes of big national events while the BBC would show commercial feature films, but negotiations broke down.[8]

After a while, television began to experience a shortage in the supply of material. In the financial year 1950-51 there were three live performances a week and some big names among the actors (Donald Wolfit, Richard Attenborough, Margaret Leighton and Margaret Rutherford), but 'finding so great a number of plays is not easy, and it will probably be necessary to look increasingly to the writing of new plays for television'.[9] This theme was taken up immediately in the BBC's *Annual Report* for the following year: 'The stock of available theatre plays is not inexhaustible. The rate at which plays are used is very high; over 100, of full length, are produced annually at present. New plays by living playwrights are a great need'.[10] The regular Sunday night play was now attracting an average of three million viewers.[11] As part of the Festival of Britain the BBC made its own cultural contribution, a Festival Theatre series of plays: Terence Rattigan, J.B. Priestley and James Bridie were commissioned to write new television plays, but the series was also made up of classics such as Shaw's *St Joan* and Congreve's *The Way of the World*.

Gradually, film began to infiltrate television. The *Annual Report* for 1954-55 was commenting that 'More films were shown and film was used more extensively in talk, play and opera productions'.[12] An agreement allowed Equity members to participate in pre-recorded programmes: 'It was no longer necessary, as hitherto, to broadcast all such performances "live"; this allows greater flexibility in the planning of drama productions'.[13]

'The full-length studio play, specially produced for the camera, offers the ideal material for television'. So wrote the author of the *Annual Report* for 1947–48.[14] And two years later, the *Report* provided statistical evidence for the importance of plays to television programming: News, Newsreel and Documentary Films together accounted for 19.7 per cent of broadcasting time, but Drama came second, with 15.9 per cent. After 1950, however, when the proportion peaked at 17.8 per cent, the amount of time given over to drama began to drift down, and this process continued steadily for the next thirty years. In 1951–52, it was down to 13.4 per cent, in 1953–54 12.8 per cent, in 1956–57 10.1 per cent and in 1960–61 7.4 per cent. When a second BBC channel, BBC2, was introduced in 1964 it carried more drama than BBC1. The proportion of drama had been rising a little for a few years and now stood at 11.6 per cent, but immediately it began to drift down again, falling back to 9.7 per cent in 1967–68, 8.0 per cent in 1969–70 and 6.4 per cent in 1972–73. Ten years later it was down to 4.2 per cent.[15]

This pattern of decline is attributable to a number of factors. At first, television was trying to win audiences away from the theatre and cinema, and, of course, the BBC's other arm,

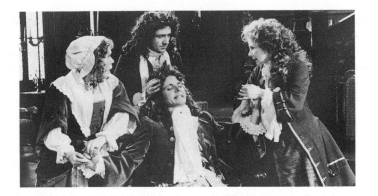

The Beaux' Stratagem. Play of the Month (1978, BBC 1).
l–r: Brenda Bruce (Lady Bountiful), Tom Conti (Archer), Ian Ogilvie (Aimwell) and Zöe Wanamaker (Dorinda).
Photo: BFI Stills, Posters and Designs, courtesy of BBC Television.

radio. The imported stage play was one element in the struggle with the theatres, and the original television play was another. In its campaign against the cinema, the BBC was for long thwarted in its desire to buy up and broadcast any British feature films, but in 1957 it managed to purchase 100 American films previously shown in the cinema. Two years earlier a new competitor had been born, commercial British television. The BBC began to look to its ratings and noticed immediately that 'lighter types of entertainment' drew the largest audiences.[16] The classic stage play was immediately under threat.

In the sixties, there developed a fixation with the series as a means of building and then holding on to an audience. One off productions of plays, whether specially written for television or imported from the theatre, gave way to series with titles, such as *Play of the Month*, which were designed to establish regularity of viewing. The first series of *The Wednesday Play* included classics such as Sartre's *In Camera* and Montherlant's *Malatesta*, but the second carried the sub-title, 'New Plays written specially for Television'. Over on BBC2, meanwhile, *Thursday Theatre* presented 'Plays by well-known authors which have enjoyed West End success'. *Theatre 625* took the treatment a stage further: individual plays from the theatre such as Anouilh's *Poor Bitos*, and Thornton Wilder's *The Ides of March* were punctuated by 'plays presented in Groups of two or three, each Group dealing with a coherent theme'.[17] Thus, Ken Taylor wrote three plays under the title *The Seekers*, Colin Morris wrote three called *Women in Crisis* and Ford Madox Ford's *Parade's End* was presented in three episodes.

John Reith's original vision of BBC radio was a national broadcasting service which educated as much as it entertained. The television service was also committed to a certain amount of intellectual and moral education, and this sometimes involved the popularisation of high, or at least upper-middle-brow, taste. In the late sixties, BBC television was applying the series formula to such improving material as Kenneth Clark's

Civilisation, a documentary about the history of western art which was broadcast (and also published in book form) in 1969, and it was having a similar success with serialised dramatisations of 'classic' novels. Examples of both genres sometimes managed to retain their hold over a segment of the audience for months on end. On one occasion at least, the BBC was obliged to apologise for its success: the 1968–69 *Annual Report* expressed official regret that the decision to repeat *The Forsyte Saga* on BBC1 at 7.25 p.m. on twenty-six Sunday evenings 'made it difficult for church-goers to attend Evening Service'[18]

Perhaps the same treatment could be administered to the ailing stage play? Shakespeare obliged, having already had the same idea of writing in the series formula. In 1960 the BBC realised what it claimed to have been 'a long-felt ambition' and broadcast a fifteen-part television series, *An Age of Kings*, which mounted the whole cycle of Shakespeare's History Plays. 'It had been done only once before on stage, and that two generations ago. Critics in this country were full of praise for the series, and its reception in the United States was equally warm'.[19]

In May 1963 there was an attempt to emulate this success at home and abroad by broadcasting Shakespeare's Roman plays in nine one-hour episodes under the title *The Spread of the Eagle*. That same autumn, the BBC launched *Festival*, a series of 'The best plays the world has to offer' – 'plays from the Greek classics and our Modern Theatre of the Absurd'.[20] Then, to mark the four-hundredth anniversary of Shakespeare's birth, the Corporation broadcast *The Wars of the Roses* from the Royal Shakespeare Company at Stratford-upon-Avon, 'entirely restaged at Stratford to suit television'.[21] It was 'the most elaborate form of co-operation yet devised between theatre and television. Each play was presented at 2 hr. 50 min. lengths in this country, while a special series of eleven 50 minute episodes was prepared for sale throughout the world'.[22] This was an example of 'the BBC policy of working with various theatrical organisations in the country'.[23] But it was also a further example of the glint in the eye of the BBC's Television Enterprises department, 'now a full partner in the Television Service proper, [for] ... the special needs of other countries, while not allowed to dominate planning for the home audience, are given increasing attention. A total of 7,426 programmes was sold throughout the world in 1964–65 [and this meant] ... an increase of 25 per cent on the previous year in the gross income from sales'.[24]

As the BBC public service came under threat from ITV it found itself caught up in conflicting discourses as it fought for new areas in the mass audience and at the same time defended what began to look like old or minority interests. The 1963-64 *Annual Report* expresses anxiety that the Corporation is coming in for criticism over the subject-matter of its drama output: 'It has been a recurring theme ... that the playwrights who write for the BBC concentrate overmuch on the sordid and the hopeless ... [The BBC] believes not only that undue offence should not be caused but also that the audience in the home has a right to hear and see plays which under the limitations of the commercial theatre might never be on offer'.[25]

This is a new development in the struggle over television drama and the theatre. Where the issues had earlier been a matter of finding a way in which television could discover its own distinctive style or form, or trying to woo the theatre into allowing television to use its material, or feeling that television is duty-bound to honour the classics of the theatre, or trying to woo famous actors into the studio, or trying to save the theatre from declining into bankruptcy, and so on – now television found that it could present existing plays or new plays which would otherwise never be performed. The 1962 Pilkington Report, Television Programme Policy in the Next Ten Years, expressed the hope that among other things BBC2 could allow the Corporation to 'cater more fully for special needs and aspirations ... [and] experiment on the screen'.[26] The BBC had taken up the role of patron of the arts, fostering new talent and indulging the connoisseur. On television in 1963 Festival had been 'designed to provide a wide variety of high quality plays for the "specialist" viewer of television drama'.[27] while, over on sound radio in 1966, the BBC seemed to imagine it had taken on the mantle of Preserver of our Heritage: 'it initiated a series called 'Repertory in Britain', dedicated to saving from extinction a theatrical institution, the repertory theatre, 'the health of which is important to drama as a whole in this country'.[28]

Recalling not just its Reithian commitment to culture but possibly, as Graham Holderness has pointed out,[29] Reith's evidence to the 1925 Crawford Committee that 'programmes which are broadcast on Sunday are ... framed with the day itself in mind', BBC Television chose 8.10 on the evening of Sunday 3rd December 1978 to launch a prestigious new series devoted exclusively to 36 classic stage plays by the world's greatest dramatist. Ten years earlier, The Forsyte Saga had been attracting 17 million regular viewers but now, even though it was heralded by introductory programmes on BBC2 and Radio 4, and a ten-page feature in Radio Times, the The BBC Television Shakespeare's opening production of Romeo and Juliet drew an audience of only 1.9 million.[30]

During the period, 1936 to 1994, there were 2,586 broadcasts of complete theatre plays on BBC television channels. At first, output was high: 1,848 of these broadcasts went out in the first 20 broadcasting years, i.e. 1936 to 1963 (the service closed down for six years in September 1939). In most years up to 1950 the average number of such broadcasts was over 100 (in 1947 alone the figure reached 159), but thereafter the number began to decline, slowly but steadily.

By 1963, for instance, the number of stage plays on BBC television was only 45. The introduction of a second BBC channel in 1964 increased output for a while, but after 1971 the figures went again into decline. Since its inception, BBC2 has gradually taken over from BBC1 the role of broadcasting plays, and in particular plays drawn from the theatre. Even though, over the whole period 1964-1994, the two BBC channels have shared the number of broadcasts (377 on BBC1, 362 on BBC2), in the shorter period 1984–1994, BBC2 has broadcast 92 stage plays, while BBC1 has only broadcast 16. Since 1991 all of the 17 broadcasts have been on BBC2, and of these only four went out in the latest year in this analysis, 1994.

A similar pattern of decline occurred on ITV. The base line was always lower: commercial television never had the same commitment to stage plays. And stage plays have ended up as the material for the 'minority' audience, Channel Four. Whereas in 1982, the first year of the second commercial channel, the number of broadcasts of stage plays on the four channels was:

BBC1: 12 BBC2: 10 ITV: 11 Ch4: 5

In 1982 it had changed to:

BBC1: 1 BBC2: 11 ITV: 3 Ch4: 9

and in 1989 to:

BBC1: 0 BBC2: 8 ITV: 1 Ch4: 3

Since then the reduction in the number of broadcasts of stage plays, the imbalance between BBC and commercial channels, and their preference for scheduling such broadcasts on BBC2 and Channel 4 rather than the more popular BBC1 and ITV has continued, with the result that in the three years in 1992, 1993 and 1994 there were no broadcasts on either BBC1 or ITV, only 17 on BBC2 and only 2 on Channel 4.)

What are the kinds of stage play which have attracted BBC television programmers over the last sixty years?

If one divides theatre history into six Phases – 1, the ancient world of classical Greece and Rome; 2, the Middle Ages; 3, the Renaissance; 4, 1660–1800; 5, 1801–1900; 6, 1901–1994 – one finds that, unsurprisingly, the overwhelming majority of stage plays broadcast on BBC television have been written in Phase 6, the twentieth century. This is largely explained by the BBC's early priorities, such as the perceived needs to be topical and to compete with the live theatre, which necessarily involved programmers in the purchase of rights to those plays which were current in the West End or in British repertory theatres; almost all of these would have been modern plays or plays written within the theatre-going lifetime of those programmers.

Equally unsurprising is the fact that television has made little use of Phases 1 and 2, classical and medieval drama. Of the two, the medieval period has provided least broadcasts, – just 22 – whereas there have been 37 broadcasts of plays from the ancient world. Most of the medieval plays went out in the earlier years of television (15 before 1962) and there have been none at all since 1977, when a 1976 Cedric Messina *Play of the Month* production of the Chester Mystery Plays was repeated, serialised in 25-minute episodes early on Sunday evenings during the 'dead' summer months.

On the other hand, there was no production of a Greek or Roman play before 1958, when Euripides' *Women of Troy* was done late one Sunday evening in early January. BBC television would therefore seem to have given up on medieval drama but developed

instead a modest interest in classical drama. But even that interest has dwindled: except in 1984, when extracts of world drama from all periods made up a 13-part series entitled *All the World's a Stage,* the only productions in the last 15 years have been Sophocles' Theban Plays in 1986 and Euripides' *Iphigenia at Aulis* in 1990.

Only slightly better represented has been Phase 4, from the Restoration through to the end of the eighteenth century. This period has been the source of 52 broadcasts of plays by nine different dramatists, but 19 of these broadcasts have been of plays by Sheridan and 12 have been of plays by Molière: these two have dominated the period, with Molière slightly and slowly strengthening his position at the expense of Sheridan.

Between them, Phases 1, 2 and 4 have only accounted for 111 broadcasts. Phase 5, the nineteenth century, has been far more popular, amassing 240 broadcasts of work by 30 named playwrights and 10 broadcasts of anonymous melodramas. At first, this seems to suggest a rich and imaginative exploration of the dramatic talents of the period. In fact, however, since 1984 there have only been broadcasts of plays by five different playwrights – Ibsen, Chekhov, Pinero, Wilde and Turgenev – and over the period as a whole Ibsen, with 46 broadcasts (and a further 11 extracts), and Chekhov, with 42, are by far the most frequently used.

Phase 3, the Renaissance, is generally regarded as the high point in the history of English drama. With 323 television broadcasts it is significantly ahead of the nineteenth century, and there have been only four years in which it has been entirely ignored. But we must be careful not to conclude from this that television has served the period well. In the first place, the four years of total neglect have all fallen in the last ten years. Secondly, the broadcast plays were written by only 8 authors or writing teams. Finally, we must note that the popularity with television programmers of the Renaissance stage play is largely due to the popularity of one playwright, William Shakespeare. He alone accounts for 84 per cent of the broadcasts from the period. Shakespeare is the banker. Without him, the Renaissance would be limping along in fifth place.

In 1937 alone there were 20 broadcasts of 25-minute excerpts from Shakespeare plays. Television's early habit was to deliver stage plays in short programming units and, even when 'complete' Shakespeare productions were introduced, starting with *Julius Caesar* on 24 July 1938, the BBC reduced the play to a mere 70-minutes. Nevertheless, Shakespeare's significance was so great that the decision was made to transmit a *Twelfth Night,* starring Michael Redgrave and Peggy Ashcroft, direct from the Phoenix Theatre on 2 January 1939: it lasted 150 minutes – 35 minutes longer than any previous broadcast (a production of Noel Coward's *Hay Fever* broadcast on Christmas Day 1938) and 71 minutes longer than the average length of a television play for that year.

Not only has Shakespeare been privileged by receiving so many, and often such long, broadcasts; he has also been given special treatment in that on a number of occasions

his work has provided the material for series, as well as serialisations. In 1960, there were not only as many as 23 Shakespeare broadcasts, but 15 of them were a series – *the Age of Kings* adaptations of the History Plays – and a further eight were a serialisation for schools of *Julius Caesar*. Similarly, in 1966 there were 22 broadcasts, of which 11 were another History cycle, *The Wars of the Roses,* and nine a school's serialisation of *Macbeth*. Eventually, between 1978 and 1985, the Corporation went further and committed itself to broadcasting the complete canon in a high-profile series, 'The BBC Television Shakespeare'. This series was extraordinary for four reasons: 1 it broadcast plays which had never been televised before, 2 it employed very full texts, 3 some of the broadcasts were therefore very long, and yet 4 they were always put out at peak viewing time. *Hamlet* may well be the world's most famous play but it is famously long and therefore at odds with television's conventions. Over the years, as the BBC has given over less and less time to the broadcasting of stage plays it has given over more and more time to individual broadcasts of *Hamlet*. In 1947 it occupied two 90-minute slots, in 1964 one 170-minute slot broadcast, in 1972 one 200-minute slot. On 25 May 1980, the BBC Television Shakespeare series sacrificed a whole Sunday evening to the play, devoting 225 minutes to its production. *Richard III* not only lasted even longer (235 minutes) but was the culmination of four successive Sunday nights (totalling 845 minutes, i.e. more than 14 hours) given over to the rarely-performed First Tetralogy in which *1 Henry VI* lasted 190 minutes, and *2 Henry VI* and *3 Henry VI* each lasted 215 minutes.

For all that Shakespeare has given Phase 3 a significant share in the output of televised stage plays, its 323 broadcasts are beaten into a very poor second place in the popularity stakes by the 2,085 broadcasts from Phase 6, the twentieth century. The most featured dramatist is Bernard Shaw who, with 99 broadcasts, alone outstrips the total output of Phases 1, 2 and 4 put together.

Shaw's prominence is predictable. In the first place, he was a popular, living and still active playwright when the service began. Secondly, in the early days his material was instantly telegenic by virtue of its length: he wrote one-acters as well as full-length plays and television needed material that would fit into a variety of slots. In the foreshortened broadcasting year of 1939 alone there were 11 broadcasts of his work: a play such as *Candida* took up 90 minutes but more than half the plays lasted less than 45 minutes. The service did not resume after the war until June 1946, and the first afternoon (7th June) included Shaw's *The Dark Lady of the Sonnets,* which not only nicely combined the attractions of Shaw with those of Shakespeare but also satisfied sentiment, viability and market-testing, having already been broadcast twice in the year the service had been forced to close. In the six-month broadcasting year of 1946 Shaw notched up a further 10 broadcasts, including *St Joan* direct from the King's Theatre, Hammersmith, and a studio production of *Arms and the Man* at the key time of Christmas Eve.

Despite the fact that Shaw's popularity has waned (half his broadcasts appeared before 1953, whereas he has yet to be broadcast at all in the 1990s), his original appeal to the programmers was subsequently supplemented by the added attraction of his 'classic'

status, and this has kept him on television in the same way that he still appears occasionally on school syllabuses and in the repertoire of British theatres. But the list of those theatre playwrights who follow him in popularity on television is a mixed one, with far fewer obvious names.

J.B. Priestley comes second, followed by Noel Coward, J.M. Barrie, Eugene O'Neill, Terence Rattigan, James Bridie, Somerset Maugham and John Galsworthy. From the perspective of those who compile school or university reading lists, or those who manage seasons at the Royal National Theatre, the Royal Shakespeare Company, or provincial reps, it seems a curiously mixed bag of names today. Priestley had a bumper year in 1949, when there were 10 broadcasts of his plays, and Coward did well in 1938, when there were six, and 1991, when there were seven. Otherwise they have both jogged on, picking up broadcasts every other year or so, and both seem to have retained enough appeal to be still produced in the 1990s. Rattigan did not feature until *French Without Tears* in 1947, and he had a lean time in the 1960s (*Adventure Story* and *The Winslow Boy* in 1961 was all he could muster), but otherwise he has popped up in each decade, including once in 1992 (*After the Dance*) and once more in 1994 (*The Deep Blue Sea*). For all that he is still regarded as a 'classic' American dramatist, Eugene O'Neill only had good years in 1946 and 1960, in each of which he was broadcast five times; he was missing from BBC television screens entirely in the 1970s and, so far, in the 1990s.

Galsworthy's tally was largely amassed before 1963, since when there have been only five more productions, and the showing of *Strife* in 1988 broke a 12 year absence from our screens. Maugham, likewise, made his impact in the 30s, 40s and 50s, and a production of his *Sheppey* in 1980 was the sole appearance of his work since 1958. Barrie and Bridie provide a similar story, though Barrie plays appeared in 1975, 1981 and 1987 (*The Little Minister, Dear Brutus* and *Mary Rose*) and in 1980 *The Anatomist*, provided James Bridie with his first broadcast since *Storm in a Teacup* went out in 1962.

Any student of drama who was challenged to name the significant theatre playwrights of the twentieth century might well include some of the BBC's 'top ten' but would probably also be mentioning Jean Anouilh, Alan Ayckbourn, Samuel Beckett, Edward Bond, Bertolt Brecht, Howard Brenton, Caryl Churchill, Jean Cocteau, T.S. Eliot, Dario Fo, Michael Frayn, Max Frisch, Christopher Fry, Athol Fugard, David Hare, Eugene Ionesco, D.H. Lawrence, Mike Leigh, Arthur Miller, Sean O'Casey, Joe Orton, John Osborne, Harold Pinter, Luigi Pirandello, Tom Stoppard, David Storey, John Millington Synge, Arnold Wesker, Tenessee Williams, or W.B. Yeats. Challenged further to put them in order of importance, the student might well put some of these names higher than those of Coward, O'Neill, Rattigan or even Shaw. So where in the list of BBC television's most broadcast plays is the work of *these* writers?

The answer is, there, but, in most cases, hardly there. Brecht, with 26 broadcasts, comes behind Galsworthy, and is only one broadcast ahead of A.A. Milne, whom most people today would not at all associate with the writing of plays. Beckett, with 18 broadcasts, has

to wait until twenty-ninth place. Orton, with two, and Stoppard, with one, are nowhere. They are having to compete for their lowly position within a pool of 638 twentieth-century theatre dramatists – almost all of whom are now totally forgotten.

Even so, the fact that all of the top 10 dramatists from Phase 6 clocked up the bulk of their broadcasts in the first 30 years of television and have appeared less often in the last 30 years should not be regarded as evidence that their place in the top 10 is merely a function of factors operating in the early years of television. Their rate of appearance has to be seen against the decline of the stage play on television. When the rate of decline is taken into account, playwrights like Shaw, Priestley, Coward, Rattigan and even Galsworthy, have demonstrated remarkable staying power in the affections of BBC programmers.

If the total broadcasts, including excerpts (which sometimes affects the order of names from those referred to above), of all the stage plays ever broadcast on BBC television are analyzed, the top 20 theatre playwrights turn out to be as follows:

		total	complete	excerpts
1.	Shakespeare	281	235	46
2.	George Bernard Shaw	99	95	4
3.	Henrik Ibsen	57	46	11
4.	J.B. Priestley	45	45	1
5.	Anton Chekhov	45	42	3
6.	Noel Coward	45	42	3
7.	J.M. Barrie	36	35	1
8.	Eugene O'Neill	34	32	2
9.	Terence Rattigan	31	31	0
10.	James Bridie	30	30	0
11.	Somerset Maugham	26	26	0
12.	Bertolt Brecht	26	23	3
13.	John Galsworthy	25	25	0
14.	A.A. Milne	25	23	2
15.	Arnold Wesker	24	23	1
16.	Harold Brighouse	22	22	0
17.	Georges Feydeau	22	22	0
18.	Arthur Pinero	21	21	0
19.	Edgar Wallace	21	21	0
20.	Ben Travers	21	20	1

They are followed by Sophocles in 21st place, then Richard Brinsley Sheridan, Sean O'Casey, Patrick Hamilton, George S. Kaufman, Emlyn Williams, John van Druten, Nikolai Gogol, Ben Jonson, Stephen Leacock, Jean Anouilh, Ugo Betti, Oscar Wilde, John Arden, Laurence Housman, Luigi Pirandello, Jules Romains, R.C. Sherriff, Eden Phillpotts, Samuel

Beckett, G. Martinez Sierra, W.B. Yeats, Ian Hay, T.S. Eliot, Shelagh Delaney, Molière, Harold Pinter, Elmer Rice, Thornton Wilder and Christopher Fry in 50th place.

What emerges from this brief history? Quite clearly, the major feature is the decline in the number of broadcasts of theatre plays. But one should note what happens to those broadcasts which remain. In 1938, when there were 127 broadcasts, they were spread reasonably equally over the whole week, although Sunday attracted rather more than any other day:

Sun 24; Mon 17; Tue 17; Wed 9; Thu 4; Fri 11; Sat 9

In the five years 1990 94, the distribution has been very different, with theatre concentrated on weekends, and Saturday in particular:

Sun 9; Mon 1; Tue 0; Wed 4; Thu 0; Fri 0; Sat 30

In 1938 the plays were evenly spread over the year. In the 1990s, however, they have tended to become grouped, either as series ('festivals of theatre'), or around particular times of the year (most notably, winter or Christmas):

	Jan	Feb	Mar	Apr	May	Jun	Jul	Aug	Sep	Oct	Nov	Dec
1990	2	2				2	3					1
1991			1	7		1		1		4	1	
1992											3	3
1993											4	2
1994											3	1
Total	2	2	1	7		3	3	1		4	11	7

In other words, theatre plays cease to be part of the normal pattern of broadcasting and become special events, associated with holidays.

The list of most broadcast playwrights reveals what one has always guessed, namely that the BBC is committed to the regular broadcasting of classic arts material, such as its own Promenade Concerts, but when it comes to theatre plays it has always played safe and gone for the typical West End or, to a very limited extent, RSC/RNT product. Its target audience has been perceived as bourgeois and middle-brow, with tastes which preclude anything very intellectual, anything sexually, morally or politically risky, anything from the fringe.

On the other hand, there has been a preoccupation with Shakespeare for almost the whole life of the BBC. Shakespeare is not necessarily safe, and he certainly does not easily fit in with certain of television's conventions (naturalism and short segments of time). The BBC Television Shakespeare reflects BBC television's ability both to 'tame' Shakespeare and to accommodate to Shakespeare's 'otherness'.[31]

Finally, nevertheless, one has to admit that the Top Twenty is in many respects a bizarre list. How could a J.M. Barrie or an A.A. Milne be ahead, let alone so *far* ahead, of an Oscar Wilde or a Harold Pinter or an Alan Ayckbourn (only nine broadcasts)? To some extent the answer has already been provided: James Bridie built up more than half his tally of broadcasts before 1950, a period when his plays were on the professional and amateur stage, and there were many theatre plays on television; Coward and, to a lesser extent, Priestley still have a place in the theatre repertoire in the 1990s, and their achievement in being fairly consistently represented in each of the six decades of television broadcasting may partly reflect that fact. But, even so, one is forced to conclude that BBC programmers hark back to their early experiences as viewers and go on perpetuating the list of playwrights whose work gets revived on television – even as the opportunities to broadcast those playwrights fall away.

NOTES

1. Williams R. (1974) *Television: Technology and Cultural Form*, Fontana: London, p. 59.
2. *The British Broadcasting Corporation Annual Report and Accounts for the Year 1946-47*, His Majesty's Stationery Office: London (1948), p. 28.
3. The first broadcast was of J.B. Priestley's *When We Are Married* from the St. Martin's Theatre on 16 November 1938. Rix's first production was *Reluctant Heroes* by Colin Morris on 11 September 1960.
4. *The British Broadcasting Corporation Fifth Annual Report 1931*, HMSO: London (1932), p. 5.
5. *The British Broadcasting Corporation Annual Report and Accounts 1958-59*, HMSO: (1959), p. 48.
6. *BBC Annual Report … 1946-47*, p. 28.
7. *BBC Annual Report … 1946-47*, p. 29.
8. *The British Broadcasting Corporation Annual Report and Accounts for the Year 1949-50,* HMSO: London (1950), pp. 27-8.
9. *The British Broadcasting Corporation Annual Report and Accounts for the Year 1950-51*, HMSO: London (1951), p. 26.
10. *The British Broadcasting Corporation Annual Report and Accounts for the Year 1951-52*, HMSO: London (1952), p. 30.
11. *The British Broadcasting Corporation Annual Report and Accounts for the Year 1951-51*, p. 46.

12. *The British Broadcasting Corporation Annual Report and Accounts for the Year 1954-55*, HMSO: London (1955), p. 23.

13. *BBC Annual Report ... 1954-55*, p. 22.

14. *The British Broadcasting Corporation Annual Report and Accounts for the Year 1947-48*, HMSO: London (1948), p. 12.

15. These statistics come from the *Annual Reports* for the years cited.

16. *The British Broadcasting Corporation Annual Report and Accounts for the Year 1955-56*, HMSO: London (1956), p. 47.

17. *The British Broadcasting Corporation Annual Report and Accounts for the Year 1964-65*, HMSO: London (1965), p. 25.

18. *The British Broadcasting Corporation Annual Report and Accounts for the Year 1968-69*, HMSO: London (1969), p. 20.

19. *The British Broadcasting Corporation Annual Report and Accounts for the Year 1960-61*, HMSO: London (1961), p. 43.

20. 'Festival. A new series of TV drama introduced here by its producer Peter Luke', *Radio Times*, vol. 161, no. 2082, Oct. 5-11 1963, p. 39.

21. *The British Broadcasting Corporation Annual Report and Accounts for the Year 1964-65*, p. 24.

22. *The British Broadcasting Corporation Annual Report and Accounts for the Year 1964-65*, p. 24.

23. *The British Broadcasting Corporation Annual Report and Accounts for the Year 1964-65*, p. 24.

24. *The British Broadcasting Corporation Annual Report and Accounts for the Year. 1964-65*, p. 28.

25. *The British Broadcasting Corporation Annual Report and Accounts for the Year 1963-64*, HMSO: London (1964), p. 10.

26. *The British Broadcasting Corporation Annual Report and Accounts for the Year 1964-65*, p. 21.

27. *The British Broadcasting Corporation Annual Report and Accounts for the Year 1964-65*, p. 22.

28. *British Broadcasting Corporation Handbook,* London (1966), p. 77.

29. In his chapter on 'Boxing the Bard: Shakespeare and Television' - in *The Shakespeare Myth*, (ed.) G. Holderness, Manchester University Press: Manchester (1988), p. 175.

30. Three weeks later, 26 million tuned in to watch a screening of the film version of what was originally a stage musical, *The Sound of Music.*

31. See Neil Taylor, 'Two Types of Television Shakespeare', in *Shakespeare and the Moving Image*, (ed.) Anthony Davies and Stanley Wells, Cambridge University Press: Cambridge (1994), pp. 86-88; Michelle Willems, *Shakespeare à la télévision*, Rouen (1987) and Susan Willis, *The BBC Shakespeare Plays: Making the Television Canon*, Chapel Hill and London (1991) *passim.*

NO RESPECT: SHOT AND SCENE IN EARLY TELEVISION DRAMA

JASON JACOBS

One of the most enduring caricatures of early television dramas is that they constituted no more than 'photographed stage plays', respectfully relaying theatrical performances, forsaking innovation and development of the televisual form itself:

> . . . in its early days TV drama picked up the predominant patterns, concerns and style of both repertory theatre and radio drama (as well as many of their personnel, and their distinct training and working practices) and consisted of televised stage plays, 'faithfully' and tediously broadcast from the theatre, or reconstructed in the studio, even down to intervals, prosceniums and curtains. Such an approach, which takes the television process itself as transparent, almost by definition precluded any innovation of TV style or any attempt to develop a specifically televisual form for small-screen drama.
> (Gardner and Wyver 1983: p. 115)

Is this accurate, and is it fair? John Wyver and Carl Gardner's essay, 'The single play: from Reithian reverence to cost-accounting and censorship' first appeared in the *Programme of the Edinburgh International Television Festival* (1980): it was a polemical piece which contrasted the innovation in television drama during the late 1950s and 1960s – exemplified by anthology drama series such as *Armchair Theatre*, *The Wednesday Play*, *Play for Today* and writers, directors and executives such as Troy Kennedy Martin, Tony Garnett, James MacTaggart and Sydney Newman – with the move to a reliance on co–production financing which necessarily compromised artistic innovation and risk-taking. For Gardner and Wyver the choice was clear; without the desire for development of the medium, that is, encouraging new writers and directors to experiment and innovate within the genre of the single play, television drama was either ruled by the Accountants or doomed to relay theatrical performance. In their 'Afterword' to this essay, reprinted in *Screen* with the original article three years later, the authors note the return to this earlier, primitive, form of drama presentation:

In drama, Channel 4 has already committed itself heavily to (inevitably co-produced) recordings of theatrical hits. *Nicholas Nickleby, The Gospel According to St. Matthew* … have already been shown … How ironic then that, in a sense, it represents a return to the theatre on television which dominated the small screen in the 1950s. And how sad that a service committed to 'innovation and experiment' has to rely on one of television drama's oldest and least interesting forms.
(Gardner and Wyver 1983: p. 129)

It is with these 'least interesting' forms that this essay is concerned, primarily the earliest drama output of the BBC from the inception of its Television Service in November 1936 to mid-1950s.[1] In particular, I want to investigate the origins of the caricature of this drama as one which respected the style and conventions of theatre, as a static form framed with a reverence for British Theatre and British Culture.

A point of comparison with this anti-theatre prejudice can be found in the study of early cinema. In film criticism and film studies, using the concept of 'theatrical' as a term of abuse is nothing new. A glance at the corpus of film criticism and theory before the mid-1970s and, residually, up to the present day will provide countless examples of the evaluation of a film as Art precisely in terms of its distance from 'theatricality'. The properly cinematic (traditionally this involved the full use of editing technique, something theatre can never do) was set against the 'merely' theatrical. For example, Eric Rhode's survey *A History of the Cinema* includes this telling passage:

The film as play tends to have inert camerawork, nondescript editing, an uneasy sense of location, grandiose actors who talk too much and call attention to their performance. *The film as an art* in itself has a probing, yet tactful camera that creates tactile values (seemingly) out of space, and an articulated editing that sets up a new kind of rhythm and intonation.

Compare the theatre, that hothouse of artifice, with its painted actors and backcloths, its glut of words and its infusions of space and time, with the trajectories through landscape and timelessness of the Western – its rugged men and fresh-skinned women …
(Rhode 1976; p. 30)

'Primitive' early film-makers – anyone before D.W. Griffith – were the guilty parties, producing films where the single shot corresponded to the theatrical 'scene'. More recently the heritage of primitive cinema has been revised, with scholars of early cinema such as Charles Musser, Barry Salt, Noël Burch and Tom Gunning, re-interpreting the formative period of cinema in positive terms, and in so doing, rescuing the term 'theatricality' from its derogatory sense, and re-locating it in terms of a range of stylistic choices available to early film-makers, rather than a fundamental misunderstanding by the pioneers of the film medium. As such scholarship has demonstrated, even a single-

shot film of a theatrical tableau involves quite sophisticated choices for the film-maker; camera height and position, shallow or deep staging, character entrance and exit, the relationship between camera position and foreground or background, the mode of address of the film (is the film spectator treated as a member of a theatre audience, a voyeur, a witness?). There was never a sense of switching the camera on and returning once the performance was over.

Similarly, early television drama has been berated for its unwillingness to engage properly with television as television. I want to demonstrate here that the prejudice which equates shot and scene, a theatrical performance with its respectful relay by a television camera, needs to be significantly modified. Rather than consisting solely of 'scenes' from plays, or Outside Broadcasts from the theatre, early television drama, like early film, developed as a new form of mediation, one which transformed and, in a sense, re-performed the theatrical event, even as it was transmitted live from the studio. There was no 'respect' for theatre in terms of the style of that mediation, but instead palpable evidence of innovation in the attempts by drama producers to capture something of the essence of the play itself, rather than the essence of Theatre.

A brief digression is necessary to outline the familiar bugbear of any historical analysis of pre-1955 television: the absence of a surviving audio-visual corpus. Technologically television was a live medium; recording the television image on film was not successfully developed in Britain until 1947, and not regularly used for pre recording until 1955 Videotape was developed in the mid-1950s and, again, not widely used until the late 1950s (see Bryant, 1989). The few fragments which do remain – the Coronation, a couple of episodes of *The Quatermass Experiment* (both 1953) and some Test Match cricket, hardly compares with the continuous archive available to scholars of early cinema. My attempts, below, to detail the stylistic changes of television drama where no audio-visual record exists, obviously contain a degree of indeterminacy. My alternative sources include the programme files kept at the BBC Written Archives Centre (WAC), Caversham Park, an invaluable source of studio plans, shooting scripts and other production information.[2]

However, like a mosquito preserved in fossilised amber, one audio-visual fragment of television drama from the 1930s does exist, a US television adaption of Dion Boucicault's Victorian melodrama, *The Streets of New York* broadcast from a small studio on 31 August 1939. It was filmed off an early television tube using an experimental camera and is available for viewing at the Museum of Radio and Television in New York. Unfortunately, only six minutes of fragments remain, and there is no soundtrack. Initially the fragments ooze precisely the kind of theatricality that Gardner and Wyver criticise: curtains, captions, an intermission, the respectful relay of a three-walled stage and some overblown acting. Yet a cursory glance would show that this is also a highly segmented presentation of that performance; three cameras cover the play, and there is often some very rapid cutting between close-up and medium shots, dialogue and reaction shots.

There is also camera mobility – pans to fellow characters across the stage, a track-in during a speech. Yes, this is a theatrical performance, but one mediated by a new means; multi-camera studio television. We are given a *selection* of viewpoints, few of which could be equivalent to the position of a theatrical spectator.

How does this compare to British television drama of the 1930s? One key difference would be the rapidity of the transitions between cameras. 'Cutting' instantaneously from one camera to another was not possible until the Television Service resumed at Alexandra Palace after the war; instead the transition from one camera picture to another meant a gradual 'mix' (akin to a film dissolve) from one to the other (a process which could take anything from two to eight seconds). Perhaps the Americans were unwilling to reveal trade secrets, but the ability to cut after the war offered an additional technique for drama producers rather than a fundamental transformation of the medium:

> How many viewers of pre-war days have noticed an important technical advance in camera work since the service re-opened? The improvement is due to the new ability to 'cut' from one picture to the next. Up till a few weeks ago, scene transitions could be achieved only by 'mixing' from one camera to another, rather in the manner of the old magic-lantern 'dissolving views'. The effect was often quite a lovely one, but it tended to slow the action and was unsuited to quick–moving drama or variety acts.
>
> Now the producer can snap into a new scene as fast as he can say 'cut'. Cutting not only speeds up the action but suggests some tempting camera tricks. (*Radio Times*, 14 June 1946)

There is a further difference. *The Streets of New York* – based on what can be seen – was a full-scale presentation of the entire story. But, as the caricature has it, early TV drama consisted of 'scenes' from the studio, or outside broadcasts, didn't it? In fact these drama extracts and broadcasts from the theatre formed only a part of television drama during the late 1930s and afterwards.

Airtime for the early schedules was short, two hours in the afternoon, 3–5pm, before the service would re-open at around 8pm for another two hours. Each slot was usually built around one main programme, perhaps a variety show or a play. Drama played a central role in the schedules and was consistently popular (although the repeats were not – consistent viewers effectively lost a night's viewing).

The provision of drama in the schedules steadily increases between November 1936 and the closedown of the Service in September 1939. There were four forms of drama production:

1. During the first months of the service (November 1936 – June 1937), extracts or 'scenes' from plays were the dominant form of drama presentation. They were short,

typically lasting from 10 to 20 minutes, but in March 1937 the standard length of extracts increases to around 30 minutes. The material used took two forms. Most commonly it consisted of extracts from current West End productions under the rubric *Theatre Parade*, for example, '*Whiteoaks*: extracts from Nancy Price's production at the Playhouse' (3–3.20pm, 25 January 1937); and 'Extracts from Athole Stewart's production of *Jane Eyre* from the Aldwych Theatre'. (8 March 1937, 3.35–4pm). Note that *from the theatre* does not refer to the outside broadcast of scenes from the theatre itself. These scenes were reconstructed in the television studio, often borrowing props and scenery from the theatre production. The second type of extract consisted of selections from well-known theatre classics (almost always Shakespeare), typically using well-known actors from the time (e.g. 25 March 1937, 3.35–4pm, 'Margaret Rawlings and Henry Oscar in scenes from *Macbeth*'). *Theatre Parade* was generally parasitic on the availability of contemporary West End players, and one can discern a certain desperation to find material, particularly when the Radio Times billing refuses to be specific, '*Theatre Parade*: Scenes from a play now running in the West End of London' (26 March 1937).

Although such extracts become far less common after June 1937, they are still used up to the end of the pre-war service as a kind of 'filler' material (As I discuss below one reason for the transition to full adaptation of non-current plays was the hostility of West End theatre managers to television.)

There were several assumptions made about the advantages of using current West End material. First, the idea that fewer rehearsals were needed, as the actors would be familiar with their lines. In fact, as we shall see, *more* rehearsals were needed with actors who were generally unfamiliar with the demands of performing for multiple television cameras. The second assumption was that, as the plays were already running in the West End, television gained publicity, and so did the plays. In this sense the televised 'scenes' acted as 'trailers', helping future theatre bookings, and promoting the demonstrational function of television that characterised the initial period of the service. They helped to reinforce the quality of television that was most invoked as a means of selling it, its immediacy, its topicality. As the first Director of Television, Gerald Cock argued:

> Television is essentially a medium for topicalities … An original play or
> specially devised television production might be a weekly feature. If a National
> Theatre were in being, close co-operation between it and the BBC might have
> solved an extremely difficult problem. Excerpts from plays during their normal
> runs, televised from the studio or direct from the stage, with perhaps a complete
> play at the end of its run would have attractive possibilities as part of a review of
> the nation's entertainment activities. But, in my view television is from its very
> nature more suitable for the dissemination of all kinds of information than
> for entertainment.
> (*Radio Times*, 29 October 1936)

Cock's view of television is clearly inflected by his previous career as Director of Outside Broadcasts for BBC radio, where the broadcasts were conceived as informative and enabling rather than entertainment; hence, the broadcast of 'scenes' from current plays, congruent with Cock's overall attitude, served as informative views on the nature of contemporary drama and performance, providing a 'what's on' function.

There is a possible debate about whether these 'scenes' count as television drama at all, or more properly belong to the genre of 'demonstrational' material which so much dominated the very earliest schedules. It is this form of drama presentation, perhaps more than any other, that exemplifies the idea of the 'photographed stage play', static, 'boring' and relayed with due reverence to the performance.

2. The second form of drama production involved Outside Broadcasts (OBs) of live stage performances actually transmitted by television cameras in the theatre. The first broadcast of this type took place on 16 November 1938 from St Martins Theatre, J.B. Priestley's *When We Are Married*. Organisationally, this format came under the aegis of Outside Broadcast (OB) personnel rather than drama producers. The OB presentation of theatre is the most pure manifestation of the 'relay aesthetic', an immediate transmission of the performance as it happens. Yet even this took the form of a specific television mediation, using two to three cameras, a mediation which attempted to capture the event of going to the theatre and watching a play, not simply the relay of the dramatic performance itself:

> Emitron (television) cameras will be installed in three positions. One in the dress circle will give a comprehensive view of the stage, while two cameras at opposite ends of the stalls will provide close-ups. The play begins at 8.30 pm, and it will be presented as a theatre performance, and viewers will see the rise and fall of the curtain. The transmission, with two 10-minute intervals, will last over two hours.

> On Thursday, November 24, television cameras will be installed at the Palace Theatre for the first London performance of *Under Your Hat*, the musical comedy with Mr Jack Hulbert and Miss Cicely Courtneidge. Viewers will see these artists interviewed in their dressing rooms before the show, and will also see the audience arriving in the foyer. An excerpt from the first act will then be televised. (*The Times*, 7 November 1938)

Viewers are not simply offered a selection of views of the performance, but a programme which attempts to capture the 'nature' of the theatre experience; arriving at the theatre, preparing for the show, watching the curtain go up. The coverage also gives access to the stars in their dressing rooms, with various close-ups of the actors in performance. In other words, television offered a *better* experience of the theatre, a more privileged view of events.

There was clearly a potential conflict, however. Theatre managers were willing to provide actors for *Theatre Parade* scenes, for the element of publicity that television offered. But

as the OB of *When We Are Married* demonstrated, watching theatre on television could be more appealing than actually going there. *Theatre Parade* offered enticing fragments, but *When We Are Married* offered the full production and more, a full evening's entertainment (8.30 to 10.40 pm). Subsequent OB drama presentations reflect this concern. *Under Your Hat*, televised a fortnight later, offered the dressing room interviews, but only 'part' of the first act (7.45 to 8.20 pm).

Again, these stage performances are one of the components of Gardner and Wyver's attack on the photographed stage play of the early period; '… in its early days TV drama … consisted of televised stage plays, 'faithfully' and tediously broadcast from the theatre …' In fact this form of drama presentation was rare: despite the myth, these two examples represent the only attempts at this form before the war, and even after the war, OBs from theatres were rare events.

3. The third drama format (prevalent throughout the pre-war period), were one act plays lasting 10–15 minutes (e.g. *Quid Pro Quo*, 'a little foul play in one act', 9.45–10am, 19 November 1937). Like the *Theatre Parade* slots, these generally increase their running time to around 20–25 minutes in 1937. These were presentations of full, if brief, narratives.

4. The fourth type of drama were adaptations of full dramatic narratives, suitably adjusted for television, rather than selected 'extracts'. This was to become the dominant form of production at least until the mid to late 1950s (when the demand for original scripts, written specially for television, increased). Initially these adaptations were drastically telescoped into 30–40 minute timeslots, such as *The Importance of Being Earnest* (3.20–4.00pm, 2 November 1937) which was cut and modified, and the staging arranged to suit the studio.

During the summer and autumn of 1937, *Theatre Parade* and the one-act dramas and sketches are gradually superseded by half-hour adaptations, not described as 'scenes' or one-act plays. The significant change from the 30 minute to the 60 minute adaptation occurs in November 1937 with George More O'Ferrall's production of *Journey's End* (9–10pm), 11 November 1937). In December, Eric Crozier presented the first 90-minute adaptation, *Once in A Lifetime* (written by Moss Hart and George Kaufman) which is repeated in January 1938 at the same length. Beginning in May 1938, there is at least one play per week running at around an hour, with the occasional production of 90 minutes or over, such as *The Constant Nymph*, (3–4.30pm, 31 May 1938). Shorter, 25–30 minute plays still make up a considerable part of the schedule, but they clearly do not have the same status of a drama 'event'.

We can now identify two clear periods of drama production during the pre-war years. First, the November 1936 to June 1937 period when the dominant form was exemplified by *Theatre Parade*: extracts or 'scenes from' current West End productions, 10–30

minutes in length, functioning as publicity for the actors, the show, and the Television Service. Also during this period there are a number of one-act plays and 'sketches' which form part of the transitional material between this period and the emergence of the next. The second period sees the increase in the adaptation of plays as full narratives, rather than demonstrational extracts, where the running time lasts varies at 50, 60, 90 and 100 minutes. This form of drama is dominant throughout 1938 until the closedown of the service in September 1939; the earlier forms *mutatis mutandis* remain, but largely in the role of supportive 'shorts'. What is most significant was that the 60–90 minute running time of the standard drama production, which was to continue to the present day, was established as early as 1938. As Michael Barry notes:

> The transmission time given to drama productions steadily increased through the summer of 1938, and plays lasting 70, 80 and 90 minutes became usual. Skilful adaptation allowed substantial versions of most plays to be given on the screen in 90 minutes. Very much later, when plays were written more frequently for television, 90 minutes became regarded as an exemplary guide to length. (Barry, 1992: p. 30)

Why did the change between extracts and full-length 90-minute adaptations occur? One reason is the breakdown of relations between West End theatre management and the Television Service. Negotiations with West End Management became increasingly fraught towards the end of 1938. While there was no evidence that the impact of television had any detrimental effect on attendance at the theatres, there were reports of a rivalry between television and the theatre.[3] The selection of extracts from current West End productions initially seemed to offer certain advantages – a well rehearsed cast, publicity for the West End, some cultural and topical kudos for the Television Service, and little need for adaptation.

By late 1937, the arrangement seemed less cosy. The exigencies of the small studio, and the unfamiliar nature of television production for the actors, meant that they had to have several rehearsals for the cameras, and it was deemed necessary to 'adapt' or cut certain script elements which made the extracted scene unintelligible. The extra rehearsals required, and consequently the extra demands upon actors' time were not reflected in the fees paid to them and the theatre management, which, at fifty pounds for a single performance was the same as that for BBC radio productions. Of course, there was considerable difference between using extracts on radio and television, as the television booking manager William Streeton pointed out to Cecil Madden, the television programme organiser:

> Sound broadcasting requires no other rehearsal other than the brief run-through on the day of transmission, when the artists are provided with a specially marked script from which they are able to read their parts without the necessity of memorising the necessary cuts etc. – and of course, without movement gesture or costume

[For television] All cuts in the script require to be memorised and there is a good deal of revision in the movements and gestures, etc. for each artist, necessitated by television technique.

While this is common to all television programmes, the essential point is that this memorising has to be kept quite distinct in the artists' minds from the stage requirements to which they have to revert the same evening, on returning to the theatre.
(Memo, 25 October 1937: BBC WAC T5/517)

Rehearsal time for West End transfers was at least three to four times that of rehearsal time needed for radio, but the fees remained equal. Even so, the televising of West End extracts was seen as expensive at a time when the Television Service as a whole was over-running its budget allocations, and the Treasury was unwilling to release more finance (see Briggs 1979: p. 181). A year later, the Television Programme Organiser Cecil Madden noted that it was too expensive and time-consuming to rely primarily on material from the West End, and that plays originating *within* the Service 'pay more'. In other words they were more economical for the BBC to produce, bypassing the need to negotiate with theatre managers, allowing the BBC to hire actors individually.

Coupled with these external problems, another reason for the change to full-length adaptation was the ambition of drama producers themselves. Almost all of them had backgrounds in either theatre or cinema (few came from radio, except, notably, Royston Morley): Stephen Harrison worked for Paramount as a film editor; Stephen Thomas had a theatre background; Dallas Bower had been a film director; George More O'Ferrall had been an assistant film director; Lanham Titchener had worked in film; Michael Barry was stage director at the Garrick and Playhouse theatres; Fred O'Donovan had been a stage actor and stage manager; Denis Johnston was a playwright and theatre director. However, it is equally clear that all of them, whatever their backgrounds, were committed to the development of *television* drama. Their connections with the theatre proved a valuable and determining factor in the selection of material, but the manner in which this material was treated was under their individual control.

The transition from West End extracts to longer adaptations can even be located with one producer, George More O'Ferrall and his production of *Clive of India* in February 1938. *Clive* had been a West End hit in 1934 for authors W.P. Lipscomb and R.J. Minney, and ran for almost a year. The play dramatises the life of Robert Clive, the man credited with conquering India for the British Empire.

The stage play consists of three acts, each with three scenes. The time scale of the play lasts from 1748 to 1773, with various locales. The play conforms to the television drama department's criteria at the time of 'suitability' and 'practicality'. That is, only a few central characters, interior scenes without spectacular action, no political or sexual controversy. The play is, after all, a *character study*, an interrogation not only of what Clive did but his

psychological motivation, viz, How do great men become great men? and What makes them tick? Whatever the spectacular historical background, it is also an intimate psychological study.

Two months before *Clive* was transmitted, the producer George More O'Ferrall, met Minney's co-author, W.P. Lipscomb, to discuss the possibility of televising two of his plays, *Clive* and *Thank You Mr Pepys*. O'Ferrall reports the substance of the meeting back to the programme organiser, Cecil Madden:

> I suggest that Mr Lipscomb (who, as you know, is a very successful scenario
> writer) should in collaboration with me make a television scenario similar to a film
> script, consisting of very short scenes following one another very rapidly, which
> I imagine will be our technique in the future.
> (Memo, 6 January 1938: BBC WAC, T5/98)

This suggests a significant shift in thinking, away from the theatrical and towards a cinematic aesthetic, 'very short scenes following one another very rapidly'. The difficulty here is to establish whether O'Ferrall means he wishes to shorten the theatrical 'scenes' themselves, or adapt the entire play as short scenes punctuated by changes from one camera to another. In the latter sense, 'scene' would coincide with shot, but it would be a modified sense of scene, not one dependent on the demarcation of intervals and scenes in the stage script. A 'faithful' rendering of the stage play would require segmenting the action at the end of each scene, giving nine segments. But studio plans for the television production indicate twenty-nine scenes, and each has a dedicated camera position. This points to the equivalence of scene and shot, but re-locates the sense of a 'scene' away from dependence on the theatrical script. 'Scene' here retains the neo-classical unities of continuous time, space and action, and its boundaries are clearly punctuated by camera transitions. O'Ferrall further departs from the theatrical presentation by dispensing with the standard 'Act 1, Sc.1' format captions. Instead, he asks for eight captions, most of them setting time and place, rather than offering theatrical dividers. 'Five Years later in London' replaces the interval between the first to second act, whilst 'Do what you must (in a woman's handwriting of the period)' is an internarrative signal (Margaret to Clive). Similarly, with the caption 'My Lord Clive of Plassey Returns to His New Home At Walcot', O'Ferrall specifies that it should 'look like a heading in a newspaper of the period' rather than 'an ordinary caption'. Lipscomb and O'Ferrall had also designed a sequence where four cameras and both telecine machines (used for inserting film into the production) were needed to achieve a 'montage' effect. Bill Ward, the vision-mixer for the play, describes the process:

> What this montage called for was a lot of fast and accurate cutting between four
> cameras in the studio and two film-outputs on telecine, one of them giving us
> various stock scenes of India, while the other was a continuous loop of film
> showing just flames blazing and leaping. Down in the studio, we had one of four

cameras on a caption that had the word 'war' written on it in very large letters, the camera starting a long way back from it so that the word 'war' looked very tiny, then gradually tracking forward till 'WAR' was screaming at you. That same camera then had to be switched to captions showing illustrations of various wars – Crecy, The Black Hole – while another of the cameras stayed on a kettle-drum that just kept going brrm … brrm … terrap. And throughout that, the remaining two cameras took shots of the actors who played characters in the play … Clive, the Indians, so on, all standing against a plain grey background.

And assuming all that came together at the right moment, what the montage would show would be a full screen full of flames, then the word 'war' superimposed, gradually getting bigger as we tracked in; then, as that faded out, the face of Clive would come through, then Clive would fade out, in would come a shot of India, then – well, you can imagine the idea.

As no record survives, we have to. And I think it is fair to imagine that in 1938, this was nothing short of a spectacular achievement, one which is hardly 'tedious' or 'faithful' to the stage play.

O'Ferrall's memo to Madden continues to outline a new way of thinking about television drama production.

I also propose that we make … a script of *Thank You, Mr Pepys* compressing the whole action of the play into about 40 minutes, instead of producing a Theatre Parade which merely consists of photographing a scene of a play … It would entail a good deal of script writing with Lipscomb ….
(Memo, 6 January 1938: BBC WAC T5/98)

O'Ferrall notes the work involved in this 'compression' rather than the more passive process which 'merely consists' of 'photographing a scene of a play'. O'Ferrall's insight was available in 1938 at the beginning – even before – the phase of television drama characterised by John Wyver and Carl Gardner as that of the *photographed stage play*. It demonstrates that television drama producers were actively engaged with the formal and aesthetic possibilities of the new medium rather than slavishly relaying West End theatre performances. It also partly modifies John Caughie's argument for the theatrical origins of early television drama's spatial and temporal organisation:

Whereas cinema, in its classical form … subordinates the codes of time and space to narrative causation, television drama, in its formative stage, subordinated time and space to performance. The time, in particular, of early television is the real time of live performance; the construction of space is that necessary to follow the continuous performance. Whereas cinema constructs a narrative space and time by ellipsis and fragmentation, live television drama was not simply constrained by continuous recording to play in real time, it actually aspired to continuity as a relay

of a 'real' (rather than constructed) performance. This specific relationship between time, space and performance, in which performance – rather than narrative causation – is the dominant, is the specific characteristic of early British television drama, marking it off from cinema and aligning it with theatre.
(Caughie 1991: p. 33)

I do not want to exaggerate the importance of a single memo, but it does seem that Caughie's suggestion of a strict alignment with the theatre needs to be revised in the light of this evidence which suggests a far more varied and eclectic formal style of television certainly not unproblematically subordinate to performance. Certainly, some (perhaps very long) sequences were structured around the faithful relay of a performance. But it was a performance already considerably mediated by adaptation, studio organisation, camera set-ups, telecine film inserts and captions. In other words, there is evidence that some early television drama was far more *segmented* than previous writers have given it credit for. The real aesthetic advantage of television is therefore not simply its ability to faithfully relay a continuous performance in real time; on the contrary, it is primarily television's ability to mediate this performance in new and exciting ways, different but similar to the techniques of film, radio and theatre.

This process is also the mediation of a mediation, that is, the treatment by multi-camera studio technique of an already adapted and rehearsed performance. Michael Barry, remembering watching his first television drama rehearsal and transmission in 1938, notes the way in which this initial mediation takes place:

> A producer develops a faculty that allows him to perceive, through the patchwork of rehearsal, the rhythmic pattern of movement that will emerge in performance. This is a sense as necessary as a pair of spectacles with special lenses. But all I saw was Dallas Bower, busy here and there, moving before, behind and in among the actors. He would touch an elbow to adjust a stance … He mounted a chair in order to look downwards, or knelt and looked up. Sometimes he would raise both hands before his face and quiz what was going on through the aperture formed by the tips of his extended forefingers and thumbs.

> The nearer that a theatre production comes to performance, the greater in a sense is the human detachment of the actors from the technical process. Their independence grows, until like a ship launched from its stocks into the sea the players and audience are alone, separated, held in suspense but face to face and in communion. This metaphor oversimplifies what is a subtle and complicated relationship; but it may help to define the difference that exists when a television play enters the studio for camera rehearsal and live transmission and, instead of the palpable mystery that is an audience, the players are face to face with a grey anonymity.

> … On that first occasion, as I watched (live transmission of Bower's play), I saw the

reasons for the producer's insistence when shaping every movement and group during the earlier rehearsals. He had anticipated what each camera would see at every moment and had planned the result as a pattern of varying shots, mid-shots, medium close-ups and close-ups. Their order and the exact moment of mixing from one to the other had been planned with infinite care. When an actor rose or sat, made a particular gesture, or turned a head, the change of picture emphasised, and added a punctuation that enriched and strengthened the narrative that we were watching taking shape upon the screen.

(Barry 1992: pp. 12-14)

Stylistic differences in the presentation of drama were largely a matter of individual preferences. During the 1940s, the availability of fast cutting and filmed inserts offered possibilities for stylistic development. Some drama producers took advantage of these, others did not. For example, Eric Fawcett's production of *Mother of Men* (8.30–10.00, Sunday 15 December 1946) based on the recent production at the Comedy Theatre, was billed in the *Radio Times*:

Eric Fawcett, who is producing, says he is adapting the piece to what might be called 'true television'. That is, there will be far more dialogue than in a film version and more action than a stage presentation. I gather he will adopt almost a film technique and introduce a greater variety of scenes than was possible on stage.

(*Radio Times*, 13 December 1946: p. 33)

Fawcett was to further develop the 'cinematic' possibilities of television. His production of *The Bunyip*, a play written for television by Henry C. James, is described in the *Radio Times*:

In his new play, written specially for television, James has adopted film technique, necessitating rapid 'cuts' from one character to another at speed rarely attempted in the television studios. 'I have tried', he says, 'to make it a fast-moving story, and I am afraid it is going to give some of the camera crews a headache. The emotional quality of the play will depend mainly on vision – rapid changes of scene – rather than on dialogue.' It is the scenery of this tense, character-revealing play that gave the producer his first worries. 'To begin with', Fawcett told me, 'I couldn't film any of the action beforehand. There are no places that I know of where one can find countryside resembling the Australian Bush. So I must re-create the scene in the studio. I have fifty feet of Australian bush and scrub almost completed. The cameramen will have to be on their toes for the eerie night scenes … we hope to make as many rapid scene changes in ninety minutes as some film studios make in a month.'

(*Radio Times*, 5 December 1947: p. 29)

But another producer, Fred O'Donovan, is given equal praise for an alternative approach in his production of *Hindle Wakes*:

> As with other of his productions, Fred O'Donovan will use a technique of his own. Theatre producer that he is – or, rather, was – he believes in showing the action of a play as if it is seen by a single member of the audience. Instead of cutting or 'mixing' from one camera to another, following the artists as they move about, he prefers to stick to one camera for any set scene.
>
> 'Mind you,' he says, 'this means much more work at rehearsals and it is more exacting in that the cast have to be grouped to suit the camera position, but I do contend that this method makes for a smoother and sometimes more polished performance.'
> (*Radio Times*, 4 July 1947)

Or his later production, in October 1947, of *Trilby*:

> ... he is hoping to give the play exactly as it was in Tree's day (1850–1900). In this respect he will find his single-camera technique a great advantage; there will be no cutting from one camera angle to another. It will be presented in a continuous version as on the stage.
> (*Radio Times*, 17 October 1947)

But O'Donovan was largely alone in his reliance on a single camera per scene, and even this adherence was modified. That O'Donovan's 'one-camera' technique is remarked upon at all suggests that he was clearly the exception among drama producers. John Swift contrasts O'Donovan's style with the multi-camera norm:

> So far I have dealt with production by means of multiple cameras. There is one other system, known as the one-camera technique. It is the speciality of one producer in particular, Fred O'Donovan, who is steeped in stage traditions and to my knowledge has adhered to this method throughout his time as a television producer. ... Particular successes of O'Donovan's, each with the use of the one-camera technique – that is, one camera to each scene – were Priestley's *The Good Companions* and Patrick Hamilton's *The Duke in Darkness*.
> (Swift, 1950: pp. 167-68)

Even where it is possible to show accurately that shot length corresponded to scene length in a production, it is important to note that this was no simple relay; even the most 'theatrical' of producers used television in some quite innovatory ways. O'Donovan's production of *Juno and the Paycock* in October 1938 demonstrates the shift between theatrical and cinematic styles. He designed a scene only talked about in Sean O'Casey's play, the execution of the Irish Republican, Robbie Tancred, and this was used as a prologue to the rest of the play. Using the 'one camera' technique, it lasts some 90

seconds. The 'Prologue Set' is situated at the rear of the studio, opposite the main set, and consists of cardboard cut-outs of a stone wall with a gate, surrounded by a few trees (Figure One). Two gunmen enter with Robbie Tancred, who is pushed against a tree and shot dead. The officer takes a card from the sentry and hangs it on the tree above Tancred's body, and the gunmen exit. The sound of a car driving away. The camera tracks in, and Tancred's body is seen up close, crumpled near the tree with the card, 'Traitor. Executed by Order.' The music returns and we mix to another caption (and camera) as the first camera is moved around to its new position facing the main set: 'Act I: A Dublin Tenement House'. The play finishes 100 minutes later, with three intervals.

Whilst the studio set suggests pure stage – a painted backdrop, sparse scenery – O'Donovan's notes specify that the sentry is '*discovered* behind a tree cautiously looking about him' (my emphasis), suggesting that it is the camera which interrogates – or processes – this theatrical space, a camera which actively *reveals* further narrative and performance space, rather than passively showing it. Seconds later the camera is static and we see a tableau scene with sound effects as the sentry and officer speak; O'Donovan's reluctance to move in or cut for reaction gives the scene an impassive quality, until the camera tracks in close to the body and the card. The legend on the card has a narrative function, the purported reason for Tancred's execution. With the return of the captions: 'Act I, A Dublin Tenement House … the home of the Boyle family.', the scene becomes familiar: a living room, as it might look in the theatre. The play continues live in three acts with three 30 second intervals (after the first and second act, with one near the end of act three). This is partly radio, (live broadcast to the domestic receiver), clearly theatre (the intervals allowing costume changes), but also cinema (tracking in to close-up to reveal narrative information). During the rest of the play, despite the apparent theatrical stasis of the living room set, the theatrical stage atmosphere is contrasted with O'Donovan's ability to cut to the 'outside' on another camera (using sets built behind the main set) and into a bedroom, revealing further spaces. One camera per scene clearly did not mean that only one camera was used for the entire performance: as adapted 'scenes' became shorter, transitions between cameras were more rapid.

Other drama producers too were establishing their own 'television technique' during the late 1930s and 1940s. There were points of similarity necessitated by the availability of studio equipment. By late 1938 the standard means of organising studio space for television drama meant one studio divided into three sets, a main set at the larger end of the studio where the majority of the dramatic action would take place, and two others dispersed either at the smaller end of the studio or along the sides (perhaps with some auxiliary sets and a caption-board area). Four cameras were used, two of which were mobile and covered the most important scenes. The third camera was reserved for special shots (possibly close-ups, or brief scenes away from the main sets). The fourth camera was usually reserved for captions. Within this multi-camera environment, scene dissection – the analytical fragmentation of performance space from various camera angles – becomes increasingly prevalent.

For example, a production of *The Ascent of F6* was televised twice during the pre-war years, in May 1937 and September 1938, with both versions produced by Royston Morley. The 1937 version is of the *Theatre Parade* variety (although not billed under this heading): 'Scenes from Rupert Doone's Little Theatre Production of *The Ascent of F6* by W.H. Auden and Christopher Isherwood'. Even with the early form of extracts, Morley still uses three cameras, two of them mounted on dollies. The studio plan for this production (BBC WAC T5/29) indicates a sparse set, encircled by three cameras. Cameras 1 and 2 cover the main action, and there is a planned change of position to a close-up. Even when selecting only 'scenes' and with the bare minimum of scenery, the aim was to use multiple cameras to obtain variety of angles.

However, it is the September 1938 version which constitutes one of the most 'mature' drama productions of this period. 'Mature' here refers to the full utilisation of resources available, in this case: telecine; sound effects; captions; full use of multiple-camera studio, that is, four cameras in various positions, and changing positions during the play; an arrangement of multiple sets (in this case nine separate sets are used); mixing between cameras *within* scenes; camera movement (pan, track, tilt) *whilst transmitting* pictures rather than between shots; and the use of shot notation (medium close-shot – M.C.S., close-shot – C.S., medium long-shot – M.L.S.) on the script. The last point is important. It indicates that by 1938, at least for Royston Morley's productions, transitions between cameras were seen as akin to cinematic shots, even if the play overall was mediated by a television technique still inflected by theatrical conventions. Scene dissection – changing from camera to camera *within* scenes – became a standard practice. This is not to imply that 'maturity' corresponds to an approximation to cinematic convention, but that there is evidence of a greater segmentation of the performance space (whether by shot change or camera movement), and an ambition to structure a continuity which is not primarily segmented around the 'scene'. A month before, Morley had produced a new, 75 minute version of *The Importance of Being Earnest* which indicates the same ambition to segment the production away from a dependence on continuity determined by the theatrical interval and the act.[4] Here too, there is an alternation between cameras within scenes, the special directions for the camera (e.g., 'camera 1 pan for Lady Bracknell's entrance'; 'pan with movement'), and, if the continuity script is an accurate guide, there are 70 separate camera changes.

The segmentation of scene into a variety of shots continues during the late 1940s. A favourite production of this period was Patrick Hamilton's 1929 play *Rope*. It was first produced for television in 1939, a 90 minute production by Dallas Bower, and billed as 'A TV Horror Play'. Stephen Harrison produced two further versions during the post-war years, first in 1947 and then again in 1950.[5]

The stage play *Rope* is divided into three Acts, but the action of the play is continuous. It is best known for the Hitchcock film made in 1948. Hitchcock had decided to experiment with the technical possibility of filming an adaptation of the play in continuous action:

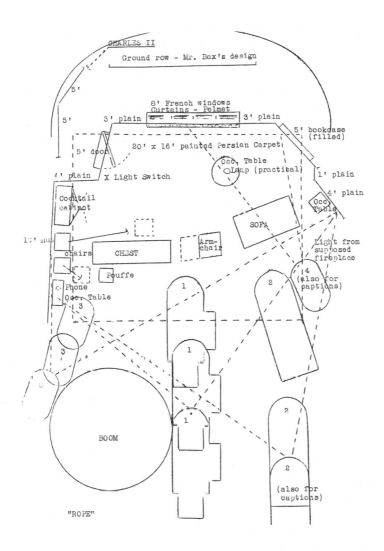

Rope (BBC, 1947 and 1950). Studio plan showing camera positions and sets.
Courtesy of BBC Written Archive.

The stage drama was played out in the actual time of the story; the action is
continuous from the moment the curtain goes up until it comes down again. I
asked myself whether it was technically possible to film it in the same way. The
only way to achieve that, I found, would be to handle the shooting in the same
continuous action, with no break in the telling of a story that begins at seven-thirty
and ends at nine-fifteen. And I got this crazy idea to do it in a single shot.
(Quoted in Truffaut, 1969: pp. 216-217)

For the film this presented difficulties: the capacity of the 35mm film camera runs at around 10 minutes and each shot in *Rope* lasts for approximately the full length of the reel of film in the camera. The film strives for the illusion of continuous action and resists the visibility of the cut. Hitchcock wanted to replicate the continuous nature of a live theatrical production, and also to restrict the space of the action to what would be the confines of a stage. As V.F. Perkins argues, 'Where another director might attempt to counteract the theatrical enclosure of the action, in the supposed interest of Cinema, Hitchcock exploits it. He shapes it as a vital development of his theme by employing a decor which allows progressive limitation of the playing space'. (Perkins, 1972: p. 90)

In a neat reversal, the television version aspires to precisely the opposite, taking a theatrical play in continuous action and segmenting it into a number of shots. Of course, this is really a continuous performance – television is still live – whereas Hitchcock's film took many weeks to complete.

For the 1950 version the *Radio Times* notes:

> There is an exciting revival in the programmes this week – Stephen Harrison's production of Patrick Hamilton's thriller *Rope*. Harrison produced the play three years ago and showed how effectively the close-up technique of television could be applied to a presentation of this kind in which the *reaction* of the characters is as important as their action and speech. His technique will be similar this time, and we should notice some subtle camera work.
> (*Radio Times*, 8 January 1950)

The debt to the theatre here concerns the focus on performance, particularly in terms of the relationship between television camera and performer, a sense that television studio drama demanded a new form of 'intimate' acting performance, a greater penetration by the cameras into the performance space, rather than a respectful distance. In a conversation with R.K. Neilson Baxter, drama producer George More O'Ferrall, notes that this is what separates theatre and film from television: television's ability to reveal the essence beneath appearance:

> NB: … Why do you prefer producing television plays to producing plays in the theatre or directing films?'
>
> GMOF: Because I have a more direct and immediate control of the medium than I have on the first night of a play … you know you are enabling other people to be creative. Now this is like the theatre, and even more exciting because for the first time you see the actor in close-up. You see him thinking. I sometimes say to actors: 'I don't want to hear what you say: I want to see what you think'.
>
> NB: Well, that brings you slap up against the direct comparison. The cinema does that too.

GMOF: No, no, no. Not with the same continuity or urgency. Fundamentally it is quite, quite, different.
(Neilson–Baxter et al, 1950: pp. 173-174)

Hence part of television drama's early stylistic development – often fetishised around the extensive use of close-ups – was motivated by a sense that the television camera could 'see better' into the performance. A decade after O'Ferrall, Norman Marshall reiterates this aesthetic:

> Graham Greene's *The Living Room* is another play in which, by means of close-ups, the television cameras were able to reveal more than one saw in the play when it was performed in the theatre. Because it is a play of thought and argument it is particularly well suited to television. In the close ups the cameras seem to penetrate into the very minds of the characters; so much so that one had the feeling that what they were photographing was not the faces of the characters but their innermost thoughts.
> (Marshall, 1960: p. 307)

Camera movement and style were therefore not simply organised around performance, but choreographed to achieve a new kind of proximity to the characters, both literally in terms of the close-up and also metaphorically in terms of the interior psychological landscapes they revealed and interrogated.

Hence the apparent 'theatricality' suggested by the studio plan for *Rope* in fact conceals another, very different, approach to theatrical staging (Figure Two). According to surviving camera directions, this version contains 114 separate shots, typically alternating between medium two-shot and close-up and giving an average shot length of around 42 seconds. If this arithmetic suggests long theatrical takes, it does not account for the variation of shot scale afforded by the studio style of frequent camera movements and re-framing to follow actors or emphasise dialogue and reaction (and hence the limited value of average shot length calculations for television analysis). Over 35per cent of the shots in *Rope* contain some form of camera movement, tracking, panning, re-framing. The movements indicated by the studio plan do not suggest any complex camera choreography, and the set oozes a three-walled theatricality, far more than O'Donovan's *Juno and the Paycock* studio arrangement. However, the intimate 'close-up style' outlined by O'Ferrall and Marshall is evident here as well. Each camera position demarcates a movement closer to the set, and to the characters. 26 of the 114 shots are in close-up, with a further dozen tracking into a close-up of a character, typically at a dramatic moment of crisis (the majority of them planned for the play's climax). We see emerging a new style not simply dependent on performance, but on a new relationship between performer and actor, with a different – live – urgency, and the continuity of theatre. Here, intimacy is not simply a question of a small, private scale, but it provides a mediated environment which demands a definite performance style which is also 'intimate'. Again,

this aesthetic requirement is demanded by the technology of the medium itself, personified as cold and 'ruthless', but also one which could enable a new acting style:

> I get the impression from many recent productions that Television may help to arrest the decadence of acting in this country. The camera is ruthless in its exposure of those facial forgeries of emotion which get by in the auditorium; the proximity of the actor to his audience imposes upon him a severe discipline of integrity in all he does with a smile or an eyebrow.
> (W.E. Williams, 'Television Notes', *New Statesman* 27 August 1949)

Here, the small sets and limited number of players allows the camera to 'expose' insincerity; the closeness of the actor to 'audience' (as camera?) reduces the repertoire of movement at the actor's disposal. Limited, even minute, movements are appropriate, in fact precisely those gestures – the smile, the lifting of an eyebrow – associated with the detail of an 'interior' (psychological) investigation. The camera not only is ruthless in its relay of such performance details, but sees further, *behind* those details. Clearly a variety of camera angles and camera movement was necessary to successfully achieve these effects, but a fast cutting rate was not essential if one wanted to linger on and expose the details of performance.

There is no simple relationship in television drama of the 1940s and 1950s between the number of shots and the play's 'theatricality'. For example, the BBC's adaptation of *Nineteen Eighty-Four* in 1954 contains 432 separate shots, giving an average shot length of around 14 seconds, and yet some shots last over a minute, and some are coterminous with 'scenes'. However, there is never any sense of tedium even during these long shots. This is because camera frequently re-frames according to the movement of the actors, for reaction or dialogue shots, varying the shot scale by movement rather than editing. It is a tendency which continues into the early 1960s (and arguably well beyond that). *An Armchair Theatre* production of 1961, *Afternoon of a Nymph*, contains only 177 separate shots, giving an average shot length of around 18 seconds. And yet the pace of the play is very rapid, and this is largely the result of continual camera movement, where variation in shot scale is provided by re-framing within the shot rather than cutting. The key stylistic difference between this production and *Rope* is the way the cameras now totally penetrate the sets, moving in and around props and characters, rather than simply tracking closer in or pulling back from a more or less frontal angle to the set. Even so, this is an extension of an earlier multi-camera studio style rather than a total transformation of it.

If early television drama depended primarily on theatrical *material*, it should not be assumed that this necessarily required a theatrical *style* of presentation. In fact, as I have shown, from the earliest days new styles were being experimented with, which were to result in the development of an entirely new dramatic form: *the multi-camera studio drama*. Of course, the material used, the ambition of the producers, and the technology

available all have an inter-related impact on the style of the production. But if new material written for television was scarce before the 1960s, this is not the fault of television drama producers, and it should not confine them to the realm of 'primitives'. In fact, the desire from producers for drama written for television was evident as far back as 1946. Denis Johnston, then Head of Television Drama, outlined his plans for future drama production in the *Radio Times*: his central policy was to encourage new authors for television. Johnston saw television as a 'shop window' for new plays of merit, and outlined the drama department's ambition to produce material written *for* television, that 'open-minded producers' were 'awaiting adventurous authors'. (*Radio Times*, 7 June 1946). Partly, this was a pragmatic response to London theatre managers refusing to allow material to be televised, but it is also evidence of the ambitious desire of the television staff to creatively expand the range of the medium. The *ambition* to produce original material for television does not originate with *Armchair Theatre*, Sydney Newman or *The Wednesday Play*, even if the consistent *practice* of original play production does.

As late as 1960 the dependence of television drama on theatre scripts continued:

> … there is little likelihood of television drama ever becoming altogether independent of the theatre. The shorter plays, up to an hour in length, are now mostly original television scripts, but first rate scripts longer than this will always be in such short supply that television will have to continue to rely upon the theatre for the majority of its full length plays.
> (Marshall 1960: p. 301)

The 1960s heralded an increase in the use of film (facilitated by lighter 16mm cameras which made crewing location filming much cheaper), and original material written by new writers keen to explore new social themes. As Tony Garnett argued, during the 1960s new writers wanted a more vivid sense of realism, and this meant that the studio was no longer adequate:

> The whole logic of the scripts we were getting was forcing us to use film and to shoot outside the studios on location. We were interested in social forces and the fabric of people's lives and the kind of conflicts that go on particularly at places of work, where people spend quite a lot of their lives. It seemed to be driving us towards actually going there ourselves. Because there's no argument for doing something at the Television Centre in a studio when you can actually do it where it would be taking place. So we started to push for more film.
> (Quoted in Hudson, 1972: p. 20)

But the various styles of studio production which emerged during the 1930s, 40s and 50s were part of an aesthetic which was different from – if variously inflected by – film and theatre. The 'tedious' and 'respectful' relay of theatre plays was in fact the beginning of the development of an entirely new dramatic form, as Don Taylor has argued:

Is there any kind of television drama that can be described as indigenous, in the sense that it is not available in any other form, and cannot be produced by any other medium? Only one kind of work answers that definition: the original studio television play. I am talking about a kind of drama made in a television studio – by people who have been given the chance to make films, and don't want to: a kind of drama that is, in crucial aesthetic ways, different from film, so different to be quite a separate dramatic form.
(Taylor, 1990: p. 255)

More work needs to be done to explore the development of this unique form, work which will have to look beyond the caricature of the 'photographed stage play' and towards a hitherto ignored historical repertoire of television drama, one which demonstrates ambition, innovation and a commitment by its practitioners, to new forms and styles of drama. They deserve a lot more respect.

NOTES

1. For an introduction to the cultural and political context of this period see Sales (1986). See Caughie (1991) for an excellent overview of early television drama production and aesthetics.

2. There are also script extracts and studio plans published in Bartlett (1955), Bussell (1952), and Gorham (1949).

3. See *The Times*, 'Television and Theatre – A Coming Rivalry.' 27 October 1938.

4. *The Importance of Being Earnest* Programme File WAC T5/248. A continuity script survives with directions for the cameramen. The production was seen as a stylistic innovation at the time, although scene dissection was to become standard by 1939. Morley: '(It is) an entirely different and far more exciting set up of which it seems a pity to have no record.' Memo to D.H. Munro, 6 September 1938, BBC WAC T5/248.

5. *Rope* tx 8.40–10.00 Sunday 5 January 1947; repeated 3–4.20 Tuesday 7 January. *Rope* tx 8.30–9.50 Sunday 8 January 1950; repeated 8.30–9.50 Thursday 12 January. Harrison produced another version in 1953 (8 December). Dirk Bogarde plays the role of second murderer, Granillo, in the 1947 version, and Peter Wyngarde plays it in the 1950 version. Early television drama often served as a training ground for theatre actors who were later to work in film.

BIBLIOGRAPHY

Barry, M. (1992) *From the Palace to the Grove*. London: Royal Television Society.

Bartlett, B. (1955) *Writing for Television*. London: George Allen & Unwin Ltd.

Briggs, A. (1979) *The History of Broadcasting in the United Kingdom, Volume 4; Sound and Vision*. Oxford: Oxford University Press.

Bryant, S. (1989) *The Television Heritage*. London: British Film Institute.

Bussell, J. (1952) *The Art of Television*. London: Faber and Faber.

Caughie, J. (1991) 'Before the Golden Age: Early Television Drama'. In J. Corner (ed.) *Popular Television in Britain*. London: British Film Institute.

Ellis, J. (1982) *Visible Fictions: Cinema; Television; Video*. London: Routledge.

Gardner, C. and J. Wyver (1983) 'The single play from Reithian reverence to cost-accounting and censorship' and 'The single play: an afterword.' *Screen*, vol. 24 nos. 4–5.

Hudson, R. (1972) 'Television in Britain: Description and Dissent', *Theatre Quarterly*, vol. 2, no. 6.

Gorham, M. (1949) *Television, Medium of the Future*. London: Percival Marshall.

Hainaux, R. (1960) 'Editorial' *World Theatre*, vol. 9 no. 4.

Manvell, R. (1952) 'Drama on Television and the Film' *BBC Quarterly*, vol. 1.

Marshall, N. (1960) 'Are Stage Plays Suitable for Television?' *World Theatre*, vol. 9 no. 4.

Neilson Baxter, R.K., O'Ferrall G., Adams M., Gough M., Manvell R. (1950) 'Television's Challenge to the Cinema'. In *The Cinema 1950*. Harmondsworth: Penguin Books.

Norden, D (ed.) (1985) *Coming to You Live!: Behind-the-screen Memories of Forties and Fifties Television*. London: Methuen.

Perkins, V.F. (1972) *Film as Film: Understanding and Judging Movies*. Harmondsworth: Penguin.

Rhode, E. (1976) *A History of the Cinema*. New York: Da Capo Press.

Sales, R. (1986) 'An introduction to broadcasting history'. In D. Punter (ed.), *Introduction to Contemporary Cultural Studies*. London: Longmans (1986).

Swift, J. (1950) *Adventure in Vision: The First Twenty Five Years of Television*. London: John Lehman.

Swinson, A., (1955) *Writing for Television*. London: Charles Black.

Taylor, D. (1990) *Days of Vision*. London: Methuen.

Truffaut, F. (1969) *Hitchcock*. London: Panther.

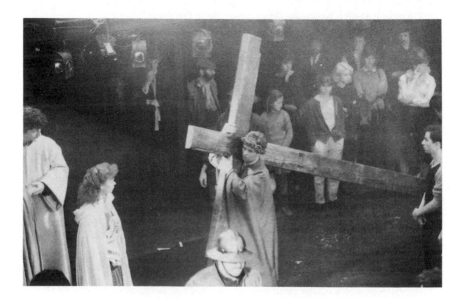

The Mysteries (The Passion). (1984, Channel 4). Christ (Karl Johnson) on his way to Calvary.
Photo: BFI Stills, Posters and Designs, courtesy of Channel 4.

THE MYSTERIES AT THE NATIONAL THEATRE AND CHANNEL FOUR: POPULAR THEATRE INTO POPULAR TELEVISION

SUSANNE GREENHALGH

National theatres, according to Loren Kruger, are utopian figurations of the nation united, which are, in reality, riven by the contradictions between a centralising reconciling culture 'from above' and 'rival, perhaps antagonistic, "popular" cultures on the social and geographical periphery' (1992: p. 3). Although Granville Barker declared that a British national theatre should be 'visibly and unmistakably a popular institution' closer inspection reveals an ideology of nation and theatre that 'shies away from an explicit invitation to the people to watch the show, let alone direct it' and instead focuses on 'the exclusive pretensions of an imaginative few' and their support for a "National House" for the preservation of the English dramatic heritage' (p. 81). On such terrain, Kruger insists, there is no place for a legitimated militant populism out of which popular theatre projects might emerge and no means of fundamentally challenging the dominance of discourses of discernment, heritage and conservation (p. 82).

Television's place in, and relation to, popular culture, is very different. Not only is television perceived as the chief site for representations of popular culture, attracting critical attention to these on their own terms, but it also gives rise to the need for what Charlotte Brunsdon has termed an *anti-aesthetic*. Engaging as it does with 'the popular, the domestic and the functional' television 'undercuts the very constitution of classical aesthetic judgement' (Brunsdon, 1993: p. 63). The intersection of television and theatre in the televised theatre event produces not only a translation of the codes of one medium into those of another, but also the potential for either endorsement or challenge of traditional aesthetic values. The 'very idea of high art or a "classic", central to the British concept of a national theatre might seem inappropriate for this 'democratic and

indiscriminate medium' (Kustow, 1987: p. 14). And yet television itself can be viewed as 'the only really national "theatre" our society is likely to have' (Hawkes, 1973: p. 231). The translation of National Theatre productions to the television screen thus offers particular scope for observation of the ways in which the ideologies and aesthetics of national and popular culture are mediated, negotiated and challenged within the fields of force constituted by the two media. Which theatre productions are televised, and where, what is done to them in the process, what audiences they seek to reach, and even more significantly, how that audience is addressed and represented within the televised production, are questions which can shed light on what Stuart Hall has termed the 'state of play' in cultural relations at a given period (Hall, 1981: p. 228).

This essay examines the attempt to transform a National Theatre event claimed – and acclaimed – as popular theatre into 'popular television' (Bryden, in Jones, 1985). *The Mysteries* evolved over nine years, from the Easter Saturday preview of 'The Crucifixion' on the NT Terrace in 1977 to the Channel Four transmission of the whole cycle in three parts, at Christmas 1985. Initiated as a collaboration between Bill Bryden and Tony Harrison, to reclaim the medieval religious play cycles of York, Chester and Wakefield as 'local northern classics', it showcased in a promenade production the company based in the NT's third auditorium, the Cottesloe, growing by the end into an epic theatrical project. The final trilogy, comprising of *The Nativity*, *The Passion* and *Doomsday*, was praised as a masterpiece, winning Bryden the 1986 London Standard Drama Award for best director. In its final form *The Mysteries* was seen as both pinnacle of, and justification for, the National Theatre's status, under the directorship of Peter Hall, as a truly national theatre, deserving of generous state subsidy.

The development of *The Mysteries* in the theatre and for television arguably defined a distinctive phase in the history of the National Theatre, years which were also ones of social change and unrest, within the theatre and in the country at large. In the late seventies and early eighties 'the religion of the market place' promoted:

> … an individualist ethos and an entrepreneurial culture where the acquisition of wealth and the consumption of goods became the prime value, in which the ethos of social responsibility and mutual aid began to unravel … England became a more morally callous country of striking social contrasts: a booming industrial Nation where many villages and steel towns (Labour Party bastions) began to wither away, and a booming South dominated by immense office and residential construction projects … Cultural and social structures that once reverberated morally and politically – like left-wing politics, the unions, the church, and even the class system – no longer played the same social role.
> (Quart, 1993: pp. 20, 33)

Peter Hall's diaries record his own and colleagues' political shift to the right as a series of industrial disputes with stage hands and technicians troubled and sometimes closed the

theatres, and created division among its personnel (Hall, 1983). In 1977 a Labour government confronted the unions and the first audiences of *The Passion* had to cross picket lines to attend the performance; *The Nativity* was added to *The Passion* in 1980, a year after Margaret Thatcher took the Conservatives to the first of four electoral victories, and *Doomsday*, the final part of the trilogy, was completed in 1985, following the defeat of the Miners' Strike. Limehouse's filming of the production for Channel 4 followed the closure of the Cottesloe, as part of Hall's campaign to dramatize the economic problems faced by the NT, and it was screened after its transfer to the Lyceum, funded in part by the politically-motivated grant from the GLC in one of its final acts before dissolution, which enabled the Cottesloe to reopen that autumn.

In this political context the production's celebration of Northern working class culture and language, its diverse aesthetic sources – from music hall to the paintings of Stanley Spencer, folk-rock music to trades union pageantry – took on an oppositional edge and urgency even as it was defensively aligned with dominant culture as 'an essential part of our dramatic heritage' (Hall, in Jones, 1985). Analysis of the technical solutions chosen to recreate a promenade theatrical event which was celebrated for its power to weld 'actor, audience, play and story into one whole', (Levin, 1985) must therefore go hand in hand with assessment of the interlinking institutional and cultural frameworks – both theatrical and televisual – in which it was produced. The theatrical strategies employed to evoke the 'timeless' mythic quality of the religious story, and the contemporaneity of the production's celebration of a lost – or fading – golden age of community values associated with a working–class culture in the process of erosion by 'market-forces', acquire added resonance when re-presented in the context of Channel 4's repertoire of screen fictions at the time, which arguably encode a comparable nostalgia for lost communities. Crucial to understanding the representation of *The Mysteries* on screen is the concept of the *performance event* in the early years of Channel 4, and the part that this played in its developing – and sometimes competing – institutional discourses of democracy, access and 'quality', at a time when, it has been argued, the increasing privatisation of cultural consumption was making the public resistant to participatory models of cultural production and reception. (Garnham, 1983: p. 26)

THE POSSIBILITY OF PEOPLE'S THEATRE: *THE MYSTERIES* AT THE NATIONAL

As has already been suggested, the fortunes of the Cottesloe, and the theatrical ends to which it was put, played a significant and complex role within the institutional structure of the National Theatre during the late 1970s and early 1980s. When the National's three auditoria were completed in 1977 the exact function of the Cottesloe was still undecided.[1] In the end Bryden was given a free hand, initially for a year. With a semi–permanent

shields on the walls and balconies, and trades union banners billowed from the roof. Everyday domestic and industrial objects were substituted for religious iconography. Jesus entered Jerusalem along a darts mat, and the wine of the last supper was drunk from a football trophy. Adam and Even appeared from a tub of building sand, Isaac was prepared for sacrifice on a butcher's block, and the crucified Christ and the souls in purgatory were lit by the beams of miners' lamps. A form-lift truck, swathed in billowing parachute silk, carried Jesus to heaven, whilst Doomsday was announced by a factory siren. Hell mouth became the jaws of a corporation dustcart, and the spectacular spinning globe of Doomsday borrowed from the Tarot pack wheel-of-fortune and Stanley Spencer's wartime paintings of welders inside ship boilers to create a Ferris wheel within which the damned revolved as though inside a gigantic tumble drier.

Tradition and high-tech were similarly juxtaposed in the production's use of what John Tams termed 'social music'. Drawing on the type of 'popular music' that accompanies communal celebrations, from Christmas Salvation Army singsongs to annual village carnivals, traditional words and tunes were reworked into the idiom of electronically amplified folk-rock, negro spirituals and New Orleans street jazz, to create an acoustic equivalent for a dramatic fiction set simultaneously in the present and the past. The communal singing or dancing that began and ended each play played a major role in creating the 'celebratory scale of the event'. Indeed the Home Service's presence often made the production as much a rock-concert as theatre, a focus of audience interest in its own right.

Bryden's open rehearsal methods, the company work on devising the text acknowledged in the theatre programmes, and the power of the myth of community represented by the plays themselves proved to be a potent chemistry. Critics and audiences responded with enthusiasm to what was recognised as a special kind of relationship with a changing cast over the years, culminating in the all-day performances of the trilogy at the Cottesloe and Lyceum in 1985.

> There was a feeling of a very risky experiment being proven, not because the audience clapped, but because they would not go home. They talked to us at the end. They had shared something with us and had broken down the barrier that the curtain is in the proscenium theatre. They took the actors for workers. Of course they knew they were actors but they had got to know them as individuals during the course of the evening.
> (Bryden, in Jones, 1985)

The production was praised for its blend of 'the ordinary and the extraordinary, of the tragic and the comic, and of the grossly supernatural' (King, 1985) into an event which combined 'democratic celebration with theatrical sophistication' (Billington, 1985). Not all shared this admiration, however. A few identified a basic illogical premise at the heart of the concept of professional actors playing non-actors playing a part, and found the

resulting performances arch, synthetic and patronising. They disliked its 'demotic mateyness', which demanded 'a false naivety on the part of the audience', finding it 'over anxious to be celebratory at all costs' (Hoyle, 1985). There was some uncertainty, too, about its recreation of religious faith. For Michael Billington the 'sheer imaginative power of the production' penetrated and sometimes even shattered the agnostic detachment of a modern audience (Billington, 1985), but Jim Hiley wondered how seriously the company took the Christian message and found their methods tokenistic: 'Wearing boiler suits and miners' helmets merely looks cynical among actors who can't even agree on a consistent accent' (Hiley, 1985). For Martin Hoyle there were three drawbacks for a modern audience: 'a basic religious scepticism; a popular culture drawn from a technological and lay society; and a range of reference, and moral awareness, both wider and more complex than was ever dreamed of by the original (literally) parochial performers' (Hoyle, 1985).

Most found the experience emotionally overwhelming, however. 'You could see the audience responding to the stupendous energy the cast were imbued with and expanding, almost literally catching it like a fever, until they ached to be given a part themselves and play it, gradually realizing, with wonder and joy, that they *had* been given a part, and *were* playing it' (Levin, 1985). Although Carol Woddis noted the anti-semitism and sexism of the original texts she found the final effect 'though occasionally frustrating ... cumulatively monumental, as swayed first on a personal, then political, social or emotional level we become the recipients of its collective joys and sorrows ... an experience at once troubling, disorientating, irritating and ultimately cathartic. It should be seen through the length and breadth of the land and is almost justification in itself for the Cottesloe's past existence' (Woddis, 1985). There was frequent recognition of the national and popular credentials of these 'celebrations of storytelling and of English life' (Gorden, 1985). Michael Ratcliffe felt that 'for a few hours inside a modern auditorium the lost tribes of England stir again ... The National Theatre on the South Bank has done nothing finer' (Ratcliffe, 1985). Access for a wider audience was also a common theme, particularly in the reviews written after the Cottesloe closure. 'If anything should be free for all, it is this' was Ros Asquith's conclusion, and even Sheridan Morley in a lukewarm appreciation recognised that this was 'an event, and one which should be shown to thousands of school children ... the first great theatrical soap-opera of all time' (Morley, 1985). Woddis' summing up caught the general mood of acclamation: 'simple, grand, monumental and truly POPULAR theatre that should be seen at all costs' (Woddis, 1985). Televising *The Mysteries* was, in part, a response to this critical recognition that the project's 'stubborn populism' (Kustow, 1987: p. 7) intrinsically demanded access for an audience far beyond the confines of the National or Lyceum in London.

CULTURE AND COMMUNITIES:
PERFORMANCE ON CHANNEL FOUR

'We must make good television, not good theatre.' This was how Peter Hall summarized the National Theatre Board's deliberations on a proposal by Granada to televise a number of its productions (Goodwin, 1983: p. 405).[4] The remark locates televised theatre squarely in that complex web of cultural and political negotiations as to what constitutes 'good television' which Brunsdon has characterised as' a range of oppositions' which re-legitimates already legitimate artistic practices (Brunsdon: 1993, p. 60). She argues that there have been two traditional ways in which television has been seen to be good in Britain:

> Television (by implication, not itself good) becomes worthy when it brings to a
> wider audience already legitimated high – and middlebrow – culture. In this mode
> … television can be good as a potentially democratic, or socially cohesive,
> transmitter. The other mode of legitimation poses … a privileged relation to the
> 'real' … sports, public events, current affairs, and wildlife programmes are 'good
> television' if we seem to get unmediated access to the real world, and are not
> distracted by thinking about television *as television* (pp. 59-60).

Citing Bourdieu's concept of an aesthetic gaze constructed in and through an opposition to the naive gaze, she asserts that television is '*the* object of the naive gaze *against which* the aesthetic gaze is constructed'. Television, then, actually secures the distinction of all non-televisual cultural forms, including theatre (p. 61). Television, in turn, is legitimated when theatre confers upon it the privilege of opening its riches to a wider public. While this can be interpreted as what Richard Hoggat calls public service 'in the most all-embracing, most direct and democratic sense' (Hoggart, 1990: p. 124), it can also be a mode of cultural imperialism, and a means of defending privilege.

> The great classics, the great cries of the human spirit are not easy to mount. They
> call for skill, experience, and for the most part they are extremely costly. Nearly
> always they fit into no known television time slot … for the literary and dramatic
> tradition of this country to persist in television terms requires the operation of a
> very special public service foundation … this means privilege … [This] tradition of
> high literary and dramatic accomplishment … (is) seen as being in some way
> characteristically and recognisably British; and these traditions and nothing else
> are what have carried us into the consciousness of audiences overseas.
> (Weldon, 1973: pp. 4,5,8)

By virtue of not being 'popular' or 'commercial' (often a shorthand for 'American') 'quality' television claims its place as a guarantor as well as transmitter of national culture, and drama plays a central role not only in its celebration of British artistic heritage but in defining the essence of 'quality' television. From its earliest days, drama brought to British

television the benefits of entertainment, prestige, and quality, by creating a sense of special event for its audience, communicated with 'the effect of immediacy, of a directness which signifies authenticity' that Caughie argues is still one of British television's distinguishing forms. The shift from direct transmission to recording simply changed drama into a tradeable as well as cultural good, often still imbued with the aesthetics of 'direct, spontaneous, authentic reality' (Caughie, 1991: p. 23). When a new channel was created, designed to be accessible, popular, and capable of appealing to large audiences, whilst also addressing those 'who want something particular or who want something different' the theatre event continued to play a significant role in its aspirations to quality (Independent Broadcasting Authority, *Blueprint for Channel Four*, 1979, cited in Docherty, 1988: p. 15).

As has often been noted, Channel 4 was a paradoxical child of the Thatcherite eighties, 'inflected by Tory ideology but not born of it' (Ellis, 1986: p. 11). Indeed, Rod Stoneman has argued that Channel 4 is best viewed as a 'delayed and overdue progeny' of the consensus that created the post-war welfare state, delivered late enough in the day to carry 'the values of late 1960s radicalism into the broadcasting of the Thatcher years' (1983: p. 133). In Docherty's neat formulation it was a body 'given a large sum of money, to fulfil a mandate laid down by Parliament that it be different, innovative, serve minorities, give voice to the voiceless, and not to worry about too large an audience or where its money is coming from – the former is not necessary and the latter guaranteed' (Docherty, 1988: pp. 15-16). According to its first Chairman, Jeremy Isaacs, the channel 'sought to satisfy a wide range of needs throughout the nation, the hallmark of public-service broadcasting' (Isaacs, 1989: p. 198). Since its funding came from the advertising revenues of the ITV companies, its situation resembled that of the Cottesloe in that small audiences were subsidised by large ones, and Isaac's remarks, in the Annual Report of 1986, recall Kruger's analysis of the ideology of the National Theatre, in which 'the people' are served through the participation of the 'imaginative few':

> Mass television sets out to satisfy mass audiences, and is content to ignore, or must ignore, the few. Channel 4 at least some of the time, seeks to satisfy a discriminating few, an endless succession, that is, of changing groups of selective viewers who enjoy something of what they see on our screens, but do not expect to enjoy all of it ... Public service broadcasting in a democracy exists to satisfy as many different individual tastes as it practicably can.
> (Channel Four, 1986: pp. 5,6)

The emergence of a channel of programme editors rather than makers can also be viewed as intrinsically linked to its historical moment in the late 1970s in which 'a publishing analogy ... resonated so powerfully in Britain because it caught the fragmented and non-consensual mood of the time ... Channel 4, at one level at least, represented a cultural response to this social disintegration' (Docherty, D; Morrison D., Tracey M., 1988: p. 36). But if the channel was designed to provide new forms of

broadcasting for 'the people' in all their diversity and difference, its pluralism was to prove in practice both economically precarious and internally contradictory (Robins K. and Cornford J., 1992: p. 194; Stoneman, 1983: p. 134). Envisioned as a safety-valve by consensus-minded politicians, as a celebration of cultural diversity by the pluralists, Channel 4, serviced as it was by independent production companies, whose lack of fixed plant or staff ensured they could respond flexibly to rises and falls in the broadcasting economy, fitted comfortably into the Thatcherite vision of a market-driven, enterprise culture (Caughie, 1990; p. 23).

Michael Kustow, the first Commissioning Editor for the arts, regarded their role as central to the identity of Channel 4:

> As well as being perceived as a channel of entertainment and information, the Channel is appreciated as a television of culture and communities. Culture in the widest sense: the culture of ethnicities as much as the culture of connoisseurs; the culture of the dispossessed, the under-provided and the excluded; the culture of survival. And communities, not just in the most broad-brush sense, but communities of interests and hobbies, of continuing self-education, of buried memories and allegiances. Communities which we try to address not as herds, but as individuals.
> (Kustow, 1987: p. 237)

Although he came to Channel 4 from a post at the National Theatre, Kustow had previously been involved in experimental theatre, as Director of the ICA, and his stated objective was to reinvent 'the relationship of art and television ... giving people experiences that would surprise and lift them' by concentrating on 'the contemporary and unfamiliar rather than on hallowed heritage' (Kustow, 1987: pp. 12-13). This was not simply a matter of content but of style: 'Everywhere else on television, actuality and immediacy were the order of the day; in the arts (other than topically based series) television tended towards timelessness and heritage' (Kustow, 1987: p. 13). To counter this he put a two-hour Sunday night performance slot, featuring predominantly live opera, dance, or theatre, from Max Wall's music hall act to *The Oresteia*, at the centre of his arts programming (Isaacs, 1989: p. 45). Ironically it is precisely this emphasis on performance as the means of rejecting heritage that Gardner and Wyver, who privilege Film on Four as a more inherently radical form for drama, regard as a fundamental betrayal of the Channel's founding commitment to 'innovation and experiment' (1983: p. 129). More recent analyses of Channel 4's film output have questioned this view that filmic form is intrinsically better suited to social critique. Paul Giles argues that certain historically-set films, precisely through their juxtaposition of film and televisual codes, examine the difficulties of a contemporary representation and reclamation of the past. Television's discourses of immediacy and the current event, its ability 'to involve its mass audience in a series of binding recognitions', and the 'atemporal feel' of videotape, are combined with the historicity of film, to produce 'a complex bifurcated perspective shifting between past and present' by means of which popular discourses of convention,

history and communal memory are renegotiated (Giles, 1990: pp. 82, 84). Kustow, too, wanted to put the 'timelessness and heritage' of classic art into dialectical relationship with 'actuality and immediacy'. In his account of the first years of Channel 4 he continually returns to the problems posed by the inherent 'classicism' of traditional aesthetic forms, questioning whether an equivalent for 'the clear space of a stage or a page, the hierarchy of literary memory and tradition' was possible in 'the cluttered profane space of the television screen' (Kustow, p. 239). To create an empty space on television for 'the encounter of live audience and performers … the presence of bodies in an event of unbroken time' an alternative 'frame or focused span' must be placed around the artwork. One possibility was to build, as Giles argues was often done for film, on the established traditions of the televisual event, with its promise of immediacy and liveliness, combined with the memorializing function of the special occasion implicit in so much outside broadcast, from football matches to state or religious ceremonial. This carving out of space in the schedules for the 'major event' demanded a matching forcefulness of form, 'a marriage between the visual language and performance style of the theatre work and the codes of television' (Kustow, 1987: p. 18).

Two early transmissions, of productions from Britain's two 'national theatres', provide an opportunity to assess the success of this strategy. Channel 4's first major drama production, broadcast in the month of opening, restaged the Royal Shakespeare Company's ambitious two-part version of *The Life and Adventures of Nicholas Nickleby*, adapted by David Edgar and directed by Trevor Nunn and John Caird (1982, Primetime Television, Channel 4).[5] Like *The Mysteries*, *Nickleby* was an epic theatre event, in part shaped by a subsidy crisis, which used a classic narrative to question contemporary social values through ensemble performance and committed theatricality, arrived at by an avowedly democratic rehearsal process derived from alternative theatre practices (Rubin, 1981). It also shared the 'series' characteristics which allowed both productions to fit comfortably into what was becoming an ever-increasing feature of the drama schedules on all channels (see Brandt, 1993: p. 16).

The nine hours of theatre were reworked by Edgar into three episodes, their transmission on Sunday evenings helping to establish the new performance slot, as well as fitting comfortably into established scheduling patterns for events of quality or moral seriousness. The Old Vic – which had gone dark as a result of withdrawal of its Arts Council subsidy – was available as location and *Nickleby* was filmed there over a period of two months in the summer of 1981 (Primetime, p. 21). Jim Goddard, an experienced television and film director, with Nunn and Caird as 'creative consultants', aimed at 'an adaptation for the medium of television' which retained the theatre setting and 'the essence and spirit of the stageshow', combining techniques from both media in a way that was still innovative for televised theatre. Although shot on videotape the production was filmed primarily on one camera, with the second camera used only for cutaways, with separate lighting for each shot by Tony Imri, whose past credits included *Cathy Come Home* and *Up the Junction*. Editing too was filmic in mode, done post-production

from rushes rather than electronically between cameras whilst shooting. For Goddard Dickens was a 'Dallas' writer, and the Dickensian narrative drive, and its inevitable intertextuality with numerous televised adaptations, translated effectively back into serial form.[6] The actors' frequent direct address to camera sought to create the accustomed televisual sense of liveness and direct access to an event, to 'bring the audience right in, involving them as an essential part of the production'. This desire to draw the audience in perhaps also accounts for the cinematic use of music, modelled on Bergman's *The Magic Flute* and Hollywood musicals. Almost twice as much of Stephen Oliver's richly rerecorded score was used on television as in the theatre (p. 25), and sound was independently rigged for each shot in 24 track Dolby stereo, best appreciated by London viewers, who could listen to a simultaneous stereo broadcast on Capital Radio.

Although Nunn had envisaged *Nickleby* as an accurate record for posterity of the event experienced by its audience in the theatre (Rubin, 1981: p. 180) its members were shown only occasionally, and never in close-up. Even at a climactic moment such as Nicholas's rebellion against Squeers, the cutaway to the audience's reaction made it appear (and sound) stage-managed rather than spontaneous with the clapping or laughter frequently lacking volume and resonance by comparison with the enriched music values. The grainy texture and stark lighting communicated something of the original production's timely critique of 'Victorian values', which tried to resist audience inclination to see it as an 'exercise in nostalgia … loveable safe Charles Dickens' (Nunn, in Coleman, 1982: p. 7) but camera shots, movements, editing and music tended to accentuate transparent story-telling and the stirring of emotion rather than the translation of theatrical defamilarisation strategies into innovative televisual techniques. Despite producer Colin Callender's vision of capturing 'the imagination, excitement, meaning and spirit of the show but… in television terms' so as to create a high-profile 'television event' the filmic restaging to remove 'staginess' weakened the direct transmission of immediacy and liveness so that much of the production's excitement derived primarily from its place in the opening schedules.

The NT's production of Aeschylus's *The Oresteia*, (1983, National Theatre, Channel 4), 'a four hour play in masks, performed by 16 fellows', (Hall, in Coleman, 1983: p. 78) in a translation by Tony Harrison and with a score by Harrison Birtwhistle, was a more typical product of classic aesthetic values. The NT formed a production company for Peter Hall to direct his own theatrical creation, and he orchestrated four cameras in different positions at four stage performances, working without a shooting script and encouraging his cameramen to pick up shots as though filming a football match. The values of immediacy and liveness might seem dominant in this approach but, as Annabelle Melzer argues, in such 'football' coverage of theatre, although the presence of an audience produces a 'primed' actor on the small screen, the performance 'is only a small selection of the game, not the ritualized conflict which is the dramatic heart of the whole. As we watch close-ups and medium shots, the game goes on as if it is not our concern' (Melzer, 1995: p. 274). This absence of the 'whole picture' was crucially inappropriate to an ancient tragedy which in origin was part ritual, part civic event.

Hall's half-hearted nod in the direction of liveness and a sense of 'being there' was further diluted by the off-screen edit, from sixteen different full length tapes, over which he took many weeks (causing the production to go over budget). He generally chose medium shots, which all too often exposed the masks and orchestrated verse and movement to damagingly close scrutiny, and removed the sense of choreography within a defined space that had been such a vital aspect of the theatre production. The audience presence was only evident when the actors processed down the centre aisle at the end of *The Eumenides*, never part of the intrinsic meaning of the performance. Kustow attempted to enhance the sense of occasion by screening the trilogy in its entirety on a single night, in an extended Sunday performance slot, intercutting it with specially devised 'video compositions of music, movement or images' (*TV Times* 8–14th Oct 1983). Further framing was provided by a *History Today* programme on Aeschylus's tragedy the previous Tuesday, and a documentary on the NT's staging of the trilogy at Epidaurus the night before. A booklet on the production was also available for purchase but there was little sense of the production as a communal rather than aesthetic event.

Melvyn Bragg has suggested that when television viewers watch the 'boxing' of performance they use their experience of looking at television as much as their experience of looking at theatre to set up a 'parallel but different system of responses based on an understanding of what they are getting' in which a desire for it to be 'like it really is' is accompanied by aesthetic pleasure in the specific visual choices of the televised interpretation (1983: p. 34) This kind of distinction between 'modes of viewing which are repeated on a regular basis and uncommon or unfamiliar modes of viewing' (Brunsdon, 1993: p. 69) is also made by Jean-Pierre Maquerlot who argues that since the viewer is constantly addressed by television's informational discourses, she is able to feel 'off-duty' from current affairs when watching televised theatre and 'free to respond to the stimulation of a disinterested, although at times difficult language' (Maquerlot, 1987: p. 116). Both observations recall the interplay between the naive and aesthetic gazes out of which the relative legitimacies of television and theatre are constituted, and also echo Giles's concept of the dialectic created from the juxtaposition of film and videotape, historicity and immediacy. Both *Nickleby* and *The Oresteia* tried to preserve a sense of an original live event, through the use of videotape and theatrical location, and at least the occasional acknowledgement of an audience presence. But both also draw on film strategies, particularly in the editing process, to frame and focus in ways that pulled against the values of immediacy. Melzer has argued that filmed theatre is documentation rather than adaptation when it is 'shot in performance, with or without an audience, *in the original setting* – that is, not shifted to a studio' (Melzer, 1995: p. 152). By her criteria *Nickleby* was clearly adaptation, even though the Old Vic was essentially used as a substitute location for the Aldwych, whilst *The Oresteia* must be called documentation although it is constructed out of edited highlights from four performances. What is missing from her account – and from much of *The Oresteia* and *Nickleby* – is awareness of multiple audiences, in the theatre and at home, and the dialectical processes at work in their joint constructions of the event. To understand the achievement of the televised *Mysteries* this relationship between audience and event must be examined further.

'HOW IT MIGHT HAVE BEEN':
THE MYSTERIES ON CHANNEL FOUR

Bill Bryden attributed the impetus to film *The Mysteries* to Jeremy Isaacs himself, who, having seen its versions, from Edinburgh onwards, 'was adamant that a television recording would be made of *The Mysteries* … he wished to keep the spirit and energy he had witnessed and believed that with an audience at the recording, showing their wonder, it could be shared by an audience sitting in its living-room' (Bryden, in Jones, 1985).[7] Limehouse Pictures filmed *The Mysteries* between 25th April, five days after the Cottesloe closed, and 4th May, 1985. Each play was given two days of rehearsal, followed by the filming of two evening performances, in front of invited audiences. The original performances had no intervals but the shooting schedules show a fifteen minute pause half way, approximately where the commercial break came in transmission. Pic-up shots were filmed before the audience left. The director was Derek Bailey, an Ulsterman with a theatre background, who had been editor of the LWT arts programme *Aquarius* when Peter Hall was presenter, and had directed that channel's documentary on the National Theatre which marked the theatre's opening (LWT, 1977). In 1977, when Melvyn Bragg's *The South Bank Show* replaced *Aquarius*, Bailey set up Landseer Productions, specialising in arts documentaries and especially performance, of opera and ballet as well as theatre.[8] *The Mysteries* was to be the first of three collaborations with Bryden and Dudley which make up a unique trilogy of large-scale televised theatre events, characterised, in Bailey's phrase, by the 'intercutting of spectacle and the human situation' (Bailey, 1995).

Bailey's most important decision was to follow the logic of the production's promenade dynamic and to recognise the role of the theatre audience, as 'an integral part of the drama'. To this he added a clear conceptualisation of the expectations of a television audience 'used to the constantly changing perspectives and viewpoints of feature films and televised drama'. Rejecting the *Nickleby* solution of restaging in a studio or its equivalent and filming discontinuously on one or two cameras, he opted for continuous multi-camera outside broadcast recording, the documentary connotations of which he considered to be better suited to non-naturalistic performance. Convinced that to convey the theatrical experience, 'the action had to be seen through three hundred degrees *simultaneously*, not only be seen but be heard equally in all four corners of the space', he used five mobile cameras, as well as a remote controlled one fixed for overviews, together with two booms and two directional microphones. The placement of cameras, on all four sides of the theatre, able to take up a variety of positions on the first or second level, with the fifth hand-held camera and sound recordist constantly patrolling the stage floor, gave a spectrum of perspectives on the action that mirrored the different experiences of the audience sitting in the galleries or promenading below, and provided ever changing angles on a constantly shifting event [See sketch of camera positions]. Recording continuously on one-and-a-half reels of videotape also allowed the performance to run without stopping, the only realistic way to film an event the precise

nature of which could not be predicted however well prepared for, since 'the amount of movement of the cast and the exact playing of the action would depend on the numbers of the audience – an unknown quantity until the doors opened'. The versatility of the multi-camera format came into its own when a leading actor was unexpectedly indisposed at the second performance and the hand-held camera was used to shoot his scenes entirely from his point of view (Bailey, 1995). The stress on the audience in the theatre, whose communicated sense of 'awe and wonder' would be the means by which the audience at home would be caught up into a celebratory experience, also determined the nature of the television's crews's participation. They would 'become another party to the event … going about our work in the same spirit of give and take and of joint sharing in the event' (Bailey in Jones, 1985). This even produced the somewhat laboured joke of a cameraman disappearing, his camera still running, into the jaws of the waste disposal-unit-cum-hellmouth, as one of the damned.

In an event that strived to be 'part circus, part rock show, part ritual and hopefully all in all, popular television' (Bryden, in Jones, 1985) the television crew consciously dramatized the accepted conventions of television coverage. A vision-mixer with rock-concert experience was brought in specially to match the music's rhythms on film; the more solemn moments were shot with the gravitas and respectful exploration of architectural detail usual to the recording of state occasions; the hand-held camera wormed its way

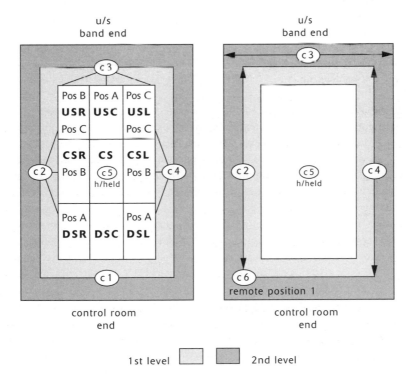

Camera positions to the *The Mysteries*. (1985 Channel 4)

like a paparazzi into the intimate circle where Jesus washed the feet of his disciples, or hounded Pilate for an on-the-record comment. In *Doomsday*, where the music and imagery of Belfast street funerals merged with New Orleans carnival, the crew chased their shots as though at a brewing riot, and a sound problem was solved by distributing mikes to the souls at Judgement Day as though they were participants in a 'true confessions' show. These fluent references to the everyday flow of televisual imagery were juxtaposed with consciously aesthetic images based on familiar religious paintings, such as the overhead shot of Christ on the cross borrowed from the Salvador Dali painting, or the iconographic pointing up of typological patterns through, for instance, an emphasis on circular action, such as the snake dance at the temptation, the Dance of Death that concluded *The Nativity*, the spinning wheel of Noah's wife or the Doomsday ferris wheel. Jon Gregory's fluid editing made consistent but understated use of dissolves and slow motion, characteristic of music-videos and also of replay of sporting highlights, to accompany the songs and instrumentals, and heighten emotional response to the key moments, such as the birth of Jesus or the crucifixion. He also found ways to emphasise the differences between the theatrical and textual style of the three plays. *The Nativity* was edited to heighten the sense of a familiar story unfolding over the centuries, mainly through medium and overhead shots, which stressed its pageantry. *The Passion*, which focused on Jesus' human ministry, contained many more close-ups, including the tightest and most dramatic, on Peter's screaming mouth as he realized his betrayal of Christ. In *Doomsday* the restrained realism of the resurrection, when Jesus returns to eat a leisurely meal with his disciples in a lovingly created Northern fishing community, contrasted with the more theatrical style of the judgement scenes, with many scenes shot in total darkness penetrated only by shafts of light from Davy lamps, culminating in the spotlit revelation of the doomsday wheel. Through it all he continually threaded the faces of the participating audience, as a visual confirmation of the emotion generated by other means.

Videotape, despite or even because of its connotations of documentary liveness, has been denounced as a 'hopeless hybrid' between film and theatre, 'recorded on slabs with unwieldy machinery which, up till now, has lacked visual finesse, against sets which have no stylistic density or texture, and lit from a grid which is too high and too crude', 'painstaking but dull' (Hare, 1982: pp. 47-48). In *The Mysteries* its limitations arguably became a strength. The production was underlit by the usual television standards, to translate the smoky atmosphere of the Cottesloe with its flickering amber lighting into the sepia tones of 'a continuous series of "old master" tableaux, as though preserved … under yellowing varnish and seen through the dust of time' (Bailey, in Jones, 1985), or to allow the moments of darkness to give way to sudden light that blinded the cameras as well as the eyes of the audience. The 'unwieldy machinery' merged with the other machines which filled the production, and the sound and camera operators became fellow workers with the actors and stagehands, manoeuvring the audience with the same gentle insistence. The booms and dollies which are usually hidden with such care were made part of the aesthetic composition of shots, so that 'untidiness became part of the visual texture', framing the action as well as recording it (Bailey, 1995).

As with *Nickleby* and *The Oresteia*, an accompanying booklet was produced, titled, significantly, *The Making of the Mysteries*, and this emphasis on process and the construction of a unique event was evident in the documentary that preceded the screenings which largely consisted of interviews with the participants, conducted at a time when the Cottesloe was closed and its fate undecided. These consistently emphasised the special nature of the experience they had shared, best summed up, perhaps, by Bailey, who referred to the production as his *Agincourt*. Although Channel 4 had no established 'God slot' the Archbishop of Canterbury endorsed the production as 'a journey back to our historical and religious roots, [which] … makes us see and feel the vigour of the faith of our ancestors' and the channel's Annual Report presented *The Mysteries* as the highlight of both its arts and religious broadcasting, an approach confirmed by its scheduling, on three Sundays, just before and after Christmas. Unsurprisingly, perhaps, the production also provided the image for the Channel's 1985 Christmas card.[9]

Kustow wryly noted that television 'isn't an ideal medium for awe and wonder. That's why it's at its best presenting the democratic and the demotic' (Kustow, 1987: p. 237). *The Mysteries* in the theatre was a compound of all these elements. In Bryden's words the plays were 'a celebration of the simple faith of the common people played in modern dress for a lot of people who have lost belief in anything at all', using show business rather than preaching to remind its audience of what it was like to believe in something. Such an awakening of communal memory might seem an impossibility on the screen, given what has been termed the 'de-ritualization of television viewing' (Zitner, 1981: p. 2). A God (Brian Glover) who addressed his people in a voice made over-familiar by television commercials not only pin-pointed the lack of real parallel between modern and medieval popular cultures (Hoyle, 1985) but brought aesthetic and popular codes into direct collision. However, Kustow concluded that the chief strength of *The Mysteries* on television was precisely this creation of a 'multiple perspective' for a mass audience:

> I am struck not just by the immediacy and intimacy of what the camera has
> captured, the way actors buttonhole it, directly addressing the viewer; even more
> arresting are the faces of the audience in the Cottesloe Theatre, in the same space
> as the actors. As Christ drags his huge cross three times around the theatre past
> the kind of crowd you might see lining the Mall for a state parade, or as the
> soldiers hammer home nails and hoist Christ up on the cross, arguing about ropes
> and pulleys, the expression of the faces we watch watching is of real emotion,
> unfaked involvement. It makes you realise how synthetically most television
> audiences are made to behave, applauding on cue, tamed by the technology,
> rerunning reactions for the retakes. Here there has been unbroken cumulative
> performance time. Here the space is hand-made for this one piece of work, not a
> technological tunnel for this week's production traffic. Here cameras and
> microphone and light are absorbed into the strong ceremony of the performance
> itself, which is open enough to admit them without losing its own order. And the
> result: complex seeing and feeling. Adam and Eve pushing up through a tub of
> contractor's sand, God clambering into a forklift truck for his entrance, a

soundman squatting with a rifle-like mike, that pretty girl in the T-shirt and the timelessness and timeliness of the tale being told — they are all gathered into a multiple perspective, available to millions.
(Kustow, 1987: pp. 20-21)

Just as the theatre production represented an act of faith in the power of theatre to juxtapose seemingly irrelevant or even anti-religious modern attitudes with the original language 'as a way of feeling how it might have been to believe' (Harrison, in Dallas, 1985) the television production aimed to create a fiction of faith, an engrossing spectacle of the temporary suspension of disbelief in the agnostic or believing audience in the theatre. 'As the camera swings along the rapt faces in the audience, you can't tell the believers from the non-believers. They are all totally involved' (Harrison, in Dallas, 1985). The event would 'live' for viewers at home briefly transformed into a community through their identification, not with the actors, but with their non-synthetic surrogates in the audience on screen. Kustow approvingly quoted Harrison's remark that 'the most avant-garde thing anyone can do today is try to be direct' and welcomed viewer feedback that suggested the television audience had 'felt a direct emotion they were unused to getting on television' (Kustow, 1987: p. 30). *The Mysteries* unashamedly embraced the televisual aesthetic of 'a directness which signifies authenticity' to encourage its audience to feel 'how it might have been' to be part of the event. It spoke to 'people's need to believe, to belong' (Brydon, in Kustow, 1987: p. 21) not only through a compelling cultural myth, but also through 'good' television's implicit promise of unmediated access to a real world.

CONCLUSION: 'ALMOST AN ACT OF DEFIANCE'

In his review of the televised *Mysteries* Karl Dallas judged them 'almost an act of defiance … which has returned one of the oldest dramatic works of the English language back to its creators – the common people' (Dallas, 1985). Did *The Mysteries* succeed in becoming 'popular' television through its unabashed celebration of televisual codes and its scheduling at a period of family gatherings and nostalgia for the community? Or did it remain locked into the aesthetic codes of classic heritage, through its theatrical origins in a national cultural institution? How fully did its celebration of popular culture translate into a political stance amid the flow of programming that surrounded it? Given that the first part went out against competition on the other channels from drama such as *Shadowlands* (BBC1), an adaptation of Elizabeth Bowan's novel *The Death of the Heart* (BBC2) and the first television showing of *The French Lieutenant's Woman* (ITV) how did its presentation of a past that was simultaneously a present and a future compare with these nostalgic, middle-class narratives? Earlier on the same day Channel 4 viewers could have watched an enquiry into police brutality at Orgreave during the miners' strike. How might this intertextuality nuance their reception of the mining imagery that pervaded *The Mysteries*? Was it, as Kustow, asserted, a 'real alternative'?

The Mysteries was perhaps the most complete expression, as regards performance, of Kustow's concept of a television of culture and communities, which addressed its audience not as a mass but as *viewers*, capable of 'complex seeing and feeling'.[10] His modification of Brecht's phrase pinpoints the dialectical processes which can be generated by televised theatre, whether these are theorised in terms of the 'naive' and 'aesthetic' gaze, immediacy and timelessness, classic heritage and demotic spontaneity, identification with a captivated audience or the 'testing' point of view of the camera. I believe that *The Mysteries*, precisely because of its contradictory origins as a theatre piece with popular aspirations, created within a centralising theatrical institution and reproduced within a televisual institution of comparable complexity, is a rich example of the possibilities for a dialectical television drama that does not use film as its primary mode.

It was also, perhaps, a characteristic product, of a brief moment in Channel 4's development. No subsequent Channel 4 televised theatre has had the space and scale of production that was given to *The Mysteries*. Kustow showed them to Peter Brook when discussing televising *The Mahabaratha* but although this was also an epic trilogy which had been celebrated as a unique theatre event, with a special relationship to the spaces in which it was performed, whether a quarry outside Avignon or the newly converted Tramway theatre in Glasgow, Brook's decision was to adapt his production by filming it in a Paris studio without an audience. Channel 4 pulled out of filming Tony Harrison's *Trackers of Oxyrhynchus* at Delphi when Michael Grade took over as Chairman, and, when the National Theatre declined to take over the financing, Tony Harrison had to raise the money himself (Taplin in Astley [ed]., 1991: p 355). The closest comparisons are with Bryden's own later promenade spectacles for BBC2, *The Ship* and *The Big Picnic*. He and Bailey formed a production company, with the same team of Dudley, Tams, and Gregory, to film live complete performances in the redundant Harland and Wolff shipyard on the Clyde with audiences drawn largely from the local community.[11] Although these also employ the strategies of multi-camera continuous filming evolved for *The Mysteries* the balance between spectacle and the human situation shifted squarely in the direction of spectacle, with the focus on the extraordinary construction and launching of an enormous liner, or the physical transporting of blocks of audience to the Western Front. The response of the audience remains a vital part of these productions but the filming is inevitably more engrossed by the logistics of such technically ambitious shows, in which the machinery of television has no place to show itself, since the fictional world is firmly that of the past.

In her survey of critical approaches to recorded performance Melzer records the warnings of theorists and practitioners against expecting an aesthetic pleasure equivalent to that of the live event from what is conceived of either as a 'transcription', 'notation' or 'documentation', or as an entirely new work. She also argues that the filmed event is always 'as seen by' a certain person, whether camera crew, director, or viewer (Melzer, 1995: p. 262), citing both Marvin Carlson's view that this re-visioning by a contemporary has value as a 'historically relevant "reading" of the performance', illustrative of ways in

which 'the free play of the spectator's focus might have selected among the proffered stimuli' and Marco de Marinis's proposal for 'a deliberately partial and partisan reading of the theatrical happening' to replace 'recording as conservation (or photocopy)' with 'recording as analysis' (in Melzer, 1995: p. 263). The filmed *Mysteries* is not simply an *historical "reading"* capturing an event for posterity through the eyes of contemporaries, by means of a documentary mode. It can also be viewed as an *analytical recording* in its attempts to find a self-reflexive yet involving equivalent to the strategies of popular theatre, above all through its representation of, and address to, its audience. If, as popular theatre, *The Mysteries* was 'a theatre of integration and unification' rather than 'a theatre of class struggle' (McGrath, 1968: p. 78) in the early eighties on Channel 4 it had the potential to form one of those 'gaps and fissures' that can open up when theatre and television are brought into relationship (Tulloch, 1990: p. 119). *The Mysteries* was *popular art* as Hall and Whannel have defined it; improvisatory in its grounding in 'the common experiences which audience and performer share', its theatrical use of popular materials, and its adaptation of them to the television medium. Such an art is not 'created for everybody, calculated to reach as many as possible' but it does have 'the pressure behind it to be widely available and understood'. Through the intensity of its reiteration of familiar values and attitudes it creates 'the surprise of art as well as the shock of recognition', and perhaps also offers a brief reminder of community as well as culture (Hall and Whannel, 1964: pp. 60, 65).

ACKNOWLEDGEMENTS

I am grateful to Derek Bailey, Jason Barnes, Sian Busby, David Edgar, Jon Gregory and Nicola Scadding for their help in providing information and materials used in the writing of this essay.

NOTES

1. One mooted use of the Cottesloe was as a television studio for recording performances. See Lewis (1990), p. 88.
2. Bryden has returned to this material on several occasions. His play *The Holy City* (BBC2, 1986) set the story of the passion in contemporary Glasgow, and in 1995 he restaged Dennis Potter's television play *Son of Man* (BBC1, 1969) as a theatrical production in the Pit at the RSC.
3. John Goodwin, credited by Bryden with coinage of the term, is quoted as saying 'It's better to say "a Promenade ticket" than 'you've got to stand' – a phrase worthy of Ian McEwan's and Richard Eyre's *The Ploughman's Lunch* (Channel 4, 1983). Other promenade performances included Bryden's *Lark Rise* scripted by Keith Dewhurst from Flora Thompson's memoir of a rural childhood *Lark Rise to Candleford*, and in 1978 *The Passion* and *Lark Rise* alternated

in a 'Promenade Season'. *The Ship* and *The Big Picnic* were also promenade productions.

4. The chosen productions, Wycherley's *The Double Dealer*, Somerset Maugham's *Services Rendered*, and Alan Ayckbourn's *Bedroom Farce*, (ITV, Granada, 1980) were redirected in the studio by their theatre directors. There was no attempt to capture the theatre event but rather an enhancement of the naturalism which was thought to make them especially suitable for television presentation. The Granada deal brought the National Theatre £25,000 per play and a small percentage of sales revenue (Goodwin, 1983: p. 412).

5. Discussions with London Weekend Television, based on filming *Nickleby* at Shepperton studios, foundered over costs, but Primetime took the project to the infant Channel 4 and secured additional funding from a German distribution company, RM Productions, and Mobil, who would screen the finished product on their Showcase Network in the USA. The costs remained high, however, primarily because of the purchase of world rights to thirty nine actor's performance for each of nine separate hours of work (Isaacs, 1989: p. 45).

6. *Nickleby* was also restructured by Edgar into nine one-hour episodes for sales abroad. The Channel 4 booklet advertised it as a 'major new drama series'.

7. This was not the first time the production had been televised. In 1980 *The South Bank Show* devoted one of its programmes to a 'special version' of *The Passion*, at the Edinburgh Festival, directed by Bob Bee, and screened just before Christmas. (ITV, London Weekend Television, 1980).

8. For instance Harrison Birtwhistle's *Yan Tan Tethera*, with libretto by Tony Harrison, and Kenneth MacMillan's ballet *Mayerling*. Landseer also produced the film of *The Oresteia* at Epidaurus. In recent years Landseer has filmed a number of performances for the Theatre Museum's video archive.

9. So far the only repeat has been a screening of *The Nativity* at Christmas 1986.

10. Other professional commitments prevented Gregory from editing *The Big Picnic*.

11. See Ellis, J. (1983) Channel 4: Working Notes' *Screen* 24/6, Nov-Dec, pp. 37-51 for an exposition of the significance of 'viewers' rather than 'audience' in relation to Channel 4.

BIBLIOGRAPHY

Bailey, D. (1985) Interview with the author, 10th July 1995.

Barber, J. (1985) *Daily Telegraph* 21st January.

Bragg, M. (1983) 'Open Space for the arts' in B. Wenham ed. *The Third Age of Broadcasting*, London: Faber & Faber, pp. 28-47.

Brunsdon, C. (1990) 'Problems with Quality' *Screen* 31/1, pp. 67-90.

Brunsdon, C. (1993) 'Television: Aesthetics and Audiences' in P. Mellencamp ed. *Logics of Television*, pp. 59-72.

Caughie, J. (1990) 'Representing Scotland: New Questions for Scottish Cinema' in E. Dick ed. *From Limelight to Satellite: A Scottish film book*, Tiptree, Essex: Scottish Film Council & British Film Institute, pp. 13-30.

Caughie, J. (1991) 'Before the Golden Age: Early Television Drama' in J. Corner, ed. *Popular Television in Britain: Studies in Cultural History*, London: BFI Publishing, pp. 22-41.

Channel Four Television Company Ltd. *Report and Accounts for the Year ended 31 March 1986.*

Dallas, K. (1985) *Morning Star* 21st December.

Docherty, D., D. Morrison, M. Tracey (1988) *Keeping Faith? Channel Four and its Audience,* London: John Libbey and the Broadcasting Research Unit.

Eagleton, T. (1991) 'Antagonism: Tony Harrison's *v*' in N. Astley ed. *Tony Harrison*, Newcastle: Bloodaxe, pp. 349-50.

Ellis, J. (1983) 'Channel 4: Working Notes', *Screen* 24/6, Nov-Dec, pp. 37-51.

Ellis, J. (1986) 'Broadcasting and the State: Britain and the Experience of Channel 4', *Screen* 27(3-4) pp. 6-40.

Ezard, J. (1978) *The Guardian* 8th June.

Gardner, C. and J. Wyver (1983) 'The Single Play: from Reithian Reverence to Cost-Accounting and Censorship' *Screen* 24, 4–5 July-Oct, pp. 114-124.

Gardner, C. and J. Wyver (1983) 'The Single Play: an Afterword' *Screen* 24, 4-5 July-Oct, pp. 125-129.

Garnham, N. (1983) 'Public service versus the market' *Screen* 24/1 (Jan-Feb).

Giles, P. (1993) 'History with Holes: Channel Four Television Films in the 1980s' in Friedman, L. ed. *Fires Were Started: British Cinema and Thatcherism*, Minneapolis: University of Minnesota Press.

Goodwin, J. ed. (1983) *Peter Hall's Diaries*, London: Hamish Hamilton.

Gregory, J. (1995) Interview with the author, August 22nd 1985.

Hall, P. (1983) *Making an Exhibition of Myself*, London: Sinclair-Stevenson.

Hall, S. and P. Whannel (1964) *The Popular Arts*, London: Hutchison Education.

Hall, S. (1981)' "Notes on Deconstructing "the Popular"' in Samuel, R. ed., *People's History and Socialist Theory*, London, Routledge & Kegan Paul, pp. 227-41.

Hare, D. (1982) 'Ah! Mischief: The Role of Public Broadcasting' in Edgar, D. et al. *Ah! Mischief: The Writer and Television*, London: Faber & Faber.

Hiley, J. (1985) *The Listener*, 30th May.

Hoggart, R. (1990) 'Public Service and the Enabling Principle: reflections on broadcasting, democracy and the arts' in Carver, R. ed. *Ariel at Bay: Reflections on Broadcasting and the Arts: a Festschrift for Philip French*, Manchester: Carcanet, pp. 120-21.

Hoggart, R. (1991) 'In Conversation with Tony Harrison' in N. Astley et al. eds. *Tony Harrison*, Newcastle: Bloodaxe, pp. 36-45.

Hawkes, T. (1973) *Shakespeare's Talking Animals*, London: Edward Arnold, p. 231.

Huk, R. (1993) 'Postmodern Classics: Verse Drama of Tony Harrison' in Acheson, J. ed. *Contemporary English and Irish Drama*, Basingstoke: Macmillan, pp. 202-226.

Independent Broadcasting Authority (1980) *The Fourth Channel: Programme Policy Statement*.

Isaacs, J. (1989) *Storm Over 4: A Personal Account*, London: Weidenfeld and Nicholson.

Jones, D. [ed.] (1985) *The Making of the Mysteries*, London: Channel 4 Broadcasting Support Services [unpaginated].

Kustow, M. (1987) *One in Four: A Year in the Life of a Channel Four Commissioning Editor*, London: Chatto & Windus.

Kruger, L. (1992) *The National Stage: Theatre and Cultural Legitimation in England, France and America*, London and Chicago: University of Chicago Press.

Lambert, S. (1982) *Channel Four: Television with a Difference*, London: BFI Publishing.

Levin, B. (1985) *The Times*, 19th April.

Lewis, P. (1990) *The National: A Dream Made Concrete*, London: Methuen.

Mulryne, R. and M. Shewring eds. (1995) *Making Space for Theatre: British Architecture and Theatre since 1958*, Stratford-upon-Avon: Mulryne & Shewring Ltd.

Maquerlot, J-P (1987) 'Le Téléfilm de Théâtre *Shakespeare à la Télévision* ed. M. Willems Rouen: Publications de l'Université de Rouen, pp. 107-17.

Melzer, A. (1995) '"Best Betrayal": the documentation of Performance on Video and Film, Part 1', *New Theatre Quarterly*, pp. 147-159.

Melzer, A. (1995) '"Best Betrayal": the Documentation of Performance on Video and Film, Part 2', *New Theatre Quarterly*, pp. 259-27.

Primetime Television (1982) *The Life and Adventures of Nicholas Nickleby: The official full colour magazine of the major new drama series,* London: Walkerprint Publications.

Quart, L. (1993) 'The Religion of the Market Place – Thatcherite Politics and the British Film of the 1980s' in Friedman, L. (1993) *Fires Were Started: British Cinema and Thatcherism,* Minneapolis: University of Minnesota Press, pp. 15-34.

Robins, K. and J. Cornford (1992) 'What is "flexible" about independent producers?' *Screen,* 33/2 (Summer), pp. 190-200.

Rubin, L. (1981) *The Nicholas Nickleby Story,* London: William Heinemann Ltd.

Shepherd, J. 'The "Scholar" Me: an actor's view' in N. Astley ed. *Tony Harrison,* Newcastle: Bloodaxe, pp. 423-428.

Stoneman, R. (1983) 'Sins of Commission' *Screen* 24/1 (Jan-Feb), pp. 127-44.

Wainwright, J. 'Something to Believe In' in N. Astley, ed. *Tony Harrison,* Newcastle: Bloodaxe, pp. 407-413.

Taplin, O. (1991) 'Satyrs on the Borderline: *Trackers* and the Development of Tony Harrison's Theatre Work' in N. Astley ed. *Tony Harrison,* Newcastle: Bloodaxe, pp. 454-8.

Tulloch, J. (1990) *Television Drama: Agency, Audience and Myth,* London: Routledge.

Weldon, H. (1973) 'British Traditions in a World-Wide Medium' *An Address given at the invitation of Standard Telephones and Cables Ltd. Dorchester Hotel,* London 12 April, London: BBC.

Zitner, S. (1981) 'Wooden O's in Plastic Boxes: Shakespeare and Television' *in Shakespeare on Television: An anthology of essays and reviews,* Hanover and London: University Press of New England, pp. 31-41.

WHERE EXACTLY IS SCOTLAND?* LOCAL CULTURES, POPULAR THEATRE AND NATIONAL TELEVISION

OLGA TAXIDOU

Border Warfare (1989), and *John Brown's Body* (1990) written and directed by John McGrath and performed at Glasgow's Tramway were both large-scale, epic productions that were co produced by Channel 4, and subsequently televised. They can be read as interesting test-cases of the way theatre and television interact in an attempt to voice a form of cultural critique within the context of late Thatcherism. Both these pieces of theatre were ambitious in terms of performance and both used theatrical and television conventions in challenging ways. At the same time, they form part of the on-going project initiated by McGrath with his former company 7:84: to explore the complex relationships between peripheral/local cultures and central/hegemonic ones. Indeed, the two plays form part of a trilogy – with *There is a Happy Land* (1980) as the first part – which re-writes the history of Scotland.

Both the modes of production, which included television from the beginning of the project, and the venue itself can inform the way we read *Border Warfare* and *John Brown's Body* as cultural events. Channel 4 was a co-producer of both events and both were created with television very much in mind. Indeed, John McGrath was not new to television. In many ways, these two quintessentially theatrical events also continued many

* From a FREEWAY FILMS/CHANNEL 4 advertisement, announcing the televising of *John Brown's Body*.

of the dialogues initiated in the sixties and seventies about the relationship between theatre and television on the one hand, and about the radical potential of television, on the other. The fact that they took place in Scotland and were subsequently televised throughout the whole UK makes some very bold claims on the mediation of 'Scottishness' to a general UK audience. In general, the themes of the plays, their modes of production and reception re-energise a set of dialogues and debates; these in a classically Gramscian manner explore the relationships between the centre and periphery, and examine the fruitful interaction between theatre and television within the framework of popular culture.

THE TRAMWAY

Border Warfare, which deals with the difficult historical relationship between England and Scotland, was the second performance to be held at the Tramway. The first was Peter Brook's production of the *Mahabharata*. No two productions could be more different in the way they relate to the specific locality of the event and to its audience, in the way they appropriate and re-write traditional and popular theatrical forms, and in the overall cultural ideology they promote. It is interesting to compare briefly these two diverse cultural projects and to see how they both, in a sense, re-create the space of the Tramway, and in doing so propose very different relationships with local cultures.

The Tramway was Glasgow's old transport museum which Peter Brook saved from closure when he chose it as a venue for his *Mahabharata*. A year earlier John McGrath had made a similar attempt to take over the Tramway in order to house 7:84. His endeavours proved fruitless. Where McGrath failed, Peter Brook succeeded and the Tramway was to host the *Mahabharata*, which had already achieved critical acclaim on the international festival circuit. It is indeed tempting to speculate how the whole phenomenon of the Tramway could have taken a completely different course had it been taken over by John McGrath. As it is, the first two productions held there made two drastically different statements, using the same space, but applying almost opposing notions of the 'traditional' and the 'popular'.

The *Mahabharata* arrived in Glasgow carrying with it all the veneer and the glamour of an international production. It had been successful in Paris and in other parts of Europe and had already been heralded as the 'theatrical event of the eighties'. The *Mahabharata* has recently evoked a new wave of criticism, mainly within the context of postcolonial theory, which problematizes some of its basic thematic and aesthetic assumptions. Through the myth of the *Mahabharata*, and utilising a combination of theatrical conventions vaguely labelled as 'eastern', Brook sets out to narrate the 'poetical history of mankind'. Brook's quest has always been for 'essential' truths and, in this case, what he constructed as Indian 'traditional tales and techniques' offered the perfect theatrical language for these eternal truths to be told. This enterprise, which assumes it can pick

and choose theatrical conventions from anywhere in the world regardless of their history and context, and then proceeds to essentialise them has rightly been read as a form of orientalism and 'othering'. Invariably the cultures borrowed from are ones which have had a colonial relationship with the West, or are economically dependent on it. Brook's notion of what is traditional about the tale of the *Mahabharata* is in fact a construct; one that first creates the idea of the traditional in the other culture, then proceeds to essentialize it as universal and eternal. This becomes even more problematic when the culture referred to – as in the case of India – has had a history of colonialism. Rustom Bharucha's critique of the *Mahabharata* within the context of postcolonialism provides some very useful insights:

> Peter Brook's *Mahabharata* exemplifies one of the most blatant (and accomplished) appropriations of Indian culture in recent years. Very different in tone from the Raj revivals, it nonetheless suggests the bad old days of the British Raj, not in its direct allusions to colonial history – the *Mahabharata*, after all, deals with our 'ancient' past, our 'authentic' record of traditional Hindu culture. For Brook's Vyasa, it is nothing less than 'the poetical history of mankind'. Within such a grandiose span of time, where does the Raj fit? Not thematically or chronologically, I would argue, but through the very enterprise of the work itself: its appropriation and recording of non-western material within an orientalist framework of thought and action, which has been specifically designed for the international market.
> (Bharucha, 1993: pp. 68-87)

When Brook toured with his production one thing he almost always did was to find a 'new' theatrical space. This was usually not a conventional theatre venue, and more often than not it was in an area that was not renowned for its cultural activity. So, in Greece he found an abandoned quarry in a working class area on the outskirts of Athens. In India he had changes made to an existing theatre so it could look more 'traditional', and, when the result was 'too traditional', he had it renovated again. This way of using space – which Bharucha calls 'the aesthetics of waste' – is typical of Brook. There is nothing inherently wrong with utilising non-conventional theatre space and staging productions in working class areas. The history of political theatre is also a history of how to use spaces other than the proscenium arch. There is a significant difference, however. Having chosen the space, Brook then proceeds to empty it of all sense of history or locality. It becomes one of his 'empty spaces', suitable for hosting universal and essential truths. The production of the *Mahabharata* in the Tramway could have taken place anywhere in the world. The fact that it was in Glasgow was coincidental.

Border Warfare and *John Brown's Body* engage with the space of the Tramway in very different ways. The fact that it was an old transport museum and the references to the industrialisation of the city that it implied are all factors that informed both productions. In fact *Border Warfare*, which traces the history of Scotland and England, and *John Brown's*

Body, a play about the making of Scotland's industrial classes, couldn't have found a better venue. All the contradictions created by the establishment of the Tramway as a performance/cultural centre and the heralding of Glasgow as cultural capital of Europe for 1990 were all present in the making of these two productions. Just as the *Mahabharata* could have taken place anywhere in the world, the Wildcat/McGrath productions could only have taken place in the Tramway. This, however, does not mean that they remain 'provincial' or of limited 'local interest'. The politics of the debate between peripheral and central cultures is something that McGrath has always taken on board. He writes:

> For the time being let me just note that I do not accept the following assumptions:
> 1. that art is universal, capable of meaning the same to all people; 2. that the more 'universal' it is, the better it is; 3. that the 'audience' for theatre is an idealised white, middle-class, etc., person and that all theatre should be dominated by the tastes and values of such a person; 4. that, therefore, an audience without such an idealised person's values is an inferior audience; and 5. that the so-called 'traditional values' of English literature are now anything other than an indirect cultural expression of the dominance over the whole of Britain of the ruling class of the south-east of England.
> (McGrath, 1981: pp. 3-4)

The Tramway productions seem to be taking this debate even further. The Tramway is similar to many cultural centres all over Europe at the moment, where old industrial spaces are gradually emptied of their local identities and are turned into 'cosmopolitan', 'neutral' spaces, suitable for the equivalent cultural events. Together with the rise of International Festivals these spaces present 'new' and ahistorical ways of relating to locality. The Wildcat/McGrath productions take this issue on board in both their themes and in the conventions they choose to use. The two large-scale shows that deal with the political and cultural history of Scotland, in a sense, re-historicise the Tramway itself, and offer a critical use of the space.

McGrath's and Bharucha's statements about aspects of cultural colonialism are strikingly similar. Indeed the complex networks of meanings and exchanges that result from a colonial history, and the equivalent tensions and contradictions that exist between local and hegemonic cultures may have a lot to learn from each other. Post-colonial criticism over the recent years has offered very helpful insights in reading these exchanges. Indeed, the dissemination and mediation of 'Scottishness', from the Tramway, to Channel 4 and throughout the UK may be read as a form of post-colonial cultural intervention.

Continuing the work of Fanon and Gramsci, post-colonial criticism has explored new ways of reading the relationship between marginal and dominant cultures. Rather than setting up a simple and non-dialectical opposition between right/wrong, powerless/powerful, it explores the 'in-between' spaces, the spaces of conflict, of emergence between two or more cultures. These 'spaces' which are often described in performance terms, are seen as helping create the possibility of critique. The role of tradition in this context is very important. As Homi Bhabha writes:

> Terms of cultural engagement, whether antagonistic or affiliative, are produced performatively ... The 'right' to signify from the periphery of authorized power and privilege does not depend on the persistence of tradition; it is resourced by the power of tradition to be reinscribed through the conditions of contingency and contradictoriness that attend upon the lives of those 'in the minority'. The recognition that tradition bestows is a partial form of identification. In restaging the past it introduces other, incommensurable cultural temporalities into the invention of tradition. This process estranges any immediate access to an originary identity or a 'received' tradition. The borderline engagements of cultural difference may as often be consensual as conflictual; they may confound our definitions of tradition and modernity; realign the customary boundaries between the private and the public, high and low, and challenge normative expectations of development and progress.
> (Bhabha, 1994. p. 2)

Border Warfare occupies such an in-between space. In charting the history of England and Scotland, it also re-invents the notions of tradition, the past and the present. It inhabits one of those consensual/conflictual spaces that triggers a critical and dialectical relationship with tradition and the 'new', history and the present. The opening sequence is characteristic of this. Denying the audience the comforting solace of a 'happy monolingual and monocultural past', it presents a conflation of past and present in the form of a corpse, which is wheeled on in a pram:

CORPSE:

> I was a Pict and slain by a Scot,
> An Anglian peasant by an English army,
> A Geal by a Gollach,
> A Presbyterian tortured by Mary's men,
> A Tim shot through the head by an Orangeman,
> A Piscy by Cromwell,
> A Highlander by Cumberland,
> I was a heretic burnt by Knox,

A Comyn stabbed by Bruce,
A Crofter's child with cholera on the boat to
Nova Scotia
I was the flower of Scotland
Broken at the stem,
I was a soldier on the Somme, I was drowned in the Minch
A young wife with T.B. in the slums of
Paisley:
I was a miner when the roof went,
A witch at the stake,
A still-born child,
A baby with AIDS:
Let me now lie in peace.
Put me in the earth with decency and
thoughtfulness.
(McGrath, 1989: p. 4)

This evocative image seems to dwell between a number of locations, cultures and meanings: life/death, past/present, hope/despair. The accuracy and the concreteness of historical place names and events scattered throughout the sequence (and characteristic of McGrath) fails to offer the comfort of familiar and historically chartered territory. In a sense, this misleading familiarity together with historical shifts – which occur throughout the text – only serve to further problematize any received notion of cultural or historical identity. This corpse appears as a kind of historical ghost, as an emblematic inhabitant of a hybrid in-between space. Indeed, much of the rest of the performance explores the historical circumstances and the contradictions that have helped create this creature, and possible ways of resuscitating it.

On the whole, history informs *Border Warfare* in a complex manner. It is not merely the backdrop on which the events are transposed, nor is it the ultimate meta-language, which critically assesses or even re-assesses events. It sets up a more intricate, two-way process. It never presents Scotland as an innocent victim and it prolematizes the idea of a coherent and homogeneous Scottish identity from the start. The following stage directions are indicative of this process:

> PANDEMONIUM, war-horns, bag-pipes, timpani as the SCOTS, the IRISH, sail in on a mighty warship: they are FERGUS, ANGUS and LOARN. They utter war-cries in Gaelic and in dreadful mock-Irish, brandishing the Tri-colour, spears, their shields covered with the West Highland Free press, their prow decorated with 'Scottish' as on the STV logo and computerised thistle. One of them with an Armalite, is in a balaclava, the rest more historical. The PICTS and BRITS swirl around trying to repel them and the noise is deafening – then suddenly they all stop and stare in amazement as another float arrives from the South-East: on it,

EADWIN and EADWINA, two tall beautiful blonde people, hand in hand, drinking
Skol lager, reading a Danish Love-Making Manual, accompanied by an Abba
number on the Ghetto-blaster.
(McGrath, 1989: p. 9)

This imaginative sequence and the theatrical conventions it utilizes helps to chart the
conflicts and encounters that forged the Scottish identity. This is not seen as something
that has occurred in the past, but is presented as an on-going process. It is interesting to
note the references to television. These run throughout the performance both as themes
and as conventions. This blending of high and low performance conventions is another
aspect of *Border Warfare* that sets up a critical debate; one that Television takes part in
as well.

In general *Border Warfare* from its title, to its themes, to its modes of production can be
read as an example of what Homi Bhabha calls a 'borderline work of culture':

> The borderline work of culture demands an encounter with 'newness' that is not
> part of the continuum of past and present. It creates a sense of the new as an
> insurgent act of cultural translation. Such art does not merely recall the past as
> social cause or aesthetic precedent; it renews the past, refiguring it as a contingent
> 'in-between' space, that innovates and interrupts the performance of the present.
> The 'past-present' becomes part of the necessity, not of nostalgia, of living.
> (Bhabha, 1994: p. 7)

Just as *Border Warfare* examines the borderlines between Scotland and England, *John
Brown's Body* sets out to examine more opaque and complex relationships. In many ways
the two pieces are in dialogue with each other.

JOHN BROWN'S BODY

Like *Border Warfare*, *John Brown's Body* sees history and politics, the local and the
international as interwoven entities. It is a monumental work that traces the 'History of
Scotland's Industrial Classes', as the subtitle suggests. Industrial is indeed the key term as
the play in its three sections – The Wealth of Nations, Discipline and Flourish, The End of
History – delineates the development of monopoly capitalism and its evolution into the
free market economy of the multinationals. This is not, however, merely a sociological
analysis. It is an ambitious cultural project that sets out to draw parallels between the
forces that helped shape the modern state and the forces that govern the lives of people.
Within a complex set of relationships the development of capitalism is seen as affecting
not only the way people work, but also the ways they communicate, the ways they love
and the ways they understand themselves and each other. At the same time, it proceeds
to make a very strong statement on the role of cultural practices as forms of critique.

This is essentially a play about work. But it does not proceed uncritically to celebrate work or to present an undifferentiated mass of people as workers. The whole concept of work is presented as a site of various, sometimes merging sometimes conflicting discourses. So, in this way, work is different for a woman, different for a man, different for a soldier, different for an unemployed person, different for a manual worker, different for an intellectual. The idea of 'freedom' receives the same treatment. The enlightenment promise of all the more freedom coupled with the idea of progress runs throughout the three sections of the play and forms one of its structural principles. How work, freedom and the pursuit of happiness all interrelate as concepts, and why they help create so much unhappiness and oppression, are some of the questions the play constantly puts before us. In many cases it provides us with an answer, but there are also instances where it stubbornly refuses to do so.

We are led through the whole sequence by two narrators: Percy Gimlet, who falls from the skies in deus-ex-machina fashion and represents a 'composite British Tory' and Seamus who emerges from the 'lower depths'. They both compete to tell us different versions of the same story:

Percy: I looked it up the Core Curriculum:
 History of the Scots.
 And found you didn't have any –
 Well not an awful lot.
 So here's my OFFICIAL VERSION
 And it won't take long, by Jingo,
 You'll be out of here in half an hour,
 And probably catch the bingo.

And a few pages further on:

Seamus: Now the story you have come for,
 And that we came here to show
 Is not on the Core Curriculum
 But it's one you ought to know
 Not tales of kings and princes
 Of the rich and the aristocratic
 But of your great-great granny's bunions
 And your grand-dad's bad rheumatics.
 (McGrath, 1990: p. 4, p.11)

This whole opening sequence is framed by a song that appears again and again throughout the three sections. It is one of the songs that sets probably the most important aesthetic and political argument running through *John Brown's Body*. The song which opens the play is called *Song of Turning One Thing Into Another*.

And seed shall be turned into bread
and flax become clothing so bright
And coal will be heat
And fish will be food –
By the burn of muscle and bone
By the risk of lung and of life
By the quickness of the eye
By the skill
By the will
Of those who work.
(McGrath, 1990: p. 3)

Just like the *Song of Turning One Thing into Another*, the play itself is about mediation
and appropriation, and just like cultural practices, it is about transformation and change.
Like the song, the play explores how labour is turned into market commodity and how in
turn this process instead of empowering those mainly responsible for creating it,
proceeds to gradually disenfranchise them. so Labour, which is initially presented as
emancipatory – as that which can free the worker from the land and help achieve
individual happiness – is from the outset problematized. A young woman says:

We are no longer slaves of course
Eighteen years ago they very kindly set is free
Free to roam the highways – as beggars.
(McGrath, 1990: p. 32)

This principle of freedom to work and create one's own destiny is seen as one of the
structuring forces of capitalism that has helped shape the way we understand the market
today. In *John Brown's Body* this freedom to work – which later becomes the right to
work – is seen as both a blessing and a curse. As John Holloway writes in his analysis of
post-Fordism, freedom has always been a key concept of the modern state:

The 'freedom' of the worker which distinguishes capitalism from earlier forms of
class exploitation is at the same time the freedom (in a much more real sense) of
the exploiter. The global nature of capitalist social relations is thus not the result of
the recent 'internationalisation' or 'globalisation' of capital, ... Rather it is inherent
in the nature of the capitalist relation of exploitation as a relation mediated
through money, between free worker and free capitalist, a relation freed from
spatial constraint. The a-spatial, global nature of capitalist social relations has been
a central feature of capitalist development since its bloody birth in conquest
and piracy.
(Holloway, 1994: p. 31)

John McGrath's project, however, is a cultural one, not strictly a political one. For *John Brown's Body* inhabits one of the great dialectics set up by the enlightenment idea of freedom: the freedom that creates exploitation and oppression also helps create the idea of hope and the belief in change. Another song that is repeated throughout the text is called *The Dream's Over*. This presents the basic humanist belief that, despite its problems, the idea of work contains within it the yearning for a better life. This is a dream that *John Brown's Body* claims is far from over. It is also this song that ends the play:

> Defeated and broken
> All certainties shaken
> We must face reality that's as true as it's hard:
> Shattered and smarting
> Our wounds are still hurting,
> As we start once again on that long winding road.
> For the dream can't be over
> And the hope will not die .
> When a half of humanity's hungry and poor:
> No the dream can't be over
> While a child still asks why:
> While the young want an answer and the old want more
> While the young want an answer and the old want much more.
> (McGrath, 1990: p. 130)

As the titles of the three sections suggest (*The Wealth of Nations, Discipline and Flourish, The End of History*), the way people work determines the ways societies are structured and communities created. The trail leads right up to the present world of the multinationals where everything including culture is commodified. With its Foucaultian undertones and its references to *fin de siecle* nihilist and neo-conservative rhetoric, *John Brown's Body* traces the great ideals of the enlightenment and the age of reason, and proceeds to question whether they are still valid today. To trace such a journey through the concept of work is exciting and innovative in both ideological and aesthetic terms.

The Russian/Soviet Constructivists (Kleberg, 1993) also found in the concept of labour not only a theme for their theatrical projects, but also a form that helped shape them. For the Constructivists plays were not only going to be about work, but the way labour was structured and organised was also to provide them with a new theatrical language. In this context it does not seem to strange that Meyerhold, despite his fervent radicalism and his commitment to dialectical analysis of theatrical conventions and processes (in ways that foreshadowed Brecht), managed to find inspiration in Taylorism. This system of fragmenting the labour process led directly to Fordism as a mode of production; in terms of labour relations it only helped to further establish the classic Marxist concept of alienation. Meyerhold, nevertheless, like Lenin before him, saw in Taylorism a capitalist process that he thought could be adapted, appropriated within a radical project.

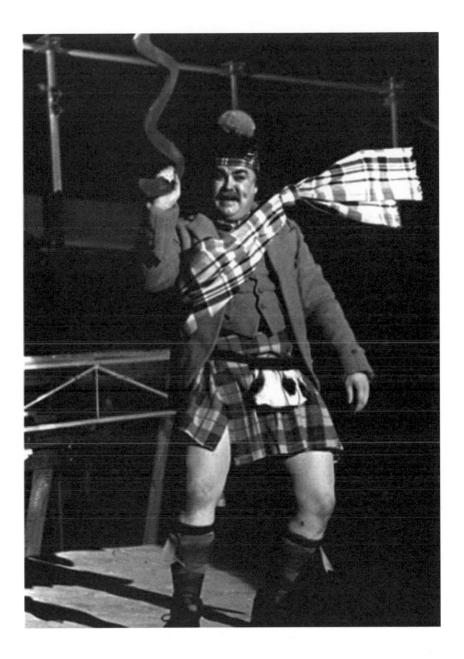

Billy Riddock as Harry Lauder in *John Brown's Body*, photo: Alan Wylie

Through his complex system of bio-mechanics bodily movements are broken down, fragmented and repeated, in imitation of Taylorist work process.

In their uncritical glorification of labour the constructivists believed they had an ally in technology. Indeed, Taylorism in line with technology presented the great hope for the workers of the future. Their utopian, almost romantically naive faith in technology was in line with much modernist thinking that saw technology as emancipatory, as the force that will finally free people from labour, bridge the gap between manual and intellectual worker and lead the working class to happiness. The theatrical designs and directions of Meyerhold, Tretiakov, Popova and Tairov all bear witness to this belief.

John Brown's Body engages with this tradition in very challenging ways, both formally and thematically. It neither glorifies nor ignores it, but chooses to set up a dialogue with it. In an age where labour has not only lost faith in Fordism and technology as emancipatory forces, but has 'progressed' to more and more inhuman and alienating modes of production like post-Fordism and information technologies, the utopias of constructivism can hardly be accepted uncritically.

The pseudo-constructivist set designed by Pamela Howard comments on the grandness and the aspirations of that tradition, but maintains a weariness and a critical distance from it. It is at once a homage and a critique. It is not bold and shiny with the promise of a better future. It is more reminiscent of a fun fair than a factory. In fact it looks tired and run down, like a constructivism that has lost its conviction. And the repetitive movements made by the actors throughout the play are exactly that: tired and repetitive. There is no bold Meyerholdian thrust. *John Brown's Body* seems to be saying that this kind of labour dehumanizes, it does not liberate.

This dialogue that the play sets up with the whole constructivist tradition is not always successful and at times the sheer scale of the design seems to take over. There is, however, one more factor that comes into play in this exchange. It is something that the constructivists could possibly only dream of, and that is television

THEATRICAL SPACE / TELEVISION SPACE

John McGrath belongs to a generation of writers for whom television presented an exciting challenge. Like Trevor Griffiths and Dennis Potter he saw television as the alternative 'national theatre'. This legacy of television drama is a peculiarly British phenomenon and has helped create what has since been called 'the golden age' of British television.

Television presented a platform for young writers to test their skills, and in the process help mould the medium itself. As Robert Holles claims:

The single play provides an entry into television for talented young dramatists, whether they come from fringe theatre, radio drama, or any other source. Over the last twenty years, it would be no exaggeration to say that eighty per cent of the television dramatists now working on drama series, serials, and adaptations made their original break-through, and learned their trade, through the medium of the single play.
(Holles, 1985: p. 7)

Shaun Sutton, who was head of drama at the BBC in the early 1970s, has drawn an extensive list which is indicative of the kind of work that television was hosting:

So abundant were the seventies, I can only dip in at random and bring out *Elizabeth R*, John Bowen's *Robin Redbreast*, Peter Nichols' *Hearts and Flowers*, Ingmar Bergmann's *The Lie*, Jeremy Sandford's *Edna the Inebriate Woman*, Tom Clarke's *Stocker Copper*, *The Wessex Tales*, Colin Welland's *Kisses at Fifty* and *Leeds - United!* There was Arthur Hopcraft's *The Reporters*, Dennis Potter's *Joe's Ark* and *Blue Remembered Hills*, John McGrath's *The Cheviot, the Stag and the Black, Black Oil* ….
(Sutton, 1982: p. 20)

And the list continues. John McGrath was not, however, a newcomer to television. He had already had years of television experience (creating the hugely successful *Z-Cars* amongst others), before he formed the 7:84 theatre company. For him, television from the beginning of his writing life presented the possibility of cultural intervention. He writes in *A Good Night Out*:

Television drama is a greatly under-explored area. Most of the attempts to grapple with it seem to me to have either misunderstood or ignored completely the nature of the communication taking place: but television drama, in this country at least, exists as a relatively powerful social force and as a challenge to every dramatic writer who is at all concerned with writing for a mass audience.
(McGrath, 1981: p. 110)

This analysis is followed by a manifesto-type catalogue of principles of how to engage with television within an oppositional cultural practice (McGrath, 1981: p. 114). Indeed, for McGrath television was never merely an innocent medium. As he states in the introduction to *The Cheviot, the Stag and the Black, Black Oil*, it taught him new ways of writing theatre as well. He claims that the editing, the time-shifting and fragmentation techniques that he learnt from working in television helped him deal with the problem of covering three hundred years of the history of the Scottish Highlands within the confines of a single play. For McGrath, theatre and television were never seen as opposing but as complementary mediums. Modes of production in one medium seemed to happily shift into the other; and all for the purposes of reaching larger audiences and of including television within broader cultural projects.

The televising of *The Cheviot, the Stag and the Black, Black Oil* was a landmark in the history of progressive television drama in Britain. It seemed to bring together a number of discussions going on at the time about the formal limitations and possibilities presented by the medium. It also presented a new fusion of theatre and television. John McGrath like Troy Martin Kennedy (the co-creator of *Z-Cars*) presented in the late 1960s and early 1970s the voices of dissent within the television establishment. In an extensive and insightful analysis of this tradition John Caughie (1981) examines the ambiguous relationship of British television to theatre:

> ... one tradition which crudely can be identified with the Royal Court or with Joan Littlewood's theatre, and the other which can be identified with the persistence of an Edwardian theatre. Thus theatre can be identified with both the conservatives of television drama, and the dissidents: it was in the magazine *Encore*, 'The Voice of Vital Theatre', that Troy Kennedy Martin delivered his assault on the naturalism of television drama.
> (Bennett, Boyd-Bowman, Mercer and Woollacott, 1981: p. 336)

Continuing his analysis, John Caughie suggests that the televising of *The Cheviot* presented a model for resolving this fraught relationship with theatre and creating a form of television drama which underlined the progressive potential of the medium. In Brechtian epic style this brought together a variety of forms like drama, historical reconstruction, documentary, reportage and theatrical performance. This model identified by Caughie as a form of documentary drama was pointing towards a progressive use of television, both in terms of contents and form. It is worth quoting extensively from this analysis:

> For the development of the formal effectiveness of documentary drama, *The Cheviot* ... represents a radical separation of the discourses of the documentary: the television production is at the same time a drama, a documentary on the way in which the theatrical performance circulated in the Highlands, a historical reconstruction, and a documentary on working conditions in the North Sea oil industry. The elements are not integrated to confirm and support each other, but are clearly separated out and allowed to play against each other ... It is the possibility of this collision of documentary drama, of the refusal of integration, which makes the documentary drama a potentially political form. It also has to be said that, whereas *Cathy Come Home* started a tradition, the model of *The Cheviot* ... has not yet been followed up.
> (Bennett, Boyd-Bowman, Mercer and Woollacott, 1981: p. 349)

In effect the television version of *The Cheviot* was a completely new form, bringing together all the aforementioned elements; it was not simply a televised piece of theatre.

McGrath's own writing on television and the debates in which *The Cheviot* both participated and helped fuel, all took place towards the end of the 1970s – just the beginning of the Thatcher years. *Border Warfare* and *John Brown's Body* were produced and shown on Channel 4 in 1990 and 1991 respectively. A decade of Thatcherite policy had intervened and an onslaught mounted on alternative cultural practices. It is interesting to note that Channel 4, in many ways, did for the 1980s what the BBC used to provide for the 1970s. When the funding for 7:84 became diminished and managerial and political interference forced McGrath to resign as its Artistic Director, he turned to Channel 4 for help in co-producing these two large-scale productions.

The televisual outcome from this collaboration was quite different from *The Cheviot*. This was not a form that blended discourses from both television and theatre, nor was it a simple case of filming the theatrical productions. Channel 4 was involved from the initial stages as co-producer, so the televising of the events was on the agenda from the early stages of production. John McGrath wrote and directed both the theatrical and the television versions. And they are quite different. As John McGrath has said recently at a Television Conference at the Edinburgh Festival (1995) the direct filming of theatre for television 'creates both bad theatre and bad television' (McGrath, 1995). Unlike *The Cheviot*, this was not a case of documentary drama; the television versions of *Border Warfare* and *John Brown's Body* did not include documentary material and reportage. Nor was it a simple case of theatre on television. It was rather a case of television as theatre, and theatre as television. This is particularly important when television is used to portray the history of one section of the population to the rest of the nation.

This seems to point towards a general direction McGrath's work is taking at present. In 1992 he won two BAFTA awards for *The Long Roads* which was written specifically for television. This was a 'state of the nation' film, tracing the effects of Thatcherism on people's daily lives; it is the story of a dying Scotswoman and her husband who set out on a journey from the North of Scotland to London to visit their children in various parts of the country. It has been compared to Ozu's *Tokyo Story*, and indeed it examines relationships between generations, between local and central cultures, using the format of the road movie (in this case with the help of British Rail). It is this epic, non-naturalistic use of television that has always interested McGrath.

The times have, of course, changed, and the 'golden age' of British television, by all accounts, seems to be over. Nevertheless, McGrath's faith in the medium together with his belief in shamelessly utilising all available means managed to create one of those rare moments in alternative culture, where theatre and television complement each other and promote the interests, the agonies, fears and identities of one localised group to the rest of the nation. The televising of *Border Warfare* and *John Brown's Body* was a case of television functioning as an extended national theatre.

In his writings on television Raymond Williams stresses the fact that any television experience has built within it the idea of flux:

> It is indeed very difficult to say anything about this. It would be like trying to describe having read two plays, three newspapers, three or four magazines, on the same day that one has been to a variety show and a lecture and a football match. And yet in another way it is not like that at all, for though the items may be various the television experience has in some important way unified them. To break this experience back into units ... is understandable but often misleading. (Williams, 1990: p. 95)

This power of the 'television experience' to unify and homogenise otherwise heterogeneous and contrasting fragments, is crucial in the cases when it mediates between local and 'national' cultures. As Raymond Williams stresses, however, this apparent unity is literally only superficial. His emphasis on the fluidity and the complexity of television anticipates approaches to television we share today. It is no longer only about time, but what seems equally, if not more important is the idea of space. Satellite TV, expansion into the sky, transmission over continents, the ability for the audience to interact are all spatial and geographical relationships. They are also categories that are vital in any analysis that deals with the tensions between local and hegemonical cultures and identities.

The analysis of space, locale and geography is also part of the postcolonial project. Where a cultural event takes place, how it is disseminated elsewhere, and how it then takes part in forming received notions and identities of the places involved are crucial factors in understanding the dynamics between central and peripheral cultures. Space, be it created or geographical is never seen as a neutral locale, as an empty space. From the space of the Tramway to the broadcasting space on Channel 4, *Border Warfare* and *John Brown's Body* enter a complex network of relationships that constantly define what is central and what is peripheral. At the same time, as they both constantly re-create culturally and politically the space they occupy (be it the Tramway or individual TV sets in people's houses) they initiate a form of critique that opens up what Homi Bhabha terms an 'in-between' space. This space seems to lie on the borders of Scotland and England, the centre and the periphery, theatre and television. In the end it makes these productions as much about Englishness as they are about Scottishness. In this sense the answer to the question 'where exactly is Scotland?' posed by a reviewer could easily be something like: 'Scotland is somewhere to the north of England, but it is also right here in your living room'!

BIBLIOGRAPHY

Bennett, T., S. Boyd-Bowman, C. Mercer and J. Woollacott (eds.) (1981)
Popular Television and Film. London: BFI/Open University.
Bhabha, H. (1994) *The Location of Culture*. London: Routledge.
Bharucha, R. (1993) *Theatre and the World*. London: Routledge.
 Holles, R. (1985) 'Independent Television and the Single Play'. In
 Self D. (ed.), *Television Drama: An Introduction*. London: Methuen.
Holloway, J. (1994) 'Global Capital and the National State',
in *Capital and Class*, 52.
Kleberg, L. (1993) *Theatre as Action*. London: Macmillan.
MacLennan, E. (1990) *The Moon Belongs to Everyone*. London:
Methuen.
McGrath, J. (1981) *A Good Night Out*. London: Methuen.
(1989) *Border Warfare*. Manuscript.
(1990) *John Brown's Body*. Manuscript.
(1995) 'Television and Theatre', seminar, Traverse Theatre,
Edinburgh Festival.
Sutton, S. (1982) *The Largest Theatre in the World*. London: BBC.
Williams, R. (1974), rpt 1990) Television: *Technology and
Cultural Form*. London: Routledge.

ROAD: FROM ROYAL COURT TO BBC – MASS OBSERVATION/MINORITY CULTURE

DEREK PAGET

A PLAY FOR ITS DAY – PERFORMANCE AND PUBLICATION

Road, Jim Cartwright's first play, was premièred at the Royal Court's Theatre Upstairs on 22 March 1986; on 9 June, it moved to the Court's main auditorium. After a short tour, the production returned to the Court in January 1987 before transferring briefly to New York. *Road* was then filmed for television, and transmitted on BBC2 (7 October 1987). The hour-long film was repeated the following year, and again in 1990 as part of a season of films commemorating director Alan Clarke's tragically early death. Play, production and telefilm attracted five national and international awards.[1]

This chapter will examine this highly successful 'translation' of *Road* from the specific stages of the Royal Court Theatre in London's Sloane Square to the screens of our televisions, in their less specific but equally definitive domestic settings. Any kind of move from one medium to another involves *transformation*, and *Road*'s three-way transformation – from 'studio' space, to 'official' main stage, to the BBC's own 'alternative' space BBC2 – is of great significance. I shall claim that Cartwright's play is a distinctive text both for British drama and for the wider culture of the 1980s, a decade forever associated in the UK with the name of Margaret Thatcher.

Set in a bleak Lancashire street, its denizens the victims of New Depression poverty, the play was widely perceived at the time of first performance as an important 'state of the nation' meditation. Programme note and published text alike stressed that in *Road*: 'The action takes place in a road in a small Lancashire town – *tonight*' (my emphasis). The play is written in the language of that heightened, even poetic, realism so distinctively a part of the Royal Court tradition, which one reviewer called its 'poetic demotic' (*Sunday Telegraph* 30/3/86). *Road* heralded the arrival of an exciting new writer who has, subsequently, stuck mainly to writing for the stage at a time when most dramatists have

eagerly sought TV and screen writing opportunities.[2] It is a play which addresses the issue of what is now routinely referred to as 'the underclass' – those in the so-called 'poverty trap', for whom the dominant class fraction in society no longer wished to take responsibility in the Thatcherite 1980s. Written post-1984 Miners' Strike, *Road* was indeed a play for its day, a day in which the organised working class were widely perceived as having been defeated by the new, militant, conservatism. *Road* can be seen partly as an 'End of History' text, articulating aspects of that collapse of alternatives to capitalism celebrated, in some quarters, at the close of the decade as the Berlin Wall came down and Soviet communism imploded.

I shall argue that its distinctiveness is not so much as a single, unitary *text*, but as plural *texts in performance* (with concomitant contexts and audiences). It is by no means the usual thing for plays to move downstairs from the Royal Court's experimental space – this in itself was a mark of high favour and index of success for the original production. Upstairs, the small audience can be placed in various 'experimental' configurations; downstairs the audience is larger, but usually fixed in its orientation to stage and actors. That the main auditorium itself became 'transformed' was, as we shall see, further proof of *Road*'s distinction. The taking up of a theatre text for television re-production, too, confers unusual favour. Finally, the single tele-play had itself become something of a rarity by the 1980s, and *repeated* transmission acquires added significance in such a context. These simple facts indicate a text with powers beyond the norm for the period under review, and one offered to progressively wider audiences.

Publication, especially in more than one edition, is further testimony to the interest generated by a play. Among other things, it opens the opportunity for further performance and for academic study, both inevitably widening access. The reader has probably been drawn to this chapter either by reading the play in the context of study and/or performance, or by seeing a stage performance/watching a video of Clarke's film, or by a combination of all these things. Such echoes of a text's original performance are an index of the collective belief, on the part of stage and academic workers and their various audiences, in *Road*'s importance to an understanding of social and political, as well as cultural and theatrical, shifts in the 1980s.

Road was published at the time of its first performance as part of a wider, on-going deal with Methuen which enabled audiences to buy the text with their programme. The 'Royal Court Writers Series' in which it was published in 1986 was a marketing initiative typical of the 1980s. The text/programme concept was used elsewhere by Methuen for their 'Swan Theatre Play' imprint ('by arrangement with the Royal Shakespeare Company'), and by Nick Hern Books ('A Royal Court Programme/Text'). This kind of thing was highly necessary in view of Government policies which were reducing public spending on the arts throughout the 1980s, and which compelled arts institutions to seek private sponsorship in order to survive financially. *Road* was revised and reprinted in an 'acting edition' by Samuel French in 1989, and by Methuen in their 'Modern Plays' series in 1990. Although the text of Alan Clarke's *Road* was never published, it too has some of

the permanence of text in its recorded form. The video is as susceptible of continued and renewed analysis as a printed text is (and as a staged performance, trapped in 'real time', is not). I shall be considering all three 'textual' manifestations of *Road*.

The main issue I will discuss is the effect of key post-war cultural institutions on the dramatic representation of social reality (and in particular, the representation of Northern, working-class, life). The intersecting histories of both the Royal Court's and the BBC's post-war commitments to such representations will provide a focus for reading Cartwright's play. As well as these overlapping post-war institutional contexts, I shall offer some remarks about *Road*'s manifest continuities with an even earlier tradition of representation in English culture, that of the pre-war Documentary Movement. *Road* is in part a late response to a 'documentary imperative' in English culture of the twentieth century, which also links it to the famous theatrical 'revolution' of 1956.

ANGER – AND AFTER?

1956 is now indelibly inscribed into history as *the* year of change in post-war British theatre. John Russell Taylor's 1962 *Anger and After*, the first book to tell this story, defined the Court as originary institution, and he was still emphasising 'the respect in which the Royal Court is held' and 'the almost unfailing distinction of its work' in his book's reprint at the end of the 'angry decade' (1969: p. 38). His very title, with its deliberate echo of the 'angry young man' tag, picks up admirably the sense of those times, in which post-war reality was dramatised for the first time and in which the Court became a major theatrical institution. Its health and vitality are now judged by reference to a continuing ability to do what it did so well then – to find new writers, and through them to speak to the major public issues of the time. It became, in short, the National Theatre of New Writing.

A minor manifestation of this institutional success and longevity is a keenness to celebrate anniversaries. The 1986 text of *Road* typifies this relatively harmless trait with an invocation of the Court's 30th anniversary. But, for all of us, some birthdays are more significant than others, and the 25th anniversary of the company's foundation in 1956 was celebrated with the publication of *At the Royal Court: 25 years of the English Stage Company*, edited by Richard Findlater. Packed with glossy photographs, this book assembled a veritable galaxy of ESC stars past and present to tell the tale of a theatre the editor calls 'the most persistently seminal, significantly productive and stubbornly controversial place in the British – perhaps in the Western – theatre' (1981: p. 7). What less Anglo-centric readers might make of this massive claim is worth pondering, but for the purposes of this chapter the reasons why it comes to be made at all in the purely British context can be easily summarised.

In the early 1950s, the Royal Court was a semi-derelict playhouse-without-a-purpose, like so many in post-war London. The commitment to new writing which is the main emblem

of its current status began with John Osborne's *Look Back in Anger* in 1956, and an up-to-date roster (to add to famous names Arden, Wesker, Bond, Storey, Hampton, Brenton, Hare, Churchill) is usually enough to substantiate continued claims to distinction. Its eminence as a powerhouse of new writing for the stage is secure while it adds to this list; discovery of new writers is the Royal Court *sine qua non*. It is this tradition which Jim Cartwright entered in 1986, and to which he has now contributed. His name, along with Winsome Pinnock, Sarah Kane and other, as yet undiscovered, writers will doubtless be cited should the Court achieve its Golden Jubilee in 2006.

This achievement has never been so threatened as it was in the 1980s, times so hard that it became a matter of doubt that the institution could survive to bite the hand that no longer seemed disposed to feed it. Cuts were so severe that only sponsorship intervention by American impresario Joseph Papp and by Barclay's Bank in the 1980s, and by the Jerwood Foundation in more recent times, preserved any kind of continuity in the Royal Court project. The Theatre Upstairs was even forced to go dark for a time in 1989, and Artistic Director Max Stafford-Clark was often to be found pleading for more resources. Yet only twenty years earlier William Gaskill had noted in passing in a letter – 'We are given a reasonable subsidy by the Arts Council ...' (see Browne, 1975: p. 78). An off-the-cuff remark from another era highlights the real difficulties involved in ensuring continuity in harsh new times.

With its sponsorship deals and new writing competitions, the Court embraced the new economic imperatives in order to secure its threatened tradition. That it has succeeded at least to some degree is evident from Richard Allen Cave's observation in the late 1980s that 'the Royal Court and its Theatre Upstairs remain the prime exhibition space for new talent' (1987: pp. x-xi), in almost direct echo of John Russell Taylor in the 1960s and Terry Browne in the 1970s. But the 1990s has seen the debate shift, and John Bull for one has claimed that British theatre is currently involved in 'a march towards total irrelevance' (1994: p. 219). The Royal Court's continued claim to relevance, and its attempted avoidance of such strictures, has been made mainly (but not solely) through a higher incidence of discovery of new writers than any other company. An additional marker of its mould-breaker image has been its capacity from time to time to provoke and to offend – to stimulate *controversy*.

COURTING CONTROVERSY

This institutional trait, too, was inaugurated by *Look Back in Anger* in 1956. The turbulence attendant upon controversy can be read as a cultural index both of the importance of the subject under discussion, and of the virility of the institution originating it. The turbulence occasioned is mostly a function of the historical conjuncture; it happens almost irrespective of the formal and other properties of plays at the apparent centre of the controversy. It is difficult now, for example, to recapture the contemporary shock

inspired by such a creaking naturalistic vehicle as *Look Back in Anger*, but offend it assuredly did. Manifestly, it re-wrote the post-war cultural agenda, and subsequent Court controversies have at the very least re-arranged items on this agenda.

Even size of audience is somewhat irrelevant to the scope of public debate following controversial plays; it becomes more relevant, in fact, to seek to know *who* is in the audience rather than *how many. Road's* theatre director Simon Curtis, now a BBC executive, recently pondered this fact somewhat ruefully:

> Moving from a career in theatre into television, it is easy to develop an inferiority complex. Critics from every national newspaper attend an opening in a tiny space above a pub … On television even a major event can be reviewed merely as a jokey one-liner or ignored completely.
> (*The Guardian* 9/11/94)[3]

Controversial theatrical events tend even more to punch above their apparent weight. From *Look Back in Anger* onwards, they are offered to mass audiences only after a minority judgement has been made.

Another celebratedly controversial Court play was Edward Bond's *Saved* (1965). This was forced initially into 'club performance' to escape the censor, as was the same writer's 1969 *Early Morning*. The Bond plays are sometimes credited with being the force that finally breached the citadel of the Lord Chamberlain's Office, leading ultimately to the end of a peculiarly British institution of overt censorship in 1968. Terry Browne, in fact, draws a direct link between police intervention at the first performance of *Early Morning* on 31 March 1968 and the passing of the Theatres Act on 28 September of the same year (1975: pp. 70-71).

In 1995, the Court demonstrated it has not lost the capacity for controversy when Sarah Kane's Theatre Upstairs play *Blasted*, a play of Tarantino-esque violence, was largely panned by newspaper critics unable to adjust to its lumping together of the real and the surreal. In 1965 the stoning of babies on stage in *Saved* had caused outrage; in 1995 (and amongst other horrors) one was *eaten* in Kane's play. *Blasted* was defended by its director, James MacDonald, in an article which is a model Royal Court justification. The play, he asserts, has 'assurance, wit and economy with language'; structurally, it is 'highly unusual and bold'. He argues that *Blasted*, co-produced with the Royal National Theatre Studio and sponsored by the Jerwood Foundation, 'is part of a range of new writing impressive in its variety of form and content'. He does concede that it lies 'at the difficult end of both, and as such will not be to everyone's taste' (*Observer* 22/1/95). Apart from the background concepts of sponsorship and co-production, MacDonald's justification-by-text could have been written by a Royal Court director at almost any point in the last forty years.

Other writers were eager to defend Court and Kane. Caryl Churchill, for example, observed in a letter to *The Guardian*, 'I found it a coherent story, starting from…social observation … but able to move into the surreal to show connections between local, domestic violence and the atrocities of war' (24/1/95). Edward Bond, too, sprang to Kane's defence via a blanket condemnation of a modern theatre 'as sleazy as our government'. The National Theatre he calls 'a national humiliation'; the RSC, 'a dalliance with the tourist trade'. The Royal Court, however, had had the courage to stage what was, he claims, 'the most important play on in London' (*The Guardian* 28/1/95). This phrase has echoes from other eras, when counter-judgements were offered to help both *Look Back in Anger* and *Saved* through rough critical waters. As Snoo Wilson so sagely remarked, '*Blasted* sounds just what the Royal Court is for' (*New Statesman* 3/2/95).

Road, like *Blasted*, was produced in one of the Court's regular 'festivals of new writing'. Both plays are part of the tradition which has made this theatre into a public platform for social and political debate in the post-war period. In a 1985 interview, Max Stafford-Clark defined the typical Court play as one with the 'ability to reflect the complexity of the society we live in' (*New Theatre Quarterly* Vol.I, No.2, 1985: p. 145). The Royal Court's place on the wider platform of public debate has been secured by a reputation for texts which critique the social in language characterised by such qualities as MacDonald enumerates (not least, perhaps, the quality of 'difficulty'). Putting on 'the most important plays in London' (for 'London', read 'the nation') is assuredly the Royal Court's purpose, one it has pursued for forty years. Following the Upstairs production of *Road*, Michael Ratcliffe even remarked: 'What Cartwright has to say is essentially what Jimmy Porter had to say at this address thirty years ago' (*Observer*, 6/4/86).

ROAD AS AN ALTERNATIVE TEXT

During the period 1968-1972 a second layer of 'new' post-war theatre – Fringe (subsequently Alternative) Theatre – emerged. For the Court, this led briefly to a disturbing counter-reputation to its innovative one. In 1975, Michael Billington wrote 'the Court urgently needs to regain contact with a whole generation of English dramatists … this once-dynamic theatre seems to be living in the past' (1994: p. 69). By the end of the decade, even a former Artistic Director, William Gaskill, was describing it as 'always a mainstream theatre, not a fringe theatre' (see Itzin, 1980: p. 226). It needed to accommodate to the 'new new writing', so to speak, and to show it could move with the new times.

The perception that the Court was becoming *institutionalised* and *conservative* was articulated most provocatively by a former employee, playwright John McGrath. In his book *A Good Night Out*, he argued that the Court's 'particular *kind* of theatre has become … respectable, conventional and pernicious' (1981: p. 9). Unlike Bond in 1995, he even lumped the Court in with those prestige theatrical institutions of late twentieth-

century Britain, the Royal Shakespeare Company and the National Theatre (now also 'Royal', of course). He concluded that it was a 'curious fantasy that the values of that place were anything other than bourgeois, élitist and utterly whimsical' (p. 10). According to his line of argument, so far from being revolutionary the Royal Court was only ever that endearingly English thing an eccentric given occasionally, like the cat, to chasing and biting its own tail. In a dissenting section of Findlater's book, David Hare observed caustically that 'there were more appeals to public school sentiment at the Court than in any institution I have known' (1981: p. 141).

The Royal Court main counter-argument to such strictures was its experimental space the 'Theatre Upstairs'. The Court's famous 'Sunday Night Productions Without Décor' (from 1957), and the work of Keith Johnstone's 'Theatre Machine' (from 1965), could be argued as activities of a proto-Fringe, but William Gaskill admitted in 1980 that the Theatre Upstairs was indeed 'an acknowledgement of something that had already happened that we had to take cognisance of' (see Itzin, 1980: p. 226). The world had moved on post-1968, and the Royal Court demonstrated its ability to adjust precisely by aligning itself with the new force in theatre. Outside the Court, Gaskill and Stafford-Clark, in additional acknowledgement of new theatrical times, extended the Royal Court project further in their work with Joint Stock (from 1974).[4] In *The Joint Stock Book*, Rob Ritchie notes: 'Stafford-Clark's experience at the Court, particularly the battles over (Howard Brenton's) *Magnificence*, made it clear that the opportunities in Sloane Square were limited' (1987: p. 15).

If 'Fringe Theatre' describes the exhilarating and anarchic work of a first phase 'frontier period' between 1965 and about 1973, the phrase 'Alternative Theatre' describes the more institutionalised form which continued into the late 1970s and which still, vestigially, hangs on into the project-funded 1990s. Theatre writers like Brenton, Hare, Edgar, Griffiths – now established in their middle years as the major dramatists of their time – began here, and where they led younger writers learned to aspire. The experimental space has become a literal and metaphorical site within which reputations can be established. The RNT and the RSC were both careful to incorporate such spaces into new London complexes in 1976 and 1982, and the RSC developed two more at their base in Stratford over the last ten years. All three 'national' theatres were *responding* to, rather than *initiating*, new developments in theatre over a consolidating decade; the Court, as ever, was ahead of the game, opening its alternative space as early as 1969.

Road's credentials as an alternative text are bound up with the history of the Theatre Upstairs. Malcolm Hay has written that the experimental space 'built a reputation on a policy of putting on new plays by writers like Howard Brenton, Howard Barker, Heathcote Williams, and David Edgar…whose work usually demanded *some form of environmental staging*' (see Craig, 1980: p. 157 – [ed.s emphasis]). These words could stand as a definition of the distinctive theatricality and experimental possibility which has continued to be evident in Theatre Upstairs work. It could certainly describe the demands of *Road*,

presented in a way which allowed the audience to move around the auditorium, and facilitated especially close encounters between performer and spectator. With its ancient history, the *promenade* performance style used by Simon Curtis for *Road* has been reckoned to be a particularly innovative method of staging in modern times.

Necessarily, it makes demands on naturalistic performance through the proxemics involved, but there is often a high incidence of direct address in promenade. The 1985 Cottesloe production of Tony Harrison's *The Mysteries* did much to bring this mode of environmental staging to a wider public, as did the 'community play' movement where it was a staple method from 1978 onwards.[5] But its emergence as a key experimental mode of the 1980s was due originally to the Joint Stock company's inaugural production, *The Speakers* (1974). Both Joint Stock's and *Road*'s use of promenade was very different from the celebratory orientation of most productions in this style, a fact which Martin Hoyle noted: 'A paradox: those promenade performances that engulf the wretched audience in folksy bonhomie leave me murderously misanthropic...(but *Road*) is stimulating, thrilling and moving' (*Financial Times* – 27/3/86).[6]

The various published texts demonstrate how some of these qualities so appreciated by Hoyle were generated in the two Court stagings. In the considerable amount of direct address, and in the poetic demotic employed, Cartwright pushed the language of social realism, the stock-in-trade of TV and film drama, into new and occasionally hilarious dimensions. Consider this dialogue from Act One, for example:

MOTHER: Have you had owt'eat?
CAROL: No.
MOTHER: Well get summat down you before you go out.
CAROL: You get summat down you.
MOTHER: You get summat down you.
CAROL: You get summat down you.
MOTHER: You get summat down you.
CAROL: You get summat down you. You're the one who's goin'
 to be pissed up and lying in it.
MOTHER: Shove it, you little tart.
CAROL: You shove it.
(1986: pp. 5-6; 1990: p. 9)[7]

In performance, the repetition of this exchange (and there are others very like it) acquired the kind of rhythmic resonance which moved beyond simple realism; the very poverty of the language acquired its own peculiar eloquence and energy (leading here to a radically dystopian picture of the mother-daughter relationship).

Secondly, sustained figurative language, often incorporating alliteration, rhyme and half-rhyme, is a hallmark of speeches which again run beyond the limits of the conventional

social realistic play, and give the lie to any simplistic notion of lower-class linguistic poverty. It was this feature of *Road* which led many reviewers to compare it to works like *Under Milk Wood*.[8]

VALERIE: He'll come in soon. Pissed drunk through. Telling me I should do more about the place. Eating whatever's in the house. Pissing and missing the bog. Squeezing the kids too hard. Shouting then sulking. Then sleeping all deep and smelly, wrapped over and over in the blankets. Drink's a bastard. Drink's a swilly brown bastard. A smelling stench sea.
(1986: p. 25; 1990: p. 55)

The foul-mouthed eloquence is often at provocative variance with middle-class notions of a working-class restricted language code. As Michael Ratcliffe noted: 'The four-lettered basics recur like punctuation and breathing throughout; old words like *devil* and *bastard* are restored to their former power; sentimental concepts like *before* and *ago* recover their pathetic importance' (*Observer* 22/6/86). The truth of this contention is shown in the conclusion to Valerie's speech, when she pleads rhythmically, 'Can we not have before again, can we not? Can we not have before again? Can we not? (1986: p. 25; 1990: p. 56).

The climax of the play is in Eddie, Brink, Louise and Carol's stream-of-consciousness prose poems, and their collective choral speech, in the final scene (1986: pp. 33-35; 1990: pp. 77-81). The gathering exultation of the mantra-like 'Somehow a somehow – might escape' replicates some of the features of Otis Redding's sinuous version of 'Try a Little Tenderness', the record which has (along with determined preparatory wine-swigging) lifted the four characters into heightened eloquence. Record and collective speech alike aspire to the condition of poetry in their respective struggles; Redding fights the lyric clichés of a Tin Pan Alley song, the characters protest their desire for something *else* in their lives. The incantatory power of both results from the vocal *enactment* of the inadequacy of language to give expression to the pain of love, or frustration, or social deprivation, or of all these things. *Road*'s collective cry of despair/defiance gives the lie to the Thatcher soundbite that there is 'no such thing as society'.

Cartwright has demonstrated in subsequent plays that this impressive, highly theatrical, writing was no fluke. But director Simon Curtis took the language one step further by reinforcing the tropes of the language through the immediacy of promenade staging. To be a few feet away from the kinds of monologue/soliloquy which pepper the text of *Road* was to feel the full ambiguous force of Cartwright's dramatisation of social deprivation. There are around a dozen such speeches in *Road*, and they seem to be, in part, a deliberate attempt to invoke a tradition of documentary observation. In a centre section of the 1986 text/programme (pages unnumbered), there are two pieces of writing: 'Mass Observation' and 'Mass Observation of Performance of *Road*, 19 April,

1986'. The former explains the 1930s movement as 'a remarkable and unique insight into the ordinary life of the British public'. In the latter the actors William Armstrong (Eddie) and Neil Dudgeon (Brink) document *their* observing-experience as performers in the promenade situation: 'Funny, them watching us watching them watching each other. Just like life. I suppose'. Their thoughts are not unlike Roger Lloyd-Pack's reminiscences about *The Speakers* (see Ritchie, 1987: pp. 103-104), and they situate *Road* as part of a peculiarly English interest in, and guardedness about, social class. The combination of distance and detail which characterised the 'Mass Observation' movement links it both to the moment of 1956, and beyond – to the texts of *Road* itself.

NORTH-FACING

In their just-the-funny-side-of-accurate account of British history *1066 And All That,* Sellar and Yeatman define Britain's nineteenth-century 'Industrial Revelation': 'women and children could work 25 hours a day in factories without many of them dying'. This, they say, 'completely changed the faces of the North of England' (1961: p. 100). English culture, with its perennially London-centred, Southern orientation has been trying to come to terms with the North and its many faces ever since Thomas Carlyle first posed the 'Condition of England Question' in 1839. Successive waves of artists (to borrow Sellar and Yeatman again) have tried to explain the working North to the playing South by simultaneously *observing* and *aestheticising* it.

Facts and entertainment, apparent opposites, have again and again been yoked together in art works to achieve this. The Documentary Movement, a pre-war tradition encompassing journalism, photography, film, the novel and painting, is one manifestation of what I have already called the documentary imperative. 'Mass Observation', founded in 1936 by Charles Madge, Humphrey Jennings and Tom Harrisson, was one part of this phenomenon. Comprising in almost equal parts idealism, socialism, artistic eclecticism, modernist experiment, and English eccentricity, it was a continuation in twentieth-century terms of such Victorian investigations into 'Darkest England' as Henry Mayhew's 1851-62 *London Labour and the London Poor.* All such initiatives exhibit a characteristic mixture of horror at, fascination with, and even bemused amusement about, the lives of successive historical underclasses. Add to this a philanthropic (rather than a political) desire to improve the lot of the poor, and you have a powerful cultural cocktail.

The 'Mass Observers' colluding to make *Road* included Cartwright himself. His biographical note encouraged audiences to have faith in his eyes and ears since he 'lives in Farnworth, Lancashire, where he was born'. Several contemporary reviewers noted that he was 'on the dole' at the time of the first production, and this *authenticated* him in a particularly important way. A recent interview with Cartwright shows his own acute awareness of the tradition within which he is located. As he prepared his own production

of *Road*, his interviewer reports him saying: 'Until 1956 ... people were only interested in middle-class theatre. In the 1960s the working class got its head. "Now it's just took a turn back. I don't like it. It's subtle but it's prejudice."' (*The Guardian* 1/3/95).

The theatre audience, too, was constructed as Mass Observers through a promenade production which turned direct address into an effect of naturalistic performance. The audience were positioned as the characters' questioners, just like the real Mass Observers of the 1930s and 1940s and just like 'the Professor' in the play itself. When the character Jerry addresses us in Act 1, for example, he responds to our (imaginary) questions about difference between the 1950s and 1980s:

> And everyone was an apprentice something. Serving your time. Or you could work for more money in the beginning in a warehouse or the railway, but it didn't pay off eventually. Or be a fly-boy and sell toys and animals in the pubs. There was so many jobs then.
> (1986: p. 14; 1990: p. 26)

Jerry's speech functions as an idyllic and nostalgic testimony to set against the Professor's respondents. It also contrasts with Clare's later remarks:

> I filled in a *Honey* quiz last week. 'Have you got driving force?' I got top marks all round. But where can I drive it, Joe? I lost my lovely little job. My office job. I bloody loved going in there you know. Well you do know. I told you about it every night. I felt so sweet and neat in there. Making order out of things. Being skilful.
> (1986: p. 16; 1990: p. 32)

The long monologues/soliloquies in *Road* have something of the quirkiness and eloquence of the Mass Observation oral history of such books as Tom Harrisson's 1976 *Living Through the Blitz*.

In promenade, the terrifying immediacy of all this included a potential for *laughter*, since the behaviour of some of these people is so strange (see, for example, Skin-Lad's speech – 1986: pp. 11-12; 1990: pp. 21-23). This tendency was a feature of some Documentary Film; Humphrey Jennings' much debated 1939 film about working-class amusements *Spare Time*, for example, leaves most viewers uncertain as to how to read the solemn seriousness of the participants in activities such as kazoo-bands. Like Mass Observation's work, our watching can be voyeuristic, or can perversely detach us (like the male audience member Dudgeon and Armstrong constantly catch 'looking at the woman next to him'). It is even possible to find, with critic John Peters, that 'the paradox of too much realism in the theatre is to make you self-conscious'.
(*Sunday Times* 22/6/86)

Whether *Road*'s production style is ultimately accounted a success or failure, it can be safely asserted that the picture frame Main Stage of the Royal Court posed new problems for a production which had so prioritised close encounters. It is difficult for the performer to confront the audience with the same immediacy through a frame, though Cartwright does claim in an introductory note to the 1989 Samuel French edition that his play 'can be equally well served in proscenium or traverse style'. But in May/June 1986 fundamental transformation of the Main Stage at the Court kept *Road* as a promenade production.

Irving Wardle described what was done to accommodate *Road* in his *Times* review of the second production: 'The Court's faith in the play appears from the total reconstruction of the auditorium into a promenade zone extending from the back wall (of the stage) to the edge of the circle' (14/6/86). A large acting area was thus created, with a number of scaffold stages around which the audience moved, their attention drawn to them by voices and/or lighting changes. It was also possible now for some of the audience *not* to have direct promenade encounters, by sitting at the front of the circle. There were also attempts further to extend the life of the 'Road' community, both literally and metaphorically, via new, 'Pre-Show' and 'Interval', sequences (1990: pp. 1-4, 43-45).

The 'Pre-Show' sequence involved action in the street outside the theatre, and conversation in the theatre bar (which became the 'Millstone' pub). In the 'Interval' sequence there was multiple-action, both in the 'Millstone' and in 'Bisto's Disco' in the auditorium. Bisto, a new character, advertised the new attraction during the course of Act 1 (1990: p. 31). Action occurred additionally in the balcony of the theatre (see, for example, 1990: p. 62). All this ingenuity and effort was designed to disrupt any tendency the proscenium location might residually have to induce audience torpor. The *danger* was thus put back into performance. For example, the ritual of the interval drink could not but be disrupted by another new character, Tom Stanley, and his raffish cabaret (1990: p. 44). Both Scullerys, Edward Tudor-Pole and his replacement Ian Drury, were former punk singers, and they sang in Stanley's cabaret to a karaoke backing, while the actresses in the company formed 'the Electric Clutch' – a disaster-prone group of go-go dancers. The comic ineptitude again recalls Jennings' *Spare Time*.

New scenes were added – for example, a scene between Louise and her Brother (1990: pp. 5-7) – and some scenes were extended. Dor and Lane's brief original dialogue (1986: pp. 21-22) was developed into a scene in a chip shop run by more new characters, Manfred and Scotch Girl (1990: pp. 46-47). Dor and Lane (intertextual as they are with the 'Fat Slags' of *Viz* magazine) embellished further the humour of the piece. There were other, more minor, changes. In the Upstairs version, Scullery had acted as a more-or-less genial guide and narrator to his community, at one point even becoming a kind of Brechtian verbal-placarder. In the Main House version, some of his

introductory functions were redistributed – the Professor, for example, introduced himself (1990: p. 18). But in general, the anarchic community of *Road* was wittily reinforced against the potentially homogenising tendency of the Main House stage and auditorium.

The inherently non-realistic concept of doubling was part of both stage versions, but this in itself did not interrupt the realism, as can be seen from Michael Ratcliffe's observation that 'an outstanding ensemble of seven performs Simon Curtis' production from the back of the stage to the back of the stalls and up through the balcony and circle with exuberance and authenticity worthy of the Court at its finest'. But contemporary reviewers' frequent use of the term 'surreal' should alert us also to the counter-realist aspects of *Road*. The combination of real and surreal, firmly embedded in the language, was probably what persuaded Alan Clarke of the play's potential. Like the stage *Road*, his film went beyond simple social realism, but in a contrasting, and certainly less humorous, way.

THE TELEVISION *ROAD*

What made the stage *Road* such a critical success was clearly the *authenticity* of the language and the playing, allied to the *immediacy* of the promenade staging. John Caughie has argued that 'the effect of immediacy, of a directness which signifies authenticity is one of the characteristics which gives British television drama its specific form'. He contends that it is a distinctively *literary* quality which distinguishes British television drama from American cinema and telefilm realism (see Corner, 1991: p. 23). Television drama in Britain has always 'tended towards the literate rather than ... the visual' (p. 32). This text-fixation may be due partly to an institutional reliance in television on personnel who often begin their careers in theatre. There has been a particularly close synergy between television, film, and the Royal Court from Tony Richardson to Simon Curtis Lines of development in TV and film intersect with the post-war dramatic tradition at the Court and, just as the documentary films of the 1930s and 1940s had claimed to be the social conscience of the nation, so the new stage and screen drama made similar claims in the post-war world.

The Royal Court-inspired Woodfall Films helped to put the 'new reality' on cinema screens in the late 1950s/early 1960s. The worlds depicted by films like *Look Back in Anger* (1959), *Saturday Night and Sunday Morning* (1960), *A Taste of Honey* (1961), and *This Sporting Life* (1963) were harsh ones in which the post-war settlement was delivering, not the dreamed-of social equality and contentment but meaningless toil, depressing surroundings, limited prospects, blighted lives.[9] The style in which these films were made was based partly on the documentary realism established by the John Grierson school of filmmakers between the wars. Grierson always argued that, but for him, the working classes would never have been represented on screen at all (see

Sussex, 1975: p. 194). The BBC provided direct continuity with the 1930s tradition through its appointment of Paul Rotha as its Head of Documentary in 1953.

The post-war tradition, however, showed both continuity and change, especially as boundaries between 'documentary' and 'drama' blurred. In particular, location work with more and more portable cameras, in more and more 'natural' lighting, was to predominate in both genres, allied to editing techniques which prioritised the 'eye witness' point-of-view. In drama, the acting style, too, stressed understatement and detailed observation, qualities so much part of the Court house-style. It is no exaggeration to suggest that the Court re-inflection of Grierson for the post-war world resulted in a new view of the Faces of the North. Stuart Laing has contended that *Room at the Top* in 1958 did for cinema what *Look Back in Anger* did for the theatre – it put the 'representation of working-class life' onto the cultural agenda (1986: p. 117).

By the 1960s, the claims of the junior medium, television, to be dealing as seriously as film and theatre with the major social issues of the day were well established in both commercial and state-funded sectors. The social-realistic thrust of the post-war years can be seen in single dramas like *Cathy Come Home* (BBC, 1966), and in series like the BBC's *Z-Cars* (1960-78) and Granada's *Coronation Street*. While it is hard to credit now, given that series' ineffable present cosiness, this started out in 1960 as a grittily-realistic, Slice-of-Northern-Life. By the 1970s, television workers like Ken Loach and Tony Garnett had secured a major tradition which went on to make significant critiques of Britain into the 1970s and beyond.[10] It is this tradition to which Alan Clarke belongs.

His *Road* can be seen as a play for its day in television terms, continuing a tradition of articulating the trials of the oppressed working class. *Road*'s highlighting of urban poverty in order to contrast it with triumphalist times was as potent on the screen as it was on the stage thanks to the vision of Alan Clarke. All the play needed was a transformation which permitted the paradoxical intimacy/distance of promenade production to be transposed to an atomised situation in which the 'audience' is large but individualised. This transformation was facilitated by Alan Clarke's use of the (then) revolutionary 'Steadicam', which was the last piece of technology he needed to complete his own oeuvre.

Alan Clarke's career fits the template of post-war times. A northern provincial in origin (Liverpool), he was educated in the climate produced by the Butler reforms of 1944. After an apprenticeship in theatre and commercial television in the 1960s, his years at the BBC were the years of *The Wednesday Play* (1964-1970) and *Play for Today* (1970-1984). During these times, television drama forged its claims to be capable of dealing with the real via new, enabling, camera and microphone technologies which freed drama from the constraints of the studio. After Clarke's death in 1990, Andrew Clifford compared the BBC in the director's formative years to a US film industry which in the same period (the early 1970s) produced Martin Scorsese and Francis Ford Coppola:

> In Britain, development in another kind of studio system, the BBC's, enabled
> writers like Roy Minton, Colin Welland, Peter Terson, David Rudkin and David

Mossie Smith as Carole, Neil Dudgeon as Brink, Jane Horrocks as Louise, and Bill Armstrong as Eddie, in *Road* (1987/BBC2).
Photo courtesy of BBC Photo Library.

Hare (to name just a few Clarke worked with) to flourish, together with directors like Les Blair, Roland Joffé, Stephen Frears, Philip Saville, Mike Leigh – and Clarke himself.
(*The Guardian* 16/7/91)

Other dramatists listed in the entry on Clarke in Catherine Itzin's *Directory of Playwrights, Directors, Designers* are Alun Owen, Edna O'Brien, E.A. Whitehead, Brian Clarke, David Leland and David Yallop (1983: p. 125). This Royal Court-type roster of post-war social realistic writers indicates one reason why Clarke was one of a handful of directors who made their reputation with socially and politically conscious work in the 1970s and 1980s – he knew good writing when he saw it.

Clifford notes, too, that he 'established a new genre: the original single television drama - distinct from its relations, the cinema film and the drama series'. Marginalised following the BBC's banning of *Scum* in 1978, Clarke continued to make his distinctive individual films for television until his death, exploring in particular the bleak lives of alienated modern individuals through innovative use of new technology. Frequently he chose to depict violence: as in *Contact* (BBC2, 1985) and *Elephant* (BBC2, 1989) – on sectarian killings in Northern Ireland, and in *Made in Britain* (Central TV, 1983) and *The Firm* (BBC2, 1989) – on gang violence. His visually-orientated films tended to downplay dialogue, becoming a kind of overstatement of Basil Bernstein's 'restricted code' theory (itself a product of the post-war world). *Contact,* for example, has minimal dialogue; *Elephant* has none whatsoever. The latter follows para-military death-squads around on their grisly missions amidst bleak post-industrial landscapes, one wordless assassination following another. Clarke tries to give the television audience a visceral understanding of the horror in a way undreamed of by news coverage – by emphasising eyes and their witnessing, giving us a direct point-of-view *without verbal explanation.* It constitutes a conscientious attempt to press the ordinariness of modern murder onto its audience, without the audio gloss of newscaster commentary, or any of the intertextual knowingness of recent films such as *Pulp Fiction* and *Natural Born Killers* (both 1994).

The concept of parallel watching-realities so important to the stage *Road* is there in the telefilm precisely because it was a Clarke trademark anyway. But he eschewed the humour manifestly present in stage performance in favour of his own savage visual aesthetic. Of necessity, he had to go for an essence of the play as written, since he was working to a time-slot about half the length of the stage play. Of necessity, too, he had to balance image with text more than in some of his other work because the nature of Cartwright's text *compels* a verbal dimension. What makes his *Road* so good (and so different from his other, linguistically-reduced, telefilms of the 1980s) is the way his camera manages the *literary* nature of Cartwright's text.

Mossie Smith (with Susan Brown the only cast member to play in all three versions) remarked approvingly that it was only with Clarke's television version that she was able to

explore *one* character, thus bringing 'a couple more dimensions to [Carol]' (BBC2 *Open Air* 8/10/87). The reinforcement of naturalism (by hermetically sealing the identification of actor with character) is pleasurable both to an actor committed (as most are) to realist modes of performance and 'depth psychology', and to an audience for whom these are staple features of drama. At this level, Clarke was making the play *more* realistic. But at another, he reinforced the tendency of the play to move beyond realism.

Many of the monologues/soliloquies had to be cut, but enough are preserved to be representative. Jerry's and Valerie's monologues are conveyed in their entirety, at daring length considering the propensity of television drama to aspire to the (visual) condition of the film and to subordinate the word to the image. Words are balanced against images through their common, weird, real/not real quality in the film. As Clarke argued at the time, 'the actuality of the real environment ... in its semi-derelict form was a kind of expression of how [the characters] felt internally' (*Open Air* 8/10/87). The *mise en scène* both heightened and subverted, rather than simply supported, the realism. The result was that the images achieved something of the supercharged quality of the language

The location, a deserted area in Darlington which was due for demolition, was eerily *empty*. The characters in the teleplay are the only 'people' we actually see (and, as in the theatre production, they are real-and-not-real). The background of back-to-back terraces and cobbled streets is real enough, but is so de-populated in comparison with such areas of nineteenth-century housing as we might know them, that the effect was of a kind of permanent Sunday. This effect, one could argue, arises from denying a place its original *raison d'être* – work. The late-twentieth century's erasure of once-bustling areas of economic importance was thus eloquently visualised as well as dramatised. The nuanced exterior bleakness was matched, too, by the bare and stripped interiors of the houses, in their pre-demolition state these too were literally de-humanised.

Perhaps the fact that Clarke didn't see the stage play helped his central perception of a terminal social decline gone beyond humour. Had he seen the stage *Road* in any of its early variants, he would surely have been aware of the literal as well as metaphorical gloom of this crepuscular representation of 'a good night out'. And yet he refused the night time shooting for which the script so manifestly calls, choosing instead to film entirely in daylight conditions. This adds a further surrealistic dimension to the bizarre 'out of time' quality already supplied by the derelict location.[11]

The film's treatment of Jerry (actor Alan David, who had also played the part in the second stage version) offers an example of Clarke's transformation of *Road*. We first see Jerry in one of the stripped and bare interiors, getting ready for his night out. He is brushing his shoes in a gesture wholly appropriate to his age and National Service history, and he looks through the camera, as it were, straight into our eyes. This kind of direct address is the televisual equivalent of promenade staging. It is also very unusual for television drama: to take such a risk calls a key observational bluff of broadcast television.

Usually, the camera is ignored by actors, and the audience is thus constituted as outside the realm of the art work. Jerry and the other characters in *Road* bring us into the action by drawing us through the frame. That they do so *in character* distinguishes them from those who are, normally, permitted to address us directly on television.

The technique is heightened further when the Steadicam follows the characters in long tracking shots in the streets outside their bleak rooms. Producer Andrée Molyneaux revealed that cameraman John Ward had had to walk backwards for four-and-a-half miles during ten takes of one shot in *Road* (*The Guardian* 3/10/87), but the experience of the shot in performance is the 'we' move smoothly and easily alongside 'them'; we *accompany* the characters. Thus Jerry confides in us as he walks to the pub/club where he is to spend the evening. He turns his head to his left and addresses us for a large part of his monologue (1986: pp. 13-14; 1990: pp. 26-27). He smiles constantly, trying pathetically to be friendly. The continuous tracking shot lasts just short of three minutes. In a significant cut, for television is not without its (self) censorship still, the imprecation 'Fucking hell' is cut from his final line. This relationship, of audience elevated to the status of friend or companion, is repeated elsewhere in the film (for example, for Valerie's speech – 1986: p. 25; 1990: pp. 54-56). Ultimately, it confers a kind of *privilege* on the audience.

Interior scenes replicate the strangeness of the real/not-real world outside – the 'estrangedness', for it is very precisely the familiar transformed in Clarke's sur-real documentary camera-work. The pub/club scene, extrapolated from the Main Stage version's attempt to reproduce the environmental quality of promenade performance during the interval, is turned into a nightmare place of Hogarthian pleasure. The representation of 'a good night out' reaches beyond simple documentary realism: bizarrely, a fire eater goes through his act in one corner of the 'room', and is applauded half-heartedly; elsewhere, people dance mechanically to fuzzy recordings of Tamla Motown; Jerry, as far away from the mirror-ball dance hall of yesteryear as can be imagined, sits bemused but still smiling; Helen (Susan Brown) begins to eye up the drunken soldier (Tim Dantay) who will later vomit as she attempts to seduce him (1986: pp. 22-24; 1990: pp. 49-52).

Following its observation of this scene, and inexplicably, Clarke's camera suddenly jerks away from this Dante-esque circle of hell to a close-up of a filthy lavatory pedestal standing, without surrounding walls (and without explanation), at one end of this hideous room. Such an eloquent poverty of design is what you get, of course, when you take over a demolition site, but in dramatic terms it blows apart the tidy referential codes of social realism, re-siting the scene beyond humour and beyond reality. It is at such points as this that Clarke's *Road* stands most clearly revealed as not simply the dystopian *Coronation Street* remarked on by several theatre critics in their reviews; it becomes more like the Granada soap's mad twin. The intertextuality of Clarke's 'Millstone' with 'The Rovers Return' derives from their common simulation of back-street Lancashire

pubs. Those who have never in their lives entered such a place will take their measure of Clarke's scene partly from the equally un-real Rover's Return. Both are part of a cultural dreaming about the working class, both mediate the faces of the North by aestheticizing them in very different ways. *Road*, however, is a twin 'mad north-north-west', so to speak. In Clarke's version, shorn of much of the humour, its hyper-real relation to any actual location in England's North West modulates into a brooding concern about the state of the nation in the 1980s.

As David Leland remarked before the screening of *Road* in 1990, Clarke's was a distinctive contribution to post-war television. It was precisely of the kind that has made British television, in Leland's words, 'the envy of the rest of the world'. *Road*, he argued, was an enactment of the BBC's historic public service commitment, now under threat from market-force ideology. Part of this public service claim has been a regular monitoring of the faces of the poor. The articulation of a classic post-war social *concern* about a dispossessed class fraction has taken place in and through culture.

Martyrdom of the underclass has a very long history in British society, and interest in the surveillance of this phenomenon is part of an on-going 'sussuration of class guilt' (the phrase is E.P. Thompson's – 1973: p. 34). The drift from the political aspect of this surveillance to the aesthetic is a commonplace in English culture, and David Hare for one defined the Royal Court as 'primarily an aesthetic, not a political' theatre (see Findlater, 1981: p. 142). The class fraction known for many years as 'the working class' has become progressively harder to define, so let us for the purposes of concluding this chapter know them by their cultural signs. Terry Browne remarks that the major success of *Look Back in Anger* was that it demonstrated 'that plays dealing with lower class characters speaking a non-standard English ... could actually become profitable theatrical ventures' (1975: p. iv). Both the BBC and the Royal Court have played a key cultural role in helping a nation in decline talk to itself about its progressive industrial and social decay. With *Road* we see a continuing fascination with the 'faces of the North' clearly enough; but their relief through social transformation is long deferred.

NOTES

1. Cartwright received the George Devine award, also awards from *Drama* and *Plays and Players* in 1986, and the Beckett award in 1987. Clarke received the 'Golden Nymph' award at the Monte Carlo Film Festival 1987.

2. Cartwright's subsequent work includes *To, Bed* (London: Methuen, 1991) and *The Rise and Fall of Little Voice* (London: Methuen, 1992).

3. Simon Curtis has been Executive Producer of BBC2's 'Performance' series since 1991. This strand of single play programming focuses in particular on the adaptation of stage texts for television (see Jeremy Ridgman's interview with Curtis, Chapter 13 of this book).

4. In recent times, there has been yet further extension, into Stafford-Clark's new 'Out of Joint' company.

5. See Susanne Greenhalgh's chapter on *The Mysteries*. Ann Jellicoe's first 'community play' was *The Reckoning* in 1978. See her *Community Plays* (London: Methuen, 1987) for further details.

6. Not everyone liked *Road*'s staging. Victoria Radin, reviewing the Upstairs production for *The Guardian*, called it 'Simon Curtis's promenade – or scrum – production' (7/4/86). See Rob Ritchie for Bill Gaskill's description of *The Speakers* as directed in 'what is now known as a promenade manner' (1987: p. 102). Michael Coveney pointed out the connection between *Road* and *The Speakers* in his review of the *Main House Road* (*Financial Times* 13/6/86).

7. This chapter will provide page references to both Methuen editions of *Road*.

8. Reviews of *Road* made several comparisons to other works: strongly represented were *Coronation Street*, *Under Milk Wood* and *Our Town*. *The Daily Telegraph*'s John Barber even discerned echoes 'reminiscent of Goethe's Walpurgisnact [sic] and Joyce's Nighttown' (14/6/86).

9. *This Sporting Life* was a Rank/Independent Artists (not a Woodfall) film, but it was directed by Royal Court director Lindsay Anderson.

10. Loach and Garnett, often with writer Jim Allen, made 'state of the nation' films like the four-part *Days of Hope* (BBC/Polytel, 1976).

11. David Leland revealed that Clarke had not seen the stage version when introducing the television *Road* during the BBC's 1990 retrospective of Clarke's work. When Cartwright himself directed the play at the Octagon, Bolton in 1995, he chose to stress the humour of it more than either Curtis or Clarke.

BIBLIOGRAPHY

Primary Texts:
Cartwright, J. (1986) *Road*. London: Methuen.
Cartwright, J. (1989) *Road*. London: Samuel French
Cartwright, J. (1990) *Road*. London: Methuen.

Secondary Texts:
Billington, M. (1993) *One Night Stands: A Critic's View of the British Theatre from 1971 to 1991*. London: Nick Hern Books.
Browne, T. (1975) *Playwright's Theatre: The English Stage Company at the Royal Court Theatre*. London: Pitman.
Bull, J. (1994) *Stage Right: Crisis and Recovery in British Contemporary Mainstream Theatre*. London: Macmillan.
Cave, R.A. (1987) *New British Drama on the London Stage 1970-1985*. London: Colin Smythe.
Corner, J. (ed.) (1991) *Popular Television in Britain: Studies in Cultural History*. London: BFI.
Craig, S. (ed.) (1980) *Dreams and Deconstructions: Alternative Theatre in Britain*. London: Amber Lane.
Findlater, R. (1981) *At the Royal Court: Twenty-Five Years of the English Stage Company*. London: Amber Lane.
Itzin, C. (1980) *Stages in the Revolution: Political Theatre in Britain since 1968*. London: Eyre Methuen.
Itzin, C. (1983) *Directory of Playwrights, Directors, Designers 1*. Eastbourne: John Offord.
Jellicoe, A. (1987) *Community Plays: How To Put Them On*. London: Methuen.
Laing, S. (1986) *Representations of Working-Class Life*. London: Methuen.
McGrath, J. (1981) *A Good Night Out: Popular Theatre: Audience, Class and Form*. London: Eyre Methuen.
Ritchie, R. (ed.) (1987) The Joint Stock Book: The Making of a Theatre Collective. London: Methuen.
Russell Taylor, J. (1969) *Anger and After: A Guide to the New British Drama*. London: Methuen.
Sellar, W. & Yeatman, R. (1961) *1066 And All That*. Harmondsworth: Penguin.
Stafford-Clark, M. (interviewed by T. Dunn). 'A Programme for the Progressive Conscience': the Royal Court in the 'Eighties', *New Theatre Quarterly* Vol.I, no.2 (May 1985) pp. 138-153.
Sussex, E. (1975) *The Rise and Fall of British Documentary*. London and Berkeley: UCLA Press.
Thomson, E.p. & Yeo, E. (eds.) (1973) *The Unknown Mayhew: Selections from the 'Morning Chronicle' Letters 1849-50*. Harmondsworth: Penguin.

ALTERED IMAGES: THEATRICAL AND FILMIC SPACE IN *TOP GIRLS*

VAL TAYLOR

> However significant the temporal structure of the performance, there is good reason for arguing that the theatrical text is defined and perceived above all in spatial terms ... The performance itself begins with the information-rich registering of stage space and its use in the creation of the opening image ... Even with the unfolding of the time-bound theatrical discourse, these constraints remain the primary influences on perception and reception.[1]

In a Western theatrical culture which is predominantly logocentric, it is provocative to assign priority in the hierarchy of theatrical languages, as Keir Elam does, to those systems which appertain to the (mute) organisation of space over those appertaining to the spoken word. This raises the status of the theatrical means by which space is organised – set design, lighting design and the blocking of actors' movement – and validates the spectator's engagement with issues of space, and movement in space, as *narrative* issues. In this respect, there is a consonance between the functioning of spatial composition in theatre and in cinema; as Stephen Heath observes:

> ... composition will organize the frame in function of the human figures in their actions; what enters cinema is a logic of movement and it is this logic which centres the frame. Frame space, in other words, is constructed as narrative space.'[2]

Such narrative functioning allows meaning(s) to be encoded directly in spatial compositions; that is, it allows the creation of a *discourse of space*. It is interesting, therefore, to speculate whether or not the translation of a dramatic text from its 'parent' medium (theatre) to a medium for which it was not originally conceived (television), may alter, reinforce or even subvert this particular discourse, where the playwright has made especial use of it. (I refer not to taped versions of theatrical productions, which are a somewhat different matter, but to new productions of theatrical texts for the television studio.) I shall take as a case-study

Caryl Churchill's *Top Girls*, originally written for the Royal Court Theatre, London, and premiered there in 1982, and its 1991 studio-based production for BBC2's *Performance* series. It seems to me a text which makes profound structural use of a discourse of space, extending far beyond a general thematic level. It is also a productive performance text upon which to test this speculation, since both the original stage production and the television version shared the same director – Max Stafford-Clark. Though the set designers differ – Peter Hartwell for the Royal Court, Paul Munting for the BBC – the continuity of Stafford-Clark, who worked with Churchill to develop *Top Girls* at the Court, suggests a potential consistency of directorial reading of the text across the different media. Significant differences in meanings which arise from the two productions may thus be argued to reside in the nature of the two media and their respective articulations of space, rather than in a simple change of creative personnel.

The term 'space' is, of course, complex in theatrical drama, in that two distinct kinds of space are in play: actual space – the material environment within which the performance occurs, particularly the stage and auditorium – and fictive space, the imaginary environment inhabited by the narrative. Actual space – in the case of *Top Girls*, the Royal Court Theatre – is usually a constant during the performance; one might debate this in the case of promenade performance, or street theatre, but generally it is the case in most fixed-feature playhouses, particularly proscenium houses. Fictive space, on the other hand, is inconstant, shifting locale as the narrative demands: in *Top Girls*, the discontinuous locations range from a private room in a restaurant, to an interview area and the general office in the Top Girls Employment Agency, to a makeshift garden shelter in Joyce's Ipswich back-yard and Joyce's kitchen.

This interplay between spatial continuity and discontinuity is a theatrical hallmark, and works perpetually to remind the spectator of the tension between reality and realism. For some playwrights, and productions, the discrepancy between the reality of the stage/auditorium and the essential unreality of the fictive space(s) is the foundation of the discourse of space; the methods by which the spectator is constantly provoked into engaging with this discrepancy constituting a major syntactical system. Within that system, the functioning of the onstage/offstage convention looms large, challenging or inviting the spectator to accept or reject the 'continuation' of the diegetic world beyond the visible confines of the stage; a decision dominated by the techniques of realism.

Bridging the two kinds of space, set design, lighting and actors' blocking employ such tools as mass, volume, scale and graphic direction, and in the actors' case, kinesics and proxemics, sometimes in counterpoint, sometimes in complement, to reconcile the thematic requirements of fictive space with the architectural limitations of actual space. The most powerful determinant in this reconciliation is the architectural relationship between the stage and the auditorium, which may be fixed or variable, working either to increase or to diminish the degree of distance between spectator and performer: spectator and *fiction*. Often, a play is written without prior knowledge of the architectural space which will

house its premiere performance (and it is of course the hope of the playwright that production will not be limited only to one theatre!). But when a play is commissioned by a theatre, the architectural configuration of the space is known, and may become a factor in the conception of the fictive space, either consciously or unconsciously; may, in short, contribute significantly to the creation of a discourse of space embedded within the play itself.

The issue of actual and fictive space is somewhat complicated in the case of studio-based small-screen drama. The material environment within which the performance of the fictional narrative occurs (actual space) ought, perhaps, to correspond to the television studio. But the same concept of a constant relationship between stage and auditorium no longer holds, for the television spectator is not housed within the same architectural space as the performance.[3] The performance space is also governed by the frame of the camera in a manner not available in theatre. So, 'actual space' in small-screen drama refers more to the constant limits of the flat television screen, which reproduces itself for the spectator as the boundaries of the camera frame: that is, when the spectator is aware of anything approaching a notion of 'actual space' at all. Generally, attention is not consistently drawn to those boundaries, and so the presence of 'actual space' becomes a largely irrelevant concept.

'Fictive space' must similarly acknowledge the extent to which the imaginary environment inhabited by the narrative is mediated by the camera frame. The onstage/offstage convention of theatre becomes on-screen/off-screen, a complex and unstable convention requiring constant 'reminders' to the spectator, reminders which depend upon the establishment of an over-arching, usually realistic, spatial logic. In the classic Hollywood model of scene construction, which tends also to be the standard televisual model for realist drama, the core element in establishing and maintaining such a logic is the master shot: a long, or possibly wide, shot which clarifies the composition of space and spatial relationships. Unlike the theatre's continuous interplay between the reality of the architecture and the shifting nature of the diegetic world, the screen offers no comparable perceptual constant: classic Hollywood narrative realism works to displace the spectator's sense of the screen through the point of view system, which denies, or relegates to insignificance, the spectator's occupation of actual space, drawing him/her 'into' the narrative (fictive) space.

Though the use of the iterated master shot allows the spectator to internalize the scenic geography, the sense of off-screen space is, as Heath suggests (quoting Burch) 'intermittent or, rather, fluctuating', in a manner significantly different from theatre.[4] The discourse of space is, in this comparative instance, missing a core structural element of its grammar. If a stage play carries meanings encoded within such a specifically *theatrical* discourse of space, then the subsequent absence of a key element of its grammar may be sufficient to modify or to subvert the reception of those meanings. I believe Churchill's *Top Girls* to be such a case.

To test this hypothesis, it is instructive to consider human perception and construction of space in the real world. I am particularly concerned with the perception of spatial depth through the phenomenon of perspective, the subjective illusion in which objects appear to diminish in size as they recede from the spectator's viewing position. What we see could not properly be described as a *distortion*, since objects thus viewed are not misrepresented; rather, they may be deemed to be *displaced*, by the perceptual act. By this, I mean that such objects are accurately represented given the circumstances under which they are being viewed; the determinant in those circumstances is the spatial position occupied by the spectator in relation to the viewed. So, while perspective is an illusion, it nonetheless expresses accurately the spectator's perception of real depth in a very precisely defined set of circumstances. What is perceived is as much the impact of space itself as the nature of the objects viewed. The objects function as vehicles for the perception of depth, an exercise in contextualization which also serves reciprocally to inform us about the objects.

Perspective is thus an exercise in relativity and reciprocity, and it is this which allows us to distinguish between distortion and displacement. Each functions by comparison with a supposed 'ideal' model (what we think we know to be the actual nature of the object); distortion is claimed when there is a perceived lack of correspondence, or falsification of correspondence between ideal and example. Displacement is claimed where an accurate correspondence is identified between ideal and example, but variation in appearance is also noted: an acknowledgement of *both* an 'ideal' point of view and the existence of multiple alternatives. The degree of displacement is perceived by comparing the variations in the appearance of ideal and model, occasioned by an alteration in the position of the spectator. What is seen thereby may be classified as a parallax view.

Stephen Heath, in his chapter on 'Narrative Space' (op. cit.) discusses the significance of Quattrocento perspective (the Renaissance formulation of the laws governing the phenomenon, reproduced in contemporary fine art) in the construction of narrative space in film. He draws attention to the notion of a prioritized, 'ideal' view governing Quattrocento compositions, to the central functioning of the 'point of view shot' in echoing this in film, and to the extent to which such a position may be ideologically encoded: 'the ideal of a steady position, of a unique embracing centre … is precisely that: a powerful *ideal* … there is a real utopianism at work, the construction of a code.'[5] In film, the notion of a 'steady position' cannot refer to a *static* position, as it might in respect of, for example, proscenium arch theatre. Film concerns itself with movement; nonetheless, in order to establish Heath's 'logic of movement', the 'steady position' appears as a *constant*. So, in film, the actual position of the spectator signifies less than her/his *positioning*. That positioning may or may not accord with the 'ideal' view; as Susan Sontag suggests, 'movies thrive on the narrative equivalent of … off-centring.' This may be achieved by a disruption of the continuity of space she calls definitive of theatre, to be replaced by the cinematic 'unified point of view that continually displaces itself.'[6] Nonetheless, lurking behind the off-centring and displacement, the issue of an 'ideal', a centre, still remains, in that term 'unified': is still a perspectival issue.

Top Girls (BBC, 1992). Photo courtesy of BBC Photo Library.

If perspective is an exercise in spatial relativity, it may also be an exercise in temporal relativity, giving rise to a perception of 'depth' of time. We are accustomed to speaking of an 'historical perspective'; the spatial term being co-opted as a useful metaphor. But this is not a loose application, since the above arguments about spatial perspective may also be tested in respect of temporal perspective. This allows us to posit the same notions of ideal and displaced 'viewing' in terms of time, and possibly to suggest a variety of interactions between the two. What is clear is that the ground has shifted from perspective as a physical perceptual phenomenon to a consideration of its functioning as a conceptual tool; and in particular, as a potential vehicle for ideological positioning of the spectator. Conceptually, however, perspective functions most successfully when constructed – reified – by application to the organization of physical space, in the semiotics of design, composition and actors' movement; and in the case of theatre, in the relationship between stage and auditorium, between actual and fictive space, towards a dynamic discourse of space: a *dialectic*.

Both Keir Elam, and Amelia Howe Kritzer in *The Plays of Caryl Churchill: theatre of empowerment* (Macmillan, 1991), point to the ideological over-coding which occurs in the architecture of theatre auditoria[7]; in particular, in 19th and 20th century proscenium arch playhouses. Kritzer identifies this with patriarchal ideology, seeing in the fixed separation of stage and auditorium both an image and a reinforcement of the construction of male subjectivity (following Freud and Lacan), in which the relationship between male and female is conceived as an opposition between self (male) and other (female), between the individual and the group. She asserts:

… because masculine subjectivity depends upon identification of the feminine as other…the male elite has appropriated the space, apparatus and products of culture to the on-going project of reifying the repression of femininity and the objectification of women. (p. 7)

She distinguishes between *innate* gendering and appropriation; that is, she suggests that the architecture may be fundamentally neutral, but patriarchally over-coded. I wonder if this is so; it seems to me that, in the proscenium house particularly, there may be grounds for regarding the gendering as inherent. Nonetheless, I agree with her that opportunities for feminist performance to reveal, deconstruct, and subvert this coding clearly exist within such architectural configurations.

For Caryl Churchill, an avowed socialist feminist, the Royal Court Theatre presents just such an opportunity. It is a proscenium house, with a raised stage and clear demarcation between the respective spaces of performer and spectator. The auditorium is not especially large, so the viewpoint of the spectator is relatively homogeneous; the principle 'displacement' occurs when one is seated in the upper rather than lower levels. The perspective – of the actual stage space, rather than any particular set design – is relatively consistent for most spectators; it is perceived generally from a 'steady position'. Kritzer allows us to consider this 'steady position' as ideologically encoded: the 'steady position' of the subject-male in a patriarchal society. This position is the 'ideal'; the feminine is displaced ideologically, and as a physical index of that, also perspectivally.

It is open, therefore, to Churchill to work with this encoded 'frame' of actual space; to explore the phenomena of perspective, distortion, displacement, parallax within the fictive and narrative spaces of *Top Girls*. The frame will remain throughout as a constant, contextual, indexical reference for the patriarchal ideal, a fixed point by means of which the 'angle of displacement' may be calculated. The spectator is not only placed perspectivally by the architecture in a position which is unified, but also 'positioned' ideologically; assigned a role within a patriarchal discourse which here expresses itself spatially. The stage/auditorium division expresses an image of masculine subjectivity; Churchill may develop this by harnessing the physical distance and distinctness to highlight the objectification of the women characters: the extent to which they are 'off-centred'. It is my contention that this is in fact what she does: we are not invited to identify or to empathise with these women, but rather to observe them – to see them *in perspective*.

Essential to the creation of this sense of distance is the pictorial framing of the proscenium arch, which reiterates for the spectator the sense of observing an image rather than a reality, yet at the same time provoking a sense of the dialectic *between* image and reality. This mirrors the dramaturgy of Act One.[8] The opening image is solid contemporary realism – 'Restaurant. Table set for dinner with white tablecloth. Six places.' (55) – a technique which is consistent throughout the play for each locale: the Top Girls Employment Agency office and interview area, Joyce's Suffolk kitchen and backyard with

Angie's and Kit's makeshift shelter. The convention signals a realist drama, consistent with the usual social realist Royal Court style. The spectator is invited to begin to disregard the theatrical frame, to commence a potential empathic engagement with the two characters present at the outset: Marlene and the Waitress.

Suddenly, disconcertingly, a woman enters, in Victorian dress: Isabella Bird, rapidly followed by Lady Nijo, in full Japanese kimono; Pope Joan in period ecclesiastical robes and Dull Gret, in helmet, pinny and breastplate; and finally, Patient Griselda in medieval wimple – an image both from history and story-book. The realism is disrupted, as each woman is introduced ('placed' historically, geographically and culturally) and begins to interact with her fellow dinner-guests. Displaced, rather than distorted: for each is *presented* entirely realistically, despite Griselda's and Gret's fictional status and Joan's questionableness ('I'm a heresy myself.' [60]). Each has her own visual and verbal idiom, consistent with her particular nature and condition: with her 'given circumstances'.

Clearly, the nature and assumptions of theatrical realism are being challenged: we cannot read these characters realistically, yet it is also not possible to disregard their presentation. We become aware of the dialectic between actor and role, as between actual and fictive space (Royal Court stage and 'Restaurant'); a dynamic series of transactions which is further developed by the structured doubling of roles, inviting intertextual propositions between each actor's role-sequences. The theatricality of the Act One characters plays off the reality of the actors, and demands that we shift our perspective continually, particularly in constructing perceptions of more straightforwardly 'realistic' characters – Marlene, Joyce, Angie, Kit, Win, Nell, Jeanine, Louise, Shona, Mrs. Kidd and the Waitress.

As character displaces character, scene by scene, overlaid upon the same pool of seven actors, it becomes apparent that the nature of character and role is being interrogated. These are not type figures; they don't embody one particular set of characteristics, or positions. But nor are they unique, rounded individuals, utterly different and distinct from each other. The pattern of overlapping, symphonic dialogue created in Act One weaves perpetually displacing patterns of relationship between and across the six diners; a patterning and a methodology which alerts us more acutely to the shifts and re-formations between the Acts Two and Three characters. Just as character displaces character, so speech continually displaces speech. Not, as has often been suggested, demonstrating that the women ultimately don't listen to each other, but precisely that they *do*: the symphonic weave is impossible without it. What emerges from the ebb and flow of intellect and emotion is an awareness in the spectator of the lack of a fully developed common language between all the women characters: a language which encompasses and expresses both their shared experiences and the wide gulfs of difference, in the details of, and in their individual responses to, those experiences and situations.

Throughout, one impression is paramount, of the dialectical forces operating upon and within these women: centripetal, drawing them together in a powerful drive towards com-

munality; and centrifugal, social and individual attitudinal pressures impelling them to the margins, away from each other. Here, the spatial constant of the stage frame anchors both forces: the unified physical perspective centripetally focusing the spectator in upon the actors, just as the characters cluster together around table and desk, or huddle in tiny make-shift refuges amidst a barren garden. Here, within the constant of actual space, fictive spaces continually displace and overlay, montaging one upon another, interrogating and informing each other: table and desk suddenly become related points upon intersecting axes, as do kitchen, office and shelter.

Throughout, the spectator is physically held outside the fictive space by the proscenium arch; receives the succession of pictorial images which are composed, are *presented*, for frontal viewing. That is, for viewing from the ideologically encoded subject-position to which the theatre architecture has assigned the spectator. From that 'steady position', which is constructed by the actual spatial continuum between stage and auditorium, the ideological continuum which eternally displaces the women is also objectified. And we notice that the women are not simply passive victims of displacement, but occupy a range of positions upon that arc: actively displacing themselves, as Isabella and Nijo and Joan do; actively displacing others, as Marlene, Win and Nell do; or holding/standing their ground, as Griselda, Gret and Joyce do, with varying degrees of willingness.

Top Girls needs this constant transactional interplay between actual and fictive space, grounding and physicalizing the parallel dramaturgical techniques which perpetually shift the point of vantage upon character and situation. It needs this because it is a play about ideological positioning whose most powerful motifs are those of movement and mobility, associated with notions of freedom, and their opposites: stasis, immobility, confinement. The play abounds with stories and the vocabulary of travel: Isabella and Nijo were actual travellers; Nell encapsulates this restless spirit when she says 'I've never been a staying-put lady. Pastures new' (100). Counterbalancing this are stories and the vocabulary of domesticity: Griselda's movement between her father's cottage and the Marquis' house; Gret's front door, the boundary between home and Hell; the contradictions between Joyce's 'Who says I wanted to leave?' and 'How could I have left?'

The perspectives upon travel and confinement continually shift and re-align, perpetually exposing criss-crossing fault-lines. Isabella, for whom travel was an adventure ('What lengths to go to for a last chance of joy.' [83]) suffers homesickness, and an enduring sense of displacement from her native Tobermory; Nijo becomes an itinerant Buddhist nun because she has been sexually and socially discarded by her Imperial master. The go-getting career women travel – or plan to – to America, Mexico, Australia, yet return with little but unease, and further restlessness. The talk is always of leaving or staying, of coming to and going from; of physical, mental, emotional movement or stasis, freedom or confinement – never simply one or the other, distinct, separate, but interwoven, perpetually dissolving into and displacing each other.

And extraordinarily, this discourse of spatiality, which resonates trans-historically, trans-geographically, trans-culturally and trans-socially, is dramatised in the most static of plays. *Top Girls* doesn't really 'move' at all. It is a succession of tightly-restricted tableaux, in which physical movement is relatively minimal: a gaggle of dinner-guests seated at a long table; formally seated one-on-one interviews; informal across-the-desk banter; squashed-together squabbling in a ramshackle hut; blazing, no-holds-barred rowing across the kitchen table. Because each set-piece is relatively still, what movement there is, signifies strongly: the Waitress' submissive trotting back and forth to serve the diners; Angie's dithering between garden and bedroom, Suffolk and London; the entrances and exits of Mrs. Kidd and Joyce, both after rows with Marlene, Mrs. Kidd rejected, Joyce, rejecting; Marlene's entrances and exits.

What moves is the argument, continuously displacing itself, continually centring and off-centring first one character, then another; but it does so within a constant, unchanging actual framework. In this sense, the dialectic between movement and stasis is itself perpetually in motion, always unresolved; as is the ideological process of positioning, upon issues of gender, class, economics, religious faith, political belief and policy, which it emblematizes. It is critical, therefore, that the spectator is subjected to the *total* process: confined by the architecture to a static, but unified and homogenized point of vantage; positioned by the patriarchal ideology of which it is an image and a result; but at the same time, intellectually in motion, opinion and attitude forced continually to displace and overlay one another. It is also critical that that 'steady position', with its concomitant distance, should not be compromised; for in order to 'measure the angle of displacement', it is, I think, essential that the spectator can always perceive the relativity between the positions – can choose to look at and listen to any one woman at the dinner party, yet cannot but keep the whole group within the range of peripheral vision. The spectator is active therefore in the process of selecting the point of view, as s/he is active in the ideological process of positioning.

That is, I think, the problem with the transfer of *Top Girls* to television: out of sight, out of mind. As I suggested earlier, the techniques of classic Hollywood narrative cinema – and by adoption, of realist television – work to deny the spectator's sense of the reality of the screen and the camera frame, with the purpose of drawing her/him 'into' the narrative (fictive) space; that is, in order to promote identification and empathy with the characters. I also suggested that in order to achieve this the establishment of an over-arching, realistic spatial logic is required, centred upon the master shot, allowing the invocation of the point of view system – denying, or relegating to insignificance, the spectator's occupation of actual space. And as I have argued above, the spectator's awareness of her/his occupation of actual space is central to *Top Girls*, to the creation and maintenance of distance between spectator and fiction, promoting the possibility of viewing the women both subjectively *and* objectively.

This causes disruption to the dramaturgy. If we examine the Act One dinner party, it is possible to perceive this disruption. The locale is fully realized: a private dining room with high windows, a fountain, a central circular whiteclothed table, and, dominating the entire left of frame, the sweep of a staircase which leads the eye in an inward-curving arc from the left upper foreground to the iterated curve of the decorative marbled floor and the table. The whole has an Art Deco appearance, and a strong sense of place. The circularity of the table excludes any position for the spectator; it is an hermetic location, a perception that is reinforced by a series of movements during the scene in which the camera obsessively (and dizzyingly) circles the ring of diners. This 360° view denies any sense of artificiality about the set: denies it as set, promoting it *as* a reality.

The problem is the spectator's position within this 'reality'. Whereas in the theatre, the spectator occupies a given place within the actual spatial continuum, but is distanced architecturally and aesthetically from the fictive space(s), here there is a confusion. The actual space of the television screen is technically denied, and there is in any case no actual spatial continuum between performance space and spectator space; and the apparent 360° set offers only a sense of closure, of exclusion. The role of observer is pre-empted, and instead, the familiar televisual techniques of subjective identification are employed, to bring the spectator 'into' the fiction and the fictive space through the point of view system.

The issue here is the construction of subjectivity. Stephen Heath articulates the distinction between subjective and objective interestingly:

> … the point-of-view shot is marked as subjective in its emplacement but the resulting image is still finally (or rather firstly) objective, the objective sight of what is seen from the subject position assumed …

> Point of view … depends on an overlaying of first and third person modes … the latter … is the continual basis over which the former can run in its particular organization of space, its disposition of the images.[9]

Critical here is the term 'overlaying', a sense of interplay between subjective and objective, which I would suggest works to interrogate the positioning of the spectator; allows a degree of autonomy. It is an alternating series of displacements, of perspectival shifts which allows the spectator some opportunity to perceive where and when s/he is being subjectively positioned.

I think this is what Churchill does *dramaturgically* in *Top Girls*, not least through the use of a theatrical discourse of space. The diminution, or eradication, of that perspective and distance in the television version radically alters the reception of the play: put simply, the women are no longer constantly viewed contextually. They become isolated from their webs of contextual references, as the spectator is drawn further and further into empathic identification with one or more of them; a process that is reinforced by the camera's penetration and fragmentation of the fictive space. The alternation of the iterated master

shot with a variety of realist devices – close-ups, two – and three – shots, shot/ reverse shot formulations – dictate where and to whom the spectator will attend: isolating the women from one another, or creating alliances and groupings which skew the constancy of the larger view.

The effect is to lose the aesthetic distance which allows the spectator to view the women as propositions within the ideological debate. We are given no opportunity to dissociate from the individual circumstances of the women, and therefore lose the sense of their own agency within the total process: an agency which is at the heart of Churchill's argument. Instead, we are positioned with the women, as victims of the process, just as the characters are constructed as objects of the camera's intrusive and controlling eye. Just as we cannot choose to look elsewhere – at the larger picture – nor are we invited to consider ourselves as having any measure of autonomy or agency within the ideological process. We are disenfranchised.

I suggest this has occurred because the television version of *Top Girls* constructs itself primarily as a realist text, and uses the techniques of visual design and classic Hollywood narrative to achieve this. Looking at the production design, one notices throughout the designer's efforts apparently to refute Sontag's assertion of the 'discontinuity' of filmic space: a sustained use of dominant, hard verticals and horizontals, of flat planes and slabs of light and paleness. It might be argued that these are attempts at restoring a sense of pictorialism, at using the mise-en-scène to throw the women into relief, however it seems to me that the abiding impression is of flatness, of a lack of depth – of a very shallow spatial perspective. And I think this alters Churchill's play, for as I have argued, depth of perspective is central to its functioning, both literally and figuratively. In the theatre, *Top Girls'* discourse of space is both iconic and metonymic; in this television version, it is reduced to iconicity alone. It seems to me that the camera, busily displacing its own viewpoint, usurps the autonomy of the spectator, and in so doing subverts the fundamental point of Churchill's argument about the constructed nature of patriarchal ideology and its systems: that they *are* constructs, and that we are agents, not recipients alone, within that process. That argument is expressed most vividly at the level of architectonics, in the construction, articulation and encoding of physical space, fictive and actual, and it crystallises, not in the virtual space of the television frame, but in the real space of the theatrical stage for which the play was originally conceived.

NOTES

1. Elam, K. (1980) *The Semiotics of Theatre and Drama,*
 London: Methuen, p. 56.
2. Heath, S. (1981) *Questions of Cinema,* London: Macmillan, p. 36.
3. Indeed, the television spectator's actual viewing space differs
 substantially from that of the theatre spectator – and also that of
 the cinema spectator. Whereas in both those cases the auditorium
 provides a public, communal space which is relatively impersonal,
 the television spectator views within a private, domesticated space
 which is personalised; which is, in short, heavily over-coded in
 subjective terms. This factor undoubtedly affects the reception of
 the television fiction, but it does not undermine the argument I
 am proposing.
4. Heath, p. 45.
5. Heath, p. 29.
6. Sontag, S. (1966) 'Film and Theatre'. In G. Mast and M. Cohen,
 (eds.), *Film Theory and Criticism,* (1979) Oxford University Press,
 pp. 365, 368.
7. cf. Elam, pp. 63-4; Kritzer, pp. 6-9.
8. All textual references are taken from *Top Girls*, in Caryl Churchill,
 Plays: Two, Methuen, 1990.
9. Heath, p. 48.

BIBLIOGRAPHY

Churchill, C. (1990) *Plays: Two*, Methuen.
Elam, K. (1980) *The Semiotics of Theatre and Drama*, London:
Methuen.
Heath, S. (1981) *Questions of Cinema*, London: Macmillan.
Kritzer, A.H. (1991) *The Plays of Caryl Churchill: theatre of empowerment*,
London: Methuen.
Sontag, S. (1966) 'Film and Theatre'. In G. Mast and M.Cohen, (eds.),
Film Theory and Criticism, (1979) Oxford University Press.

SCREEN PLAY: ELEMENTS OF A PERFORMANCE AESTHETIC IN TELEVISION DRAMA

JOHN ADAMS

INTRODUCTION

'Performance' is complex notion that extends across a number of concepts. In social life it carries connotations that are both positive and negative. There is, for example, the mechanical sense of things effectively accomplished (as in 'performance-related' pay as a criteria for reward), or the more organic sense of the ability to make an effective presentation (a public speech as a good or poor performance), or with overtones of dissimulation. In each case, however, the idea of social performance is linked in some way to a process of making sense: of shaping elements from the flux of events in such a way that they become intelligible, largely with reference to pre-existing forms and criteria of expression and interpretation. 'Performance' has much to do with 'conforming' things to expectation, constructing 'reality' by representing actuality in terms of pre-existing frames of reference.[1]

With this kind of context in mind, my intention in this article is to concentrate on a theatrical concept of performance and, with reference to film and theatre, explore ways in which television fictions have developed distinct tendencies in terms of an aesthetic of screen performance.

THE IDEA OF SCREEN PERFORMANCE

Screen performance, something on which every viewer has an opinion and which is grist to the mill of journalistic review, has been dealt with a good deal more tentatively within the academy, where the linked areas of acting and performance have received surprisingly little consideration in the rapidly expanding literature centred on television studies. This may reflect a lack in the wider field of screen studies. As one film historian recently noted:

... film scholars have neglected the study of performance ... Neither classical or contemporary film theory nor historical enquiries into specific national cinemas have provided the means to assess the contribution that actors and their performances make to a film's overall meaning. A central component of cinema as text and cinema as institution has been widely ignored and, when not ignored, undertheorized.
(Pearson, 1992: p. 5)

Such is the paucity of critical and theoretical approaches to the aesthetics of screen performance that any discussion of the subject still requires a definition of terms and concepts. Richard Dyer in his seminal book *Stars*, largely devoted to the semiotics of the star system, provides a useful starting point:

Performance is what the performer does in addition to the actions/functions she or he performs in the plot and the lines he or she is given to say. Performance is *how* the action/function is done, *how* the lines are said (my emphasis).
(Dyer, 1979: p. 151)

However, this definition confines the concept of performance to the field of enactment, and I think it is useful to locate the term in a wider context that reflects its original meanings, associated with a sense of completion: 'to accomplish entirely, achieve, complete' (Oxford English Dictionary). This would properly re-locate the concept with the spectator, and take account of the structuring and mediating elements that shape perceptions of the acting. As the experimental work of the early Russian formalists (particularly Lev Kuleshov, Vsevolod Pudovkin and Sergei Eisenstein) sought to establish, readings of screen performance hinge on enactment in a narrative and iconographic context. So, in order to arrive at an adequate concept of performance, it is necessary to take account of a number of factors. These include questions of narrative address (plot structure that locate the viewer in relation to character and events), of the mediating impact of the technical elements, centred on ways in which the pace and rhythms of the enactment are selectively emphasised by the camera and editing, and questions centred on the nature of the 'aura' that accompanies the individual actor.

Dyer's definition of performance therefore needs to be extended, and the terminology redefined, to take account of a signifying system of which the actor-in-role is only a part. In this discussion, I therefore refer to Dyer's notion of performance, focused on acting, as *enactment*, and reserve the term *performance* for the enactment contextualised by textual and stylistic strategies. This will include some comment on aspects of audience address in narrative and iconography (ways in which 'subject positions' may be inferred through text structures and meta-texts), but not move into areas of reception (approaches that engage with actual viewer response).

At the turn of the twentieth century, a key innovation of film as a dramatic form centred on the comparatively effortless production of spectacle. The new form in a sense released the theatre from the hysterical drive towards realism[2] and, drawing on the realist traditions of the 'well-made play', allowed the development of a new ontology in the respective realisms of Strindberg, Ibsen and Chekhov. These chamber plays made new demands of theatre actors, and new approaches to acting were devised by practitioners such as Konstantin Stanislavsky in Russia and André Antoine in France. Influenced by recent insights and models of the mind developed by psycho-analysis (particularly Freud), these dramas of intimacy focused on inner landscapes of feeling and thought within a bourgeois milieu. Theatre text and *mise-en-scène* moved together to re-locate narrative within a system of psychological causality and social verisimilitude.

At much the same time, contemporary film acting in the early years of the twentieth century (between, say, 1896 and 1912) drew heavily on the melodramatic tradition, with few concessions to the new – and quite different – contexts of production and presentation of film. Within the dominant realist strand (as opposed to the fantasies associated with Méliès), the story element of film was little more than a pretext for spectacle – scenic marvels, chase scenes and every other kind of daring-do; internal narrative coherence was not a prime consideration. Beyond spectacle, early playing style was located in 'display', the rehearsal of a repertoire of gestures that conventionally signalled a dominant characteristic and/or emotion. Where the situation was complex, and or the gestural code inadequate, actors would 'rest on a gesture' – an intertextual convention understood with reference to the conventions of the magic lantern picture plays, in which the narrative was presented as a series of tableaux. In this context, the actor functioned both as an agent of the narrative and as a sign of 'the real', playing on the sense of the marvellous induced by the apparatus of reproduction.

However, a number of factors provided the impulse to a more coherent and self-contained narrative system. In terms of industry determinants, there was increasing demand for a product that would 'stand alone', allowing the nickelodeon exhibitors to dispense with some of the labour-intensive auxiliaries to exhibition (such as the 'lecturer'/story-teller and the dialogue actors). Stories needed to change and develop to meet the more sophisticated requirements of the patrons for film fictions. There was also a growing sense that the melodramatic style, detached from the experience of the live performance, was in some ways inadequate to the new photography-based form of film, which coldly isolated the conventional nature of melodramatic acting. Alfred Lunt, for example, reports his response as an eleven-year old to the appearance of Richard Mansfield in *The Scarlet Letter* (1904): 'I thought he was awful – he overacted so. Even at that age I knew he was carrying on far beyond the limits of truth' (Brownlow, 1968: p. 394). Both actors and spectators felt an uncomfortable degree of artifice, and the attempt to find more appropriate acting styles became a prime concern of a number

of actors and directors. In order to draw the spectator into the emotional textures of the lives of the screen characters, there was a need to transcend the styles and conventions of melodrama imported from theatre. D.W. Griffiths, who had started directing one-reelers for Biograph in 1908, developed some of the most imaginative responses to the need for greater verisimilitude. In the early films, he placed greater emphasis on the development of story, creating sequences of events rather than simple situation (introducing the film scenario as an aid to achieving narrative coherence). Within a short time, he was working with a succession of young actors and (notably) actresses to develop a sense of characterisation *visibly* located within the processes of the mind as much as in the requirements of the story.[3] As a contemporary critic noted in 1913, writing in praise of Griffith's methods, 'moving picture audiences are rapidly becoming critical, and men of discerning taste will be needed to respond, or even direct, this change … The decreasing insistence in plot, and a correspondingly stronger emphasis on character portrayal is one of the most hopeful signs of the times.'[4]

One other factor that distinguished early screen acting from its counter-part in theatre was the radical redefinition of the role of the written/spoken word: the craft of screen acting was defined by the need to tell a story with minimum recourse to language, (although this in some ways worked against the new realism, since the clarity of situation and character in melodrama was in a number of ways better suited to the non-verbal form). Griffiths sensed that the emotional value of enactment could be heightened through a more dynamic use of the mechanisms of camera and editing. In effect, he sought to situate the spectator in a mobile rather than static relationship with the enactment, creating an address that would maximise the dramatic and emotional potential of any given scene. His innovative use of the close shot at key moments in the drama allowed the spectator access to the thoughts and feelings of a character with an intimacy previously unknown in theatrical convention. Less widely recognised, but of equal importance for the developing notion of performance, was Griffiths' use of the long shot to dramatise character through the symbolic use of landscape.

Such formal innovations provided the basis for the classic narrative system in cinema, the development of conventions that would maintain the effect of 'the real', despite the potential dislocation caused by fragmenting temporal continuity through the necessity of editing, and it is these conventions that underpin the performance aesthetic of television drama.

TELEVISION DRAMA: PROGRAMMING AND FORM

Within this field of dramatic fiction, television has developed a remarkable range of forms. In the early days, 'television drama' was synonymous with the single play, within generic or themed programme strands, which has largely given way to the 'television film' (not forgetting that television also functions as an important secondary release outlet for

cinema film). However, most television drama programming is now presented in one or other of the extended narrative forms: the soap, the series or the serial.[5] Within these forms, drama is largely categorised by the broadcasters in terms of 'format': the sitcom, the historical drama, the hospital drama, police and crime drama and so on. Under the constant pressure to provide innovation, variations on these forms are a regular feature of programming, centred around concepts of documentary-drama e.g. *999*. In addition, although not for detailed discussion here, are the micro-dramas: television news items, dramatic reconstructions, television commercials, party political confections, pop promos.

Up to the 1950s, realist theatre had offered the most intimate form of drama. With the growth in popularity of the single play, intimacy and immediacy became the province of television. Studio-based drama shrank further the dimensions of the theatrical stage, producing a new environment for the actor that bore little relation to the film studio and less still to the theatre stage. Although the early television plays were transmitted 'live', at the moment of enactment in the studio, live studio performance differed from theatre in a number of respects. There was no audience response to 'assist' the actor during the course of the performance, providing the unique chemistry between player and spectator that lies at the heart of theatre;[6] nor was there a possibility of refining performance of a character across the length of the run. With the live broadcast the enactment was *definitive*, living and dying at the moment of transmission without benefit of adjustment to audience response or recourse to retakes. Finally, acting for the camera required an intimate playing style; theatrical projection produced an air of melodramatic and artificial intensity that was quite inappropriate for small-screen intimacy. Howard Thomas (Managing Director of ABC Television and responsible for the introduction of *Armchair Theatre*) writing in 1959, offered a view that scarcely concealed his sense that the disciplines of television acting had yet to be fully acquired by many of its practitioners:

> The problem we face is to make television drama live and progressive…(Much of the responsibility) lies with the actor, to learn more about their trade and to work harder at their parts, so that they do more than 'mug' their lines and positions and get under the skin of the parts they are playing. Television drama will certainly demand a higher standard of intelligence from actors and actresses than the stage ever did, with its nightly repetition of parts worn or shed like costumes. (p. 15)

However, live transmission maintained one vital link with theatrical presentation – the continuous run from beginning to end, which (in theory at least) allowed the actor to endow the enactment with rhythm and flow, a continuity from one scene to the next. This link with theatre was severed with the introduction of image recording technology – first the 'tele-cine', that recorded the television output on film, and then the introduction of videotape (1958). This technological development was coupled, from the early 1960s onwards, with the trend towards location filming. These factors shifted the temporal

dynamics of television performance decisively towards the realm of film, where single-camera production techniques and temporal conventions fractured the traditional rhythms of enactment. The basic unit of enactment became the single shot, with the emphasis for the actor on 'beat' and 'phrase' over a period of seconds, and the longer rhythms structured through the process of editing. As with the silent film, enactment became performance by virtue of technological mediation.

PERFORMANCE AND FILM AESTHETICS

The multi-camera production systems of live television drama would transmit the enactment and simultaneously construct the performance through the rhythms of the multi-camera/vision mixing system, moving in and drawing back in a crude balletic mimesis of the intensity of thought and/or feeling. With the actor located in a mobile relation with the spectator, the theatrical enactment in the television play was subjugated to the rhetoric of the narrative moving image, and television enactment became increasingly a construct of the film impulse. At this point, it should be born in mind that film acting has a number of facets, of which the presentation of character is only a part:

> … much of the footage in a film is simple physical action: getting in and out of vehicles, riding horses, looking up, down, or all around … Part of the footage is montage in which the actor is simply one facet of several rhythmic elements that create impressions and ideas…some of the work in the film will relate to characterisation, and it is this area that the actor can contribute the finer elements of *his* (sic) skill and talent.
> (O'Brien, 1983: p. 25)

The introduction of location-based drama consolidated the ascendancy of the director in what had been essentially a collaborative hierarchy between producer, writer and actor. A number of directors sought to import film values to television, reflecting a range of creative intentions and professional ambitions which, in effect, began to redefine television drama as small-screen cinema. Television directors such as Philip Saville, Ted Kotcheff, Ken Loach and Ken Russell all sought (for widely differing reasons) to increase the 'status' of television drama through a shift towards cinematic techniques and production values – effectively the creation of a small-screen cinema.

The impulse towards the cinema aesthetic in television drama reached a logical conclusion when David Rose, the first Head of Drama at Channel 4, established the innovative and influential strand *Film on Four* in 1981, which envisaged cinema release as an integral part of funding and distribution strategy for television drama.[7] With the refinements of production technologies and institutional practice, and the interlocked complexities of finance, distribution and exhibition, the single-play crossed into the orbit of cinema.

While it bears many of the traces of its television provenance, the single play – now the television film – lays claim to a cinematic aesthetic and is of interest in the context of this discussion only in the extent to which these ambitions fall short of their goals.

REALISM AND THE BROADCAST INSTITUTION

Given the institutional context of production and the 'mass' nature of the medium, it is useful to link the predominantly realist aesthetic to the dominant culture of liberal conservatism that has characterised post-war broadcast institutions in the UK. Michael Grade, Controller of Channel 4, has provided a succinct summary of this position, asserting that television drama, as a popular medium, 'undoubtedly contributes to the formation of a sense of national identity'. Questioned on whether or not drama should be more stylistically innovative, he asserted that mainstream television drama had to 'concentrate on telling stories in ways that people understand … if it is to fulfil a prime function of creating *shared* (my emphasis) understanding and memories'.[8] This linkage of realist modes with socio-historical issues has characterised film and television output in the UK, and the sense that the role of broadcasting was primarily to reflect the real world of national life underpinned the development of the various forms of television drama: serials (e.g. *Coronation Street*), series (e.g. *Z Cars*) and the single play (e.g. *Armchair Theatre* strand). Howard Thomas, with instinctive and influential sense of the direction that television should take while carrying the audience, put the case for innovation in drama in terms of content rather than form in the 1950s: 'television drama is not so far removed from television journalism, and the plays that will grip the audience are those that face up to the new issues of the day'.
(Thomas, 1959: p. 15)

Styles of enactment obviously conform to the broader aesthetics and conventions of a given programme, and the dominant forms of commercial film and broadcast television are located in forms of realism. A more precise definition of the term requires reference to a range of historical and philosophical perspectives but, in the context of performance, the term may be understood as a way of making social and physical reality (in a generally materialist sense) the basis for the investigation and/or illumination of the social world.[9] Attempts to introduce experimental forms into mainstream plays are made on an occasional basis, but such attempts to introduce radical innovation in narrative and iconographic form have rarely made significant impact on the dominant conventions of generic realism, which retain the emphasis on psychological verisimilitude, chains of narrative causality, convincing social relations, and environmental influence.[10] As Raymond Williams (1977) has convincingly argued, realism is the dominant mode of drama for the modern era and formal innovations are in many ways marginal in terms of this historical trajectory.

CONVENTION AND ENACTMENT

In the realist traditions of performance, the actor is no longer literally dis-guised; s/he no longer physically dons a mask but simply, as Richard Southern puts it, steps forward and declares a persona: 'I am St. George'.[11] This suggests an entity that may be thought of as a 'mask' in the script, a mask in the form of language. From this point on, in the interests of developing a more precise vocabulary for text and performance related concepts, I will use terms more specifically.I In particular, the idea of *role* is broken into constituent concepts located in the text: *persona* to refer to individual *dramatis* personae (the character in the text),[12] *agent* to refer to structural (narrative) dimensions and functions, *type* to identify generic elements of individuation within the text. This implies degrees of both fixity and openness in the dramatic persona. What redeems the television character from its textual fixity is, of course, enactment – the individuation and interpretation of the *persona* through the presence, skills and iconography of the actor. In this context, I reserve the term *character* as a concept exclusively relating to enactment – the *actor-in-persona*.

As a purely textual entity, the 'persona' is a construct of desires (passions, motives, impulses) individuated through the attributions of qualities, traits and tics allowing a character to be thought of as 'life-like'. In terms of verisimilitude, the persona should allow the character to be sufficiently individuated to fulfil the allotted dramatic function; to appear, act and speak in a way that broadly conforms to models and expectations of social type; to be recognisable in terms of types encountered through other representational forms and genre; and to possess within the terms and requirements of the narrative.

However, the paradox of realist performance is located in the twin dynamic of presence and absence – the physical presence of the individual actor and the absence of the social being, effaced by the persona – the 'mask in the text'. One of the affective functions of the presence of the actor is to affirm the continuing absence of the social being. The theatre has always celebrated its power to play on this paradox through exploration of kinds and degrees of the inscription of physical presence (the body) into a world of fiction. In naturalist theatre, the fiction liberates the sensuality of the gaze, legitimating the desire to look. However, the logic of theatre is only fully engaged when conventions are tested. Productions such as Deborah Warner's *Richard II* at the Cottesloe (June 1995), with Fiona Shaw in the title role, celebrate the conventional nature of theatre with the recognition that 'since intelligence and imagination count for as much in acting as gender, it makes perfect sense for women to play male roles'.[13] Pushing the links between the convention of representation and the physical presence further are (post-modern) approaches such as those explored in the theatrical communitarianism of Bill T. Jones' *Uncle Tom's Cabin* (1992). Here, the insistent emphasis on the naked presence of the (amateur) participants from the local community creates a dynamic in which the world of fiction may/does (depending on the sensibilities of the individual spectator) resolve into existential actuality at any given moment. At which point, narrative and myth (in this case centred on oppression and liberation) condense into the material reality of the theatrical event.

Television drama cannot attain these *transcendental* qualities of theatre, rooted as they are in the fragile spheres of temporality and convention; and, in comparison with film, the small-scale conditions of production and of reception inhibit the capacity to transcend the pre-texts of situation and character. The singular demands of television drama militate against achievement of goals of realist enactment, which may be traced back to Stanislavsky, are given a contemporary gloss by Simon Callow (in the most traditional terms):

> ... for an image of humanity to engage and move us it must be more than the portrait of an individual. It must be crystallised. Rembrandt knew about this: when he paints his mother she is at once herself and an essence of age, woman-liness, motherhood.
> (Callow, 1995: p. 7)

In short, the intimacy of television drama counters the reading of enactment in terms of this kind of ontology; rather, it offers precisely a 'portrait' of individuals and, through such portrayals, the promise of revelation – a sense of insight into the territories of desire and, beyond this, affirmation of the ground of experience in individual identity and personal relationships.

CHARACTER BEYOND NARRATIVE

With limited budgets and small screen reception, television drama from the early days centred on 'characters, conflict and emotion ... introspective personality conflicts and tales intrinsic to television's singular demands' (Marschall, 1987: p.66). As a consequence of these 'singular demands' (financially constrained and physically contained conditions of production, the structural intimacy of the text, and so on) the dominant modes of action in television drama tend to be character centred rather than located predominantly in other possible modes (e.g. spectacle, event, style or discourse).

This focus on character is clearly reflected in the emphasis of the publicity surrounding a production. A 40-second trailer for a BBC historical drama, *Elizabeth R* (first broadcast in February, 1971) provides a clear illustration, constructing the outline of the narrative pre-dominantly in terms of character, completed through the shift in focus from character to actress (Glenda Jackson) in the final seconds:

Voice Over	*Picture*
'She's the daughter of a whore ...'	LS Elizabeth on horse. CUT TO
	C S Elizabeth ('wanton' laughter).
'She's much loved by the people ...,'	CS Elizabeth (affectionate smile).
'No woman can rule a kingdom ...'	CS Elizabeth pulls bow. CUT TO
	Arrow hits bull on target.

Voice Over	Picture
'No man has ever commanded her ...	
... or ever will ...'	MS Elizabeth in embrace.
'They say she is very, er ... majestical ...'	LS Elizabeth looking stern, surrounded by courtiers.
	CS Elizabeth laughs.
'She survived the bloody reign of	CS axe falls.
Mary Tudor ...'	MS Elizabeth climbs Tower steps in rain.
'... ruled for nearly half a century ...'	CS hand kissed.
'She is Elizabeth R ...'	CS Elizabeth smiles.
... as played by Glenda Jackson'	LS Elizabeth with courtier.

Elizabeth R is a particular example of drama that deals with major events in the public sphere, but this kind of focus clearly illustrates the extent to which plot (the way the story elements are structured) tends to refocus the scope of the action from public event to personal re-action.

Developing from this character-centred approach to writing and performance, the extended narrative forms construct dramas in which *characterisation* – resolutely located in worlds of generic realism – *transcends narrative*; characterisation and narrative are not locked in the integral relationship that typifies the feature film, the single television play or the theatrical text. Character is established through response to events, but thereafter it possesses the potential to assume an 'independent' life: the story develops around a dramatic character with whom the viewer has established a relationship prior to the sequence of events that constitute a particular situation. In this context, it would probably be more accurate to say that the extended narrative allows the 'type' of a character to change across a period, rather than allowing a 'deeper' construct of character; put another way, extended narrative forms allow greater familiarity (on part of viewer) with a character rather than increased complexity of character.

CHARACTER AND NARRATIVE ADDRESS

Character traits are shaped through the fixed viewpoint defined by the narrative operations of the text. In the intimate dramas of television, such positions are typically structured in an ironic mode, with the viewer for the most part in possession of a greater degree of knowledge of events than any single character. As the story unfolds, the viewer gains knowledge of a situation at roughly the same time as a given character.[14] S/he will usually have the benefit of multiple viewpoints, and so be placed in a position of possessing a greater degree of knowledge than any single character. This position will be gained through insights not permitted to other characters, including 'privileged' access to character in those scenes where a character is present alone. This kind of scene has special dramatic

status, providing insight into what a character thinks/does when they are detached temporarily from the social sphere and therefore from the necessity to adopt a public persona. Such programmes in essence utilise extended narrative form to offer the pleasures of familiarity and knowledge: insight into/control over an intimate knowledge of 'parallel' worlds that unfold alongside – and, in some senses, become a part of – the life and experience of the viewer.

This 'play of knowledge' – the way the action is plotted – locates the viewer precisely and intimately within the world of the drama in close proximity to the protagonist(s), and it is this structure of address (the 'location' of the viewer within the narrative) that provides the structural position for readings of television performance.

PRESENCE AND ICONOGRAPHY

Revelation of thought and the quality of presence have provided the measures of the quality of screen acting from the early days of cinema. In the words of one early and apparently awe-struck spectator (at an unidentified screening) in 1911 'you can see her think'.[15] Exactly the same sentiment is expressed by a critic praising Helen Mirren's performance (in 1995) as Superintendent Tennison in *Prime Suspect*:

> Helen Mirren ... was playing the newly promoted Detective Superintendent Jane Tennison ... There is no better acting to be seen on television. She has speaking silences when you can see thoughts moving like fish in water.[16]

The question of presence, above all in silence and repose, as a quality of screen acting is fundamental. Barry Norman, for example, treads a well-worn path in using this criterion to identify the star qualities of Gene Hackman:

> Like many other star character actors ... Hackman improves with age. (...) What he has acquired is presence and the vital quality of stillness ... it's not the person who cavorts wildly about the screen but the one who doesn't appear to be doing much, who uses only the most subtle facial and body movements, who catches the eye.[17]

In other words, screen enactment is much to do with the rendering of the inner world of motives, desires and feelings in terms of *appearance* as the bridge between text and subtext, between what is said and what is intended. Above all, quality of enactment is inextricably linked to the ability to disclose an inner landscape of attitude, feelings and/or ideas that lie beyond the *socially constrained exchanges* that constitute the written/spoken element of the dramatic text.

Much of this quality of enactment is derived from the 'aura' of the actor. The prime function of performance convention is to efface the individual player as a condition of the

assumption of the persona – the fictional identity. This denial of the social dimension of the individual is, in a sense, the negative charge of performance. However, this denial allows the qualities of the actor (a particular physiognomy, a gestural repertoire, certain vocal characteristics of accent, rhythm, pace, tone) to provide the pre-history of the character in the world of the fiction. Our reading of these qualities hinges on social perceptions drawn from both life and conformation to 'genre verisimilitude' – ways in which similar characters have been represented both in television fiction and other media. At which point, character and relationships are brought into definitive focus through the adoption of an attitude to events, beat-by-beat, within the aura of the performer's presence and physical qualities.

In the case of an established actor, certain performance qualities are derived from sources outside the immediate experience of the particular drama, since the public persona of the actor is an important element in creating expectation and developing anticipation of the pleasures of the performance. These elements extend beyond programmes to embrace the whole system of associated 'texts': television chat-show spots, journalistic interviews, celebrity appearances, magazine feature articles and so on.

I will turn again to *Prime Suspect*, where a typical example of a publicity meta-text is provided by the *Radio Times* 'profile' of Helen Mirren in the issue that covered the transmission of the first episode of the fourth series. This short feature includes anecdote (Mirren herself took up smoking as a result of the requirement that the character she plays, Tennison, smokes), reveals her marital status, number of homes, Oscar nominations, political sympathies, and so on. However, points about her domestic and professional life receive less prominence than the aura that is created by her exotic background (half Russian, born Helen Mironoff) and physicality:

> … blonde-haired, voluptuous … and once dubbed 'the RSC's sex queen' …
> (Her body) used to be on display rather frequently in films such as Ken Russell's
> *Savage Messiah*, *Caligula* and Peter Greenaway's *The Cook, the Thief, His Wife
> and Her Lover*. Now the only things that get taken down are statements
> from the creeps she collars as newly promoted Detective Superintendent
> Jane Tennison.[18]

The article is accompanied by a 'glamour' shot of Mirren (ecstatically pushing back her hair) rather than, say a production still from the series. This apparently gratuitous emphasis on Mirren's sexuality provides a fairly typical example of 'iconographic address' – ways in which an image of an actor is constructed, with emphasis on selected aspects of personal qualities and values, beyond the dramatic character in question. This kind of publicity text is now a standard part of the elements that contribute to the reception of any given television drama, and has a direct bearing on the affective 'readings' of performance. The 'aura' of the actor is brought into play as a separate (but, arguably, equally fictional) construct as the character in the drama through these meta-texts. Such publici-

ty is a routine aspect of television drama that allows the viewer to bring to the drama an understanding of character gained from sources outside the text itself, and which may or may not be aligned directly with the character as developed in the programme. In this case of Helen Mirren, for example, the publicity is part of a meta-text of sexuality surrounding the actress, adding a dimension to the character that is not significantly developed with the narrative itself.

LANGUAGE, IMAGE AND TECHNOLOGY

The parameters of acting style are, with few exceptions, defined by the style of the written word – the dialogue script. Beyond this, factors such as wise-cracks, imagery and slang will gloss the realism of the characters in different ways. However, I want to look at relations between language and event that come into play as a key element of the broader performance aesthetic.

Theatre writing, where physical constraints have always fuelled the search for new conventions, is often enough characterised by complex and shifting relations between the spoken word and the 'image-event' in language – guidance of what I will call the 'imaginative focus' of the spectator, where the imagination is held at points by the stage image, and at points by events in the spoken word. Frequent use of this dynamic is found in the work of Samuel Beckett. In *Endgame*, to take one example almost at random, Hamm sits centre stage, blind and immobile, in an allusive set that Beckett describes in some detail without offering any defining commentary. At certain points, he reminisces (sketching a story which may or may not be based on an encounter from his past but in which the details change with each telling):

> It was a howling wild day, I remember, a hundred by the anemometer. The wind was tearing up the dead pines and sweeping them … away. (*Pause. Normal tone.*) A bit feeble, that. (*Narrative tone.*) Come on, man, speak up, what is it you want from me … etc. (p. 36)

The stark language draws the imagination into the world of elsewhere (history/fiction) contained in the language. This evocation is then fractured as, through the device of having the character comment on his own delivery, we are abruptly returned to the stage image, to the moment of telling and the reality of Hamm's terrible and inescapable situation. To different ends (and with careful use of the moments of transition), the dynamic of focusing the imagination on events in language for certain elements of the drama was a feature of Hollywood films produced during the studio sound era (1930 to -mid-1950s) and, to a degree, still characterises British film writing. Hollywood film since the 1950s has long recognised that language and sound will hold an image in a certain affective 'perspective', but that language will rarely dominate or transcend the image. Television drama, dominated by the overwhelming presence of character, rarely finds ways for language to

envelop the character to the extent that the imaginative focus shifts into the world of the language. Information may be exchanged, stories told, but the rhythms of enactment and performance insistently subjugate worlds within language to the attitudes and emotions of the character at any given moment.

However, if the mobility between the image-event and the world in language that characterises theatre is not a significant feature of television drama, a degree of mobility is achieved through the technologically determined aesthetics of camera work and editing. The dominant forms of camera framing are the medium long shot (MLS), the medium shot (MS), the medium close shot (MCS) and the close shot (CS). The CS is the most significant of these in the context of this discussion, since it provides the measure of all other shots in terms of enactment. Through the close shot, a number of things happen: the body is decisively fragmented; the character is detached from setting; the character is privileged, emerging from the encounter and/or the group. Above all, the looks and personality of the actor are imposed on the narrative persona: the physiognomy of the player provides a map of the landscape of individual thought and feeling, to be read in terms of the narrative context.

In dramatic terms, the close shot is primarily a signifier of significant thought or feeling. Such readings are then further structured by the sequential context and the camera position – the extent to which a CS is aligned with a camera position associated with the viewpoint of another character in the scene, for example, or whether it sits within a sequence of active/re-action shots. In other words, camera placement and choice of lens position the viewer to share and respond to the inner process of the character (that is, a subject of the drama) or as an object of the look, where judgements have to be made about the process of thought.

CONCLUSION

'In the olden and golden days' wrote Alan Plater almost despairingly, 'when TV drama was made in the studio, there was a tacit acceptance that it was a writer's medium. The drama directors came from the theatre and treated the work of Alun Owen and David Mercer with the same respect they would treat a text by Ibsen or Chekhov'.[19] Since those 'golden days', when television drama was essentially intimate theatre, there has been a significant shift away from the creative autonomy of the writer. One trajectory of television drama has re-located the single play in the domain of film; however, the major forms of television drama now centre on the established audience preference for extended narratives. As one observer of the contemporary television landscape argues:

> … viewers like soaps and recurrent series more than almost any movies, whether
> hatched in Charlotte Street (i.e. Channel 4) or Hollywood. Previously familiarity
> with characters and settings goes down better than the unpredictability of the

one-off story. In 1960 a live, original Pinter play, *A Night Out*, was ITV's Number One for the week. That age is long gone and cannot be restored by low budget films.[20]

These extended narratives inhabit the forms of realism but with much greater emphasis on genre (sitcoms, soaps, hospital drama, police and crime series and so on), all of which have their roots in melodrama. The concept of melodrama is complex and unstable, but I am using the term here to indicate an expressive code rather than a genre – a code characterised by narratives and mise-en-scène that foreground domestic groupings as the site of action, with inward-looking characters whose horizons are constrained and contained by domestic and local circumstance, and responses to the world generally conceived in immediate emotional responses rather than intellectual terms.[21] In this perspective, television writing creates micro-deities, types that reflect contemporary sensibilities within forms of expression shaped by the demands and desires of contemporary culture. On the screen, the melodrama in the script is veiled by the perceived realism of enactment style, and differences and distinctions of 'character' (frequently in a context of narrative fatigue) are increasingly located in the 'aura' of the actor, where iconographic qualities acquire a self-contained, quasi-moral authority. In this context, an aesthetic of performance necessarily centres on the point of reception rather than enactment, drawing on those elements of genre, narrative address, characterisation and iconography by which enactment is mediated.

NOTES

1. There is a large body of literature that deals with elements of 'performance' as part of a larger metaphor of 'social drama'. See, for example, Goffman (1959) and Burns (1972).
2. For discussion of this thesis, see Vardac (1949; 1987).
3. Most notable of Griffith's actresses were Mary Pickford, Blanche Sweet, Mabel Normand, the Gish sisters (Lilian and Dorothy) and Mae Marsh.
4. Louis Reeves Harrison, 'David Ward Griffiths: the Art Director and his Work', *The Moving Picture World*, vol. 18, no. 8, 22 November 1913, pp. 847-48, in George C. Pratt, *Spellbound in Darkness: a History of the Silent Film*. New York, 1966: rev. ed. 1973, pp. 107-8.
5. A 'serial' usually implies a narrative that continues from one episode to the next across a limited number of episodes e.g. *A Very British Coup*. A 'soap' implies a similar narrative that runs across a large number of episodes e.g. *Dallas, Coronation Street*. A 'series' implies that the main story is largely confined to a single episode e.g. *The Bill, Prime Suspect*.
6. Peter Brook points out that the term *l'assistance* (the audience) in French combines the dual notions of 'presence' and 'assistance', in the sense of supporting the actor in his work (1968, p. 156).

7. *Film on Four* was followed by BBC2's *Screen 2* in 1985 and, in 1986, BBC1 launched *Screen Premiere* (later *Screen One*). The concept has been praised and vilified. William Phillips (1990 provides a closely argued criticism that such products should not form a part of television programme investment.

8. Michael Grade, from transcript of a talk given in Bristol to the Bristol Channel Group, 4 May 1995.

9. For a fuller discussion of the complexity of the term, see Williams, 1976: pp. 257-62.

10. This question surfaces from time to time. See, for example: Troy Kennedy Martin, 1964, and McGrath, 1977.

11. Nearly all early theatre takes the form of masked drama, reflecting its origins in forms of ritual. See, for example, Southern, 1962: p. 51 and *passim*.

12. L. *Persona*: mask. The link between the masked player and the textual entity is made specifically in the term *dramatis personae* – literally, the masks of the drama.

13. Review of *Richard II* in *The Guardian Review*, 5 June 1995, p. 8.

14. In the context of story (*what* is told) and plot (*how* it's told), it is worth noting the origins of 'narrative' in L. narrus: knowledge.

15. Fell, 1983: p. 98.

16. Gillian Reynolds, review of *Prime Suspect* in *The Guardian*, 1 May 1995, p. 2.

17. *Radio Times*, 29 April 1995, p. 56.

18. *Radio Times*, 28 June 1994, p. 9.

19. Alan Plater, 'Writers and Wrongs', *The Guardian*, 5 June 1995.

20. William Phillips, 'Film one-offs that prove a turn-off', *Broadcast* 27 July 1990, p. 25.

21. For a useful introduction to positions on melodrama, see Pam Cook (ed.), The Cinema Book, London: BFI, 1985; an excellent recent publication is Jacky Bratton et al (eds.), *Melodrama: Stage Picture Screen*, London: BFI, 1994.

BIBLIOGRAPHY

Beckett, S. (1958) *Endgame*. London: Faber & Faber.

Bratton, J. et al (eds.) (1994) *Melodrama: Stage Picture Screen*. London: BFI.

Brook, P. (1968) *The Empty Space*. Harmondsworth: Pelican.

Brownlow, K. (1968) *The Parade's Gone By...* London: Secker & Warburg.

Burns, E. (1972) *Theatricality: a Study of Convention in the Theatre and in Social Life*. London: Longman

Callow, S. (1985) *Being an Actor*. Penguin: Harmondsworth.

Cook, P. (ed.) (1985) *The Cinema Book*. London: BFI

Dyer, R. (1979) *Stars*. London: BFI.

Fell, J. (ed.) (1983) *Film Before Griffiths*. Berkeley:
University of California Press.

Reynolds, G. Review of *Prime Suspect* in *The Guardian*,
1st May 1995, p. 2.

Goffman, E. (1959) *The Presentation of Self in Everyday Life*.
New York: Doubleday.

Kennedy Martin, T. (1964) 'Nats Go Home'.
In *Encore*, vol. 11, no. 2, March-April.

Marschall, R. (1987) *The Golden Age of Television*. London:
Bison Books.

McGrath, J. (1977) 'TV Drama: the Case against Naturalism'. In
Sight & Sound, Vol. 46, no. 2.

O'Brien, M. E. (1983) *Film Acting: the Techniques and History of Acting
for the Camera*, New York: Arco.

Pearson, R. E. (1994) *Eloquent Gestures*. Los Angeles & Oxford:
University of California Press.

Phillips, W. 'Film one-offs that prove a turn-off',
Broadcast, 27 July, 1990.

Plater, A. 'Writers and Wrongs', *The Guardian*, 5 June 1995.

Southern, R. (1962) *The Seven Ages of Theatre*. London: Faber.

Thomas, H. (1959) 'The Audience is the Thing'.
In ABC Television (ed. anon) *The Armchair Theatre*. London:
Wiedenfeld & Nicolson.

Vardac, A. N. (1949; 1987) *Stage to Screen*. Mass:
Harvard University Press; reprinted New York: Da Capo.

Williams, R. (1976) *Keywords*. London: Fontana.

Williams, R. (1977) 'A Lecture on Realism'.
In *Screen*, vol. 18, no. 2.

ACTORS AND TELEVISION

PETER REYNOLDS

Leading actors in every generation, from Will Kemp to Hugh Grant, have found it necessary to live in the public eye, their reputations founded as much on their private as their professional lives. In the late 1990s, despite the virtual demise of regular theatre going in Britain, actors have never been more subject to public scrutiny. This is largely thanks to television and the VCR which, for better or (more probably) for worse, have dramatically changed the nature of acting and what it is to be an actor. Once people flocked to theatres, music halls and other venues for public performance precisely to observe famous actors (Kean, Irving, Bernhardt), revelling in their technique and their display of virtuosity. The global audience created by these new technologies means that millions of people now spend far more time reading about, listening to, and especially watching thousands of actors at work on television, often without realising that they *are* watching actors. It is the nature and consequences of this change from visible to invisible acting, the working practices within the industry, and television's role in representing the job of acting, that I will be exploring in this chapter.

The television industry is the largest employer of actors in Britain. It represents them not only as characters in dramas and advertisements, but also as personalities in chat shows, and as participants in game and quiz programmes. The representation of actors as television 'personalities' is reinforced in the public consciousness by a relentless stream of interviews on talk radio (*Midweek, Women's Hour*, and *Start the Week*) and by the regular appearance of their faces an opinions in the pages of almost the entire output of the print media from *Hello* Magazine to *The Observer*.

Perhaps the quintessential example of the way television and the media simultaneously constructs and deconstructs actors is provided each year when the television viewer has the opportunity to watch actors being lionised when receiving or presenting awards (or simply being present at the relevant ceremonies) such as the American Oscars, the Olivier Awards, and those of the British Academy of Film and Television Arts (BAFTA). Although many individuals are eligible for awards in a wide range of categories covering the various production processes of film, television and the theatre, awards to *actors* are foregrounded by the press and by the inevitable television coverage of the event. Such occasions are understandably popular with actors, production companies, and the broad-

casting authorities: they provide a convenient (and cheap) means of advertising both actors and the products in which they appear.

The often aggressive selling of selected individuals as 'media personalities' is considered by international entertainment companies, who often own both print and broadcast media, an essential part of their strategy in marketing mass produced and mass consumed cultural products. However, continual media exposure to a carefully chosen range of actors helps to create a powerful and influential mythology about the job and the lifestyle of a contemporary actor, not the least component of which is that most actors work in the theatre: that the theatre is where 'real' actors belong and where 'real' acting is done. In award ceremonies, for example, whatever medium the actor is best known for, and whether the award is for a performance in a play, a film a TV sitcom or a soap, the trappings of the event are designed to make an association between his/her work and the theatre. The venue (for the televised awards) is almost always a theatre. Even when a theatre is not used, as is the case in the London *Evening Standard* awards which are held annually in the Savoy Hotel, the setting is constructed to recreate a conventional theatre space with a raised stage facing the audience. This is in contrast to other televised awards such as the BBC's *Sports Personality of the Year*, which is always recorded in an actual television studio. The studio audience of distinguished sportsmen and women are seated around the presentation area, and no attempt is made to disguise from the viewer the nature of the location – the presence of cameras, lights and technicians is proudly displayed rather than, as is the case in other performance award ceremonies, disguised.

The name of the awards made to actors (the *Olivier* the British *Academy* etc.), the celebrity of the award presenters, and the almost universal adoption by presenters and recipients alike of formal evening wear, all signal an association with high rather than popular culture. This strategy is adopted in order to distance the viewer from the reality of the often mechanistic and distinctly un-glamorous processes that produce most television acting. Instead of being the marginal product of a low-status, highly automated, semi-industrial process, the actor is constructed as desirable. Someone at the centre of what is perceived as being the more leisured, smaller-scale, craft-centred and high status activity of theatre.

At the Oscars telegenic young actors are hired, given a costume (evening dress), and told to stand by in the aisles of the theatre. If required, their role is to slip into the seat of any invited guest who might temporarily vacate it so that the television audience is never confronted with the spectacle of empty seats. The careful stage managing of such occasions fictionalises actors, making their work and their lives seem part of a glamorous, desirable, but to most viewers, unattainable world. The reality for the vast majority of actors is, of course, very different. Most of those who belong to the actors' union, Equity, are out of work for most of the time. They are poor, unacknowledged, and unknown. But what mass stage-managed television exposure achieves is the perpetuation of the mythology of mystique and romantic individualism created in the last

century: acting is marketed as the activity of gifted, usually beautiful, and distinctive individuals.

There are other ways in which the mass perception of acting as a job is distorted; most of them developed from and invented by television. For instance, the conventions used in television drama production do not encourage viewers to recognise (or even to *want* to recognise) what they see actors doing on screen as *work*. Whilst the theatre in Britain still employs pluralistic conventions of presentation, the majority of television drama does not. Small screen acting in particular is judged in proportion to the extent that it appears to the viewer to be a natural and spontaneous activity. The almost inevitable use of illusion-istic conventions, and the dominance of psychological naturalism in their enactment, leads spectators to recognise characters, not the individual actors who represent them, and to regard acting simply as an extension of everyday (i.e. unskilled) behaviour. The conse-quence is that the actual task of acting for television does not require the use of traditional theatre skills such as physical transformation, narrative development, and sustained char-acterisation; instead it simply requires the consistent representation of the self.

In television drama, viewers are, offered a diet of actors who have usually been cast because of their physical suitability, especially facially, to fit the specifications demanded by the script or the casting director. Any ability that they might have physically to trans-form themselves into someone else is largely irrelevant. They are usually screened in close-up, frequently alone or in small groups, and generally in contemporary domestic set-tings. This is especially so in an arena which employs the majority of British actors – low-budget, mass-marketed soaps such as *FastEnders*, and drama series typified by *The Bill*. In these dramas, if the script requires an 'ugly', short, working-class young male, an actor who is 'ugly', short, male and working-class is chosen to play him.

The proliferation of independent television production companies brought about by the creation of Channel 4, and a Government induced change of policy by the BBC in the 1980s exacerbated these tendencies through required changes in working practices with-in the television industry. A significant percentage of its output (including drama) is now commissioned from independent producers. One result of these changes has been a deterioration in the working conditions of television actors. The fact that television is a cap-ital-intensive and complex technological process under ever-increasing commercial pres-sure to achieve high ratings at low cost contributes to the marginalisation of the actors' role in the creative process. Drama series are now often commissioned by television com-panies after the script has been put out to competitive tender, creating competition not necessarily on the basis of a successful track record or reputation for quality, but on the basis of cost. At the pre-production stage, and following a pilot episode for a proposed new series, as well as during the run of an established programme, market research will have been conducted to determine whether viewers find the characters (and therefore the actors playing the characters) 'sexy' or attractive. If the answers are negative, the series will be re-cast or it will fail to find a producer.

Despite a growth in the number of opportunities for actors to appear on television, the range and arguably the quality of work in which they can participate has declined. Also, an important aspect of the previously close relationship between working as a stage actor and working as a television actor, has become seriously undermined. For instance, in the past, 'quality' drama, including the staging of classic and modern plays, was part of the BBC's public broadcasting mandate, and this work was always accorded rehearsal time. It thus replicated many of the processes of putting on a play in the theatre and this was reflected in the titles given to the slots allocated in programming – *Play for Today*, *Theatre Night* etc. But the 1980s witnessed a decline in BBC television drama production (only in part compensated by the growth of drama commissioned by Channel 4), and certainly far fewer televised *plays* were in the BBC's schedules than previously. As a result, actors working for television enjoyed many fewer opportunities to rehearse their work at the BBC's studios in North Acton. By the mid 1990s even more rehearsal opportunities had disappeared. Their loss can arguably be said to make little discernable difference to the changing aesthetics of most televised drama. However, it does make a great difference to the working lives and professional expectations of most actors, and to what it means to *be* an actor. Rehearsals are the one time in which an actor can experience acting as a *collective* process, and it is also the time in which they can explore and develop their craft without the immediate pressure of being watched by a paying audience. Traditionally rehearsals have been regarded as a necessary part of the creative process; they are the location of any contestation of meanings that may take place before the performance is finalised.

Time spent making television programmes which use actors, whether on location or in the studio, is extremely expensive; consequently rehearsals are kept to a minimum and dispensed with altogether when possible. There is seldom time (or indeed, a perceived need) for rehearsals. On a series such as *The Bill*, for example, there are literally no rehearsals for actors at all, other than those informally organised by the actors themselves when the director is otherwise busy setting up the shot. Indeed, many television directors consider actors' rehearsals to be unnecessary. Their concern is with directing the camera; actors, they assume, have been paid to 'rehearse' at home. The exceptions to this rule come about when, for example, a 'high art' product is transferred to television. For example, in 1995 the Royal National Theatre's production of David Hare's play *The Absence of War* was transmitted by the BBC. It was directed, as it had been at the Royal National Theatre, by Richard Eyre. Eyre chose not to film a staged version of the play, but to re-direct the text as a film (shot largely on location in Manchester Town Hall). However, the conditions under which the BBC facilitated the filming were qualitatively different (and superior) from those of the vast majority of television drama. Eyre was given one week to rehearse for camera (with a cast unchanged from that used by the RNT), and the luxury of five weeks for shooting – five pages of script per day! The fact that the production was shown at all on television was probably also due to the fact that it starred an actor very well known to television audiences – John Thaw of Central Television's popular *Inspector Morse.*

As a result of enforced changes in employment practices, an understandable ambivalence about working on television has developed amongst actors. Most acting for television, although giving valuable employment opportunities to actors who would almost certainly otherwise be without work, is now in effect a dis-empowering of the actor and a de-skilling of the craft of acting. It creates a working situation in which actors are isolated from one another, and it removes from the individual actor, and from the actors as a collective, interested party, any real creative scope to influence the eventual outcome of the production. The filming of most television drama takes place on location because this is cheaper than renting expensive studios. The conventions of filming exclude opportunities for extended ensemble playing, and even in a scene involving only two characters, the way in which it is shot often means that only one actor at a time is required on the set. Responsibility for the narrative, and the skills required to sustain and deliver it to an audience, is relocated by television from the performer to the editor and the cutting room.

All this is contributing not only to radical changes in what acting is, and, I would argue, to the decline in range and quality of the acting pool that is available, but it is also leading to what must be the eventual homogenisation (if not to the actual destruction) of the aesthetics of live theatre. Unless change happens soon, theatre may suffocate, not least because so many actors find it increasingly difficult to transfer the minimalist techniques and the fractured bursts of on-camera energy and concentration required for the screen into the very different playing conditions required in live performance; especially those designed for large stages.

It is no surprise, therefore, to have witnessed over the last twenty five years the growth of small studio theatres. Their evolution, like the decline in large cast plays, is down to more than simply economic expediency on behalf of theatre managers. It also signals that actors (and directors, writers and audiences) *all* now feel more secure when small casts and minimalist acting conventions are being employed in order to reproduce the desired intimacy so familiar from televised dramatic encounters. There is a real danger too that the shrinking pool of existing theatre-going audiences are gradually being de-sensitised, and becoming less receptive to the more expressive and large-scale alternative conventions of theatricality still available in at least some theatre-based performances. Spectators who are never deliberately made aware of the contrived nature of the fictions they consume are in no position to contest them.

Although television gives work to actors who might otherwise be unemployed, I have argued that its influence over theatrical performance practices is generally negative. Its power and economic, as well as aesthetic influence, actually reduces the number of opportunities actors have to be part of an active theatrical culture of scale, power, and risk, down to a controllable and safe inter-play largely to do with representing bourgeois domesticity.

The broadcast output of television demonstrates an almost schizophrenic attitude towards actors. On the one hand, the majority of its practices signal a disregard for

maintaining and fostering the skills of the majority of those it employs as actors; on the other it looks back with nostalgia (especially in televised award ceremonies) to the past, where the conditions of most televised drama mirrored those of the theatre. But television also vaunts the classical theatre actor, paradoxically celebrating the very training methods and techniques which it will not (or cannot) use.

In the occasional programme which focuses on classical actors, everything is usually done to disguise the fact that television is the medium through which the actor's work is being illustrated. Invariably these one-off Arts documentaries feature established actors: individuals who have made their artistic reputations on stage and, to a lesser extent, in film, as opposed to television (which has often been responsible for dramatising their private lives). For example, in London Weekend Television's *South Bank Show*, a 1994 programme featuring Vanessa Redgrave had the actress interviewed by the show's regular presenter, Melvyn Bragg, but the interview was interspersed with footage showing her rehearsing and performing a staged scene from Shakespeare. Despite being interviewed for a television programme, Redgrave was not shot in an obvious studio setting, but in a domestic interior complete with symbols of high culture; there was no television in the room, but there was a grand piano, carefully arranged flowers, and elegant and expensive furniture and fabrics. The chosen examples of her work, and its enactment (extracts from *Anthony and Cleopatra*) were filmed not in a television studio but in the archaic setting of the St. George's *theatre*. (Ironically, when a year later, the production of *Anthony and Cleopatra* for which Redgrave was preparing was finally staged, it was in the Riverside Studios, a complex of converted television studios.)

Even less frequently, television will attempt to explore not just an individual actor but acting as a job of work. Once again, however, that world of work is invariably assumed to exclusively be that of the theatre, not of television. Furthermore, it is not the commercial or popular theatre that receives attention, but work undertaken in the subsidised companies, particularly that most closely associated with the prestige and cultural status of the National poet: The Royal Shakespeare Company. In order to get commissioned, and to secure air time, documentaries on the RSC and the actors who work in it are predicated on the assumption that the target middle-class 'Arts Programme Audience' will be able to contextualise the subject and invest it with meanings of their own.

In BBC1's 1991 *Omnibus* documentary *Living Shakespeare: a year with the RSC* the opening shots of half-timbered houses quickly located the viewer in the Stratford-upon-Avon associated with heritage and antiquity. The programme makers made all the locations chosen for filming the activities of members of the RSC as different and unconnected to those of a television studio as possible. Shots of the 1930s foyer of the Royal Shakespear Theatre, and those taken back stage both there and in The Swan Theatre, were indeed sites for acting and spectating, but they were constructed by the programme makers as different, rarefied art houses, in which the true mysteries of theatre were created by actors. The film's creation of an appropriately solemn magisterial atmosphere was assisted by

shots of the stage accompanied by organ music, and the voice-over of an anonymous actor telling the viewer that, 'as far as the theatre is concerned, it's a cathedral, an enormous thing that just goes up and up'. He went on to add 'it's heady addictive stuff being here in this building. Whenever I come in the stage door and inhale the mixture of dust, sweat, make-up and paint, I get a fix'.

Throughout the documentary actors were given similar opportunities to indicate that they were somehow softer, more sensitive and ethereal, but less *weighty* and serious than the directors of the company. Both established and novice actors were seen in a variety of settings – in rehearsal, at home in their Stratford digs, in performance, and alone, talking direct to the camera. However, proportionately more air time was given to those whose job it is to direct and control the actors' world of work, the directors (past and present), of the Royal Shakespeare Company. Unlike the actors, they stated a position, and put forward an argument; there was no attempt to contest their statements. The actors, on the whole, were shown expressing – *doing* rather than thinking or talking or arguing about how something should be done. They were made to appear largely passive by the television coverage which reflected but also legitimised the dominant power structure and hierarchy of the directorcratic RSC, and that of most other British theatrical institutions.

This documentary, like others subsequently made by or on behalf of the BBC, for example *Omnibus*'s 1994 film *Every Inch a King* based on Robert Stephens' performance of King Lear for the RSC, exploited the camera's ability to penetrate beyond the policed stage door, and to take viewers 'back stage'. It offered them an apparently privileged (and voyeuristic) access to a closed and private environment. The effect was enhanced by scenes which included a preponderance of shots in cramped spaces (dressing rooms, corridors) and by the unusual practice of interviewing Stephen's during live performance. However, far from this serving to demystify the process of how plays are made, and in particular the potential as well as the actual role of actors (as opposed, in this case, to one individual actor) in making them, this programme only added to the general mystique that actors spend all their time in theatres.

In 1993 British television viewers were given a unique opportunity to take a prolonged look at an aspect of an acting rarely if ever considered by any part of the mass media: the training of actors. *Theatre School*, directed by John Barnes, was transmitted in five episodes by BBC2 at 7.40pm in the winter of 1993. It was a documentary, made for the BBC by an independent production company, which set out to look at how actors were trained at a London drama school. However, what was represented in the subsequent episodes was a training specifically for the theatre. Classes in voice and improvisation were illustrated, students were filmed in various acting exercises before live audiences, but nothing during the hours of filming indicated that students were trained specifically to perform for a camera. Only in the final episode was it acknowledged that of those graduating from the course, the majority would find work, if they succeeded in finding any at all, in television.

The Drama Centre, in Chalk Farm, London, prepared young actors for what was referred to throughout the series, as 'the profession'. The choice of the Drama Centre is revealing. Britain has many accredited acting schools, and some university departments of drama also offer professional training for actors. It would appear that the Drama Centre was chosen as the location of the series because it is well known as an acting school with teaches an approach to acting based on the teaching of Konstantin Stanislavsky (1865-1938), the founder of the Moscow Art Theatre, who taught actors how to be more natural and to appear more spontaneous in their work. The training at Drama Centre involved what Sir Anthony Hopkins called on camera in this series, 'an emotional stripping down'. The Drama Centre's curriculum with its emphasis on the self-revelation of emotionally immature young people, was a process eminently suited to voyeuristic television dramatisation.

The documentary makers' choice of an episodic narrative format and, whether consciously or not, the use of many conventions familiar from popular television drama serials, made the transmission of *Theatre School* into a serial drama in itself. Like other products of the genre, it was filmed entirely on location, used a rolling narrative, fast inter-cutting (preferring intimate close-ups to long/wide shots); it had atmospheric lighting; contained lots of action and not a lot of dialogue, and offered an abundance of human interest stories. The series contained several linked personal narratives (of selected student actors) and their real and enacted 'dramas' were recorded through various crises that apparently befell them. Continuity through all five programmes was provided not only by the voice of the anonymous male narrator but also by the weekly on-screen presence of the main character, the Principal of the school, Christopher Fettes, seen talking to students in groups, and talking to the camera.

The screening of the opening episode was prefaced by the voice of the (female) continuity announcer setting the tone of the new series by preparing the audience to anticipate a provocative unfolding of a new narrative. As the BBC2 ident. appeared she announced 'Naked ambition now on Two as the process of literally bearing all begins'. The opening titles for the series then illustrated a complex but clichéd picture composed of both still and moving images. There were the familiar paraphernalia associated with live theatre: masks, hats, fans, make-up, and a script, but also student actors could be seen through the alcoves of what looked like a cut-out toy theatre, but was actually a photograph of the facade of the redundant church that houses the Drama Centre. All this was located within a 'skip' (a large wicker basket). This Pandora's Box was set on bare boards presumably placed there to represent a stage. Nothing in the image suggested that acting in the late twentieth century had any connection whatsoever with television. As the camera tracked back from the image the accompanying sound track moved from a sung harmonic voice exercise executed by the students, to the familiar strains of another ancient theatrical cliché – a camp male voice singing Noel Coward's 'Don't put your daughter on the stage Mrs Worthington …'

The first episode was designed to shock by emphasising the supposed differences between the process of acting and other forms of behaviour – both public and private. It chose to illustrate extreme dramatic situations chosen from the range of work undertaken within the school in contrast to other, later episodes, which illustrated more familiar, safe, and domestic dramas. It quickly fulfilled the expectations raised by the mock-warning of the Coward song by showing, in the first five minutes of transmission, images of young women as vulnerable, passive, and undressed.

In the first frames, viewers were shown a close up of an open mouth, uttering the sounds of a woman apparently in distress. The focus then widened and the camera position changed so that spectators saw, from behind, a group of six anonymous people, seated in a room, all looking towards a young woman sitting on a chair, plainly in a state of considerable emotional distress. Her recollection of an apparent childhood trauma was gently but insistently prompted by a male tutor. The way in which the emotional memory exercise (for that is what it was) was set up, and the way in which it was shot by the director, emphasised the power of the spectator and the vulnerability of the player – she was alone, exposed, and separated from the group, her distress was played out (encouraged and prompted by the tutor) and although it was notionally for her own benefit, the public rather than the therapeutic nature of the event made it into a performance for those watching in the studio, and more significantly, those watching in the anonymity of their own room on television. As the student cried out in the echoing room, another contrasting voice, this time that of an omniscient male commentator, told viewers in soft and reassuring tones, that 'training to be an actor can be a complex and sometimes painful process'!

There was no attempt to contextualise or challenge the drama of this brief but telling opening sequence; instead it was rapidly followed by another action, this time of physical as opposed to mental exposure. Both events were presumably placed at the beginning of the episode in order to act as a lure for the series as a whole, and to introduce the viewer to the promised vicarious thrills involved in the privileged and anonymous position of a spectator able to observe the discomfort of those apparently submissively involved in the painful revelatory processes. The camera cut from the previous spectacle to show a different audience, this time made up of both males and females, sitting together with an older, casually dressed man who occupied a central position, all watching intently and in silence as a young woman, stripped to the waist, enacted washing herself, using a bowl, jug, and finally a towel to 'dry' herself. The camera lingered on the faces of the spectators, especially that of the older man, and on the woman's upper body. There was no commentary.

From these examples of the presentation of acting and spectating, the opening episode cut to another scene of intimacy, this one showing the older male from the previous sequence, in close up on camera and identified and given a status by the caption as: 'Christopher Fettes, Principal of the Drama Centre'. The chosen location for his on-camera interview contrasted sharply with the bleak, public spaces of the previous sequence. Fettes was filmed in a softer, quieter, and more refined domestic setting; a room filled with

solid polished dark wooden period furniture, a warm rich dark red carpet on the floor. The images of vulnerable exposure generated by the young actors were juxtaposed by the editing with a contrasting icon of confident authority: a fully clothed middle aged man, softly lit, and dressed in reassuring avuncular clothes: a sober brown sweater, white shirt, and brown tie. He seemed to have been dressed as if in a costume designed to offer reassurance to the viewer. Despite what they had seen, everything was now calm, considered, and controlled.

The reassurance offered to the viewer was enhanced by the cutting away from these and other unfamiliar and sometimes disturbing acting exercises to further on-camera interviews with recognisable (i.e. commercially successful) actors including, in the first episode, Simon Callow, Anthony Hopkins, Geraldine James and Penelope Wilton. Like Christopher Fettes, they all spoke directly to the camera, there was no interrogation of their text, no questions were asked and no interviewer was visible – their role was to justify, explain, and above all legitimate what was going on in the Drama Centre, and why those who constructed its syllabus believed it to be a necessary and inevitable rite of passage to becoming a successful actor.

In episode one, further reassurance (including that of Sir Anthony Hopkins) was followed by another short narrative sequence, again one illustrating the vulnerability of the young actors. The camera cut to an exterior location shot and framed an image familiar from the screening of romantic fiction. A young woman is seen at a distance, walking towards the camera; she is apparently alone and on a deserted beach. The brief sequence is captioned 'Lossiemouth, Scotland'. An on-camera interview followed in which the young woman was identified in the surroundings of what, presumably, was her own home, as 'Caroline'. She talked to camera in anticipation of taking up her place at the Drama Centre. She spoke of the 'typical view that it (the theatre) is all about sexual perverts and all that…' Her parents, filmed in their home, were then given the opportunity to express their anxiety (echoing the 'typical view' and the sentiments of the Coward song) plus their fear of modern urban living, and especially of London 'kids getting into drugs and all that sort of thing.' This articulation of general and non-specific anxiety and fear of the Other was heightened by the location of the filming – a deserted beach and a domestic interior in a small Scottish town almost as far away from London as it is possible to get in the UK, and also by the age of Caroline, seventeen we later learn, but looking younger. 'My mum's sat me down and made me promise never to take my clothes off on stage' Caroline confided to the camera, 'but I want to do that one day'. This statement was immediately followed by a cut, taking the scene back to the rehearsal room in London where the same half-naked student actor witnessed in the previous sequence, was being observed by *a different* audience, this time one made up exclusively of men. The camera was mobile, not static like the audience, it slowly circled the woman framing the upper half of her body.

The short sequence devoted to establishing Caroline's narrative was juxtaposed with that of another prospective student, Paul. He had been chosen by the programme makers to

be filmed, in deliberate contrast to Caroline, in an urban setting (Birmingham the caption informed the viewer) standing in front of a shop selling dance clothing. It is night, and the neon sign of the shop reflects up from the wet pavement. Paul is black. The location and casting echo the familiar clichés of many urban-based drama series. Paul is accompanied by a male friend, there is no footage of *his* family, or any suggestion that they might be concerned about his future city life, sex, and possible involvement with drugs. Instead, Paul's rite of transition is represented as a clichéd clash of cultural expectations as he undertakes *his* equivalent of appearing naked on stage: entering the shop, and, squirming with self-consciousness, asking the male shop assistant for 'a pair of size 11 or 12 ballet shoes – black leather'.

The final prospective student's narrative took the viewer to another familiar location of television drama – an urban scene of back-to-back houses, cobbled streets, and washing on the line. This, the caption informed the viewer, is Nelson, Lancashire. The student selected was identified as Nicola; she, her mother and mother's friends (seen in one shot watching TV whilst talking) all talk with broad Lancashire accents. This soap opera setting is given comic potential by the voice over comments of Nicola's mother: 'To think that a girl from Nelson has been picked at 18 to go to London drama school … it's like a dream in't it really … A few people from round here have made it, but not many. The Hollies (a 1960s pop group) came from round her, well, one of them did.'

These three carefully chosen locations, and the casting of the main protagonists, add up to scenes from provincial life in which three young and naïve characters are foregrounded. Their stories are designed to clash and contrast with the footage in the first episode showing scenes from the training process, and interviews with older, sophisticated 'expert' witnesses from the 'profession' and alumni of the metropolitan Drama Centre.

The initial experience of the training at the Drama Centre from the student's point of view is narrated through the observation of Caroline and Paul as part of a class in which, once again, the private is made public, and sensibilities are tested. They, along with other students, are set the task of silently enacting the rituals of waking up and getting dressed – including, in Caroline's case, awkwardly miming (clothed in a black leotard) going to the lavatory. '… that for me was an absolute nightmare' (Caroline).

The first episode also introduced the viewer to another middle aged male, who, like Fettes, was to become familiar to regular viewers. He was filmed in a classroom at Drama Centre together with a group of young student actors including Nicola. They were silently taking notes. The man was identified to viewers by the narrator as the 'legendary Yat Malmgren.' Following a brief gnomic statement to the class about the 'outer outer and the inner inner' Nicola informed the viewer 'that he is obviously so advanced and we're so dumb that a lot of things he finds difficult to explain to us'. Like Fettes, when Malmgren was subsequently interviewed on camera, he too was placed in a private, domestic space, chosen (by the director?) to enhance his authority and authenticity. There are significant 'props'

present in the image: more antique solid dark furniture, but also silver candlesticks, a decorative flowered vase, and other signs denoting class wealth, quality and maturity. There is no direct attempt to question either Fettes or Malmgren, or Nicola's statement. Their words are left for the viewer to digest. But both men have been constructed by the filming as teachers (not actors) who are powerful authority figures, keepers of esoteric and valuable truths which to acquire is both a rare privilege and an act of self-revelation requiring suffering. This construction was never interrogated by the documentary, and the representation of actors, and the job of acting, was thus seen as essentially involving an unproblematic submissive acceptance of the authority of the teacher.

The first episode ended on a note of apparently real and spontaneous, as opposed to contrived, drama: Caroline hears that her local authority is refusing to give her a grant for the three years of the course and that she must fund the first year's training herself. But how 'real' was it? The tearful Caroline was filmed on the telephone to her mother. But was this another emotional memory exercise? Was her mother really on the other end of the line? Will she get her money? Can she carry on? Will Paul and Nicola live up to their potential? With these questions hanging viewers were left awaiting the sequel promised in episode two.

All three young actors had been personalised (Caroline, Paul and Nicola) and represented as players in dramas (Romance, Drama, Comedy/Soap). They were also represented, together with others, as apparently powerless players in a scenario controlled, directed, and understood by others. Despite the fact that other teachers were occasionally seen at work in the Drama Centre, it was Malmgren and Fettes who were constructed by Nicola and other students, and by the creators of the series, as the central figures in the unfolding drama. They were represented as all-powerful and wise, worthy not only of unquestioning respect, but even of worship: 'If he (Fettes) says good morning to me in the corridor I completely faint … everything that he said in the first year was so inspiring, to the point of tears … thank God, thank God that I came here!'.

In a subsequent episode, Paul, following a reported unauthorised absence, was used to represent another example of the apparent power relationship between these young actors and those with authority over them. Fettes and Malgram, were, 30 years ago when he first met them as a student, 'merciless' according to the admiring tones of Sir Anthony Hopkins. 'Fettes would strip you down in order to build you up again.' In a scene filmed in Fettes office, with the latter seated behind a desk, the Principal is represented as the caring Father, Paul as his wayward child who must be gently but firmly chastised, 'look here old love, this won't do', and thus brought into line. Other young and intelligent people were filmed being subjected to a less gentle approach. They were publicly insulted and humiliated ('you are like a dead fish'… 'your work is crap' – Malgram).

All the young people witnessed in the series were at the Drama Centre to learn how to become actors, there to learn, which, if the camera was to be believed, meant learning to

do as they were told, learning to obey instructions even when they were not fully understood: 'Yat's training is completely fascinating and completely baffling' (Geraldine James). But was the camera to be believed? Was television simply using the school, its staff and students, in order to fabricate myths about actors? That they are 'chosen'; that their future work actually *requires* a highly complex and often painful rite of transmission; that they are inevitably slaves and not masters, people who are capable of feeling ('luvvies') but who lack intellectual skills. The programme certainly appeared to lack balance, it opted from the first episode to foreground the dramatic as opposed to the reflective and self-critical aspects of the work. It achieved its impact by highlighting (and perhaps contriving) obvious situations of conflict and stress, compressing in the process three years of training into a few hours of television.

Throughout the entire series, the on-screen chorus of distinguished actors all supported and confirmed the authority and legitimacy of their training (they were all trained at The Drama Centre) and emphasised the need for 'discipline' (Geraldine James); in the theatre 'they do need whipping along' (Warren Mitchell). *Theatre School*'s continual referencing of these external authorities (actors who were well known to a television audience) was meant to lend credence and legitimacy to what might appear, from the evidence of the series, to be an almost unbridled use of power over young people. The personal narratives not only in episode one, but throughout the series all emphasised that if an actor is to succeed in 'the profession', s/he must not be 'difficult' but malleable, learning to do what s/he is told without hesitation or question. The actors in *Theatre School* were never seen actually wielding any real authority of their own. Their training as represented by television was in *how* to act. There was no debate either in the series, or in the way in which television continually represents (or ignores) the actor, about what acting is, or what it might be. No admission that there are potentially many ways of acting, a multiplicity of choices, controversies, different approaches, and contrasting opinions. Actors were constructed by *Theatre School* as people who do not ask questions, and above all never challenge authority. Their role is to act and to react, not to generate actions of their own, or to provoke them in others. This essentially passive mode was, as television constructed it, apparently an ideal formula for the creation of a compliant and obedient actor workforce: in fact just what the industry of contemporary television drama production requires.

SHAKESPEARE RESCHEDULED

CAROL BANKS AND GRAHAM HOLDERNESS

But then are we in order when we are / Most out of order.

(Jack Cade, *The First Part of the Contention betwixt the two famous Houses of Yorke and Lancaster* or *The Second Part of King Henry the Sixth*. 4.2. 188-9)

Shakespeare's English history plays were originally composed out of chronological order, *Henry VI Part 2* preceding *Henry VI Part 1*, and all the *Henry VI* plays and *Richard III* preceding *Richard II*, both *Henry IV* plays and *Henry V*.[1] Hence the common references to the first and second tetralogies, when in historical chronology they are the other way around. It seems highly improbable that in the theatre of their origin the plays were subsequently staged as 'sequences'; on the contrary, recent research indicates that each was independently and individually shaped by contemporary cultural pressures.[2] Certainly in later theatres they existed in disaggregated form, with plays like *Richard III* and *Henry V* used as star-vehicles for the great actor-managers, whilst the *Henry VI* plays were virtually forgotten. Nevertheless, the lives and the historical events recalled in these plays first occurred in chronological sequence, in the seamless past out of which England's history is written; and, although cinema continues to produce individual plays in isolation, as exemplified by film versions of *Richard III* (Olivier, 1955) and *Henry V* (Olivier, 1944 and Branagh, 1992), the historical model of ordering and linking the plays into groups, has become the preferred mode of presentation for television productions from *An Age of Kings* (BBC 1960) to *The BBC Television Shakespeare* (BBC/Time-Life 1978–85). The purpose of this essay is to examine the aesthetic and ideological implications of television's rescheduling of individual plays into a grand historical epic or meta-narrative.

Television producers are not the first to re-order the plays in historical sequence. When Shakespeare's work was first collected and published in the prestigious 'First Folio' of 1623, the editors of this posthumously printed volume also chose to present the ten plays, catalogued as 'Histories', in their historical order. Here, like the renamed television dramas: *An Age of Kings* (BBC 1960) and *The Wars of the Roses* (BBC 1964), titles of plays which had previously appeared in single quarto format were also altered. For example, the quarto text descriptively entitled: 'The first part of the Contention betwixt the two famous Houses of Yorke and Lancaster, with the death of the good Duke

Humphrey: and the banishment and death of the Duke of *Suffolk*, and the Tragicall end of the proud Cardinall of *Winchester*, with the notable Rebellion of *Jake Cade: And the Duke of Yorkes first claime unto the Crowne*', became simply *The Second Part of King Henry the Sixth*. Changing the order of presentation and the titles, immediately creates a new 'literary' position for each play, suggesting not the individuality of specific events, but continuity; an arrangement which also begins to resemble a more 'natural' order, rather than artificial or aesthetic composition. However, it is important to observe that this orderly grouping of the plays within the 'First Folio', a practice continued in subsequent collected editions,[3] was an editorial, rather than an authorial or theatrical strategy, a change which, first and foremost, satisfied the conditions of printing, particularly of lengthy volumes of collected writing. The Jacobean 'First Folio' came into circulation at a time when printing plays for a reader was a new idea; Elizabethan drama was not a 'literary' genre but still very much an oral/visual art form. Each live performance was, by its very nature, a unique presentation; its form was therefore fluid and unstable, open to free adaptation and interpretation. However, once transformed into the linear printed text, set out on numbered pages in a bound book, that transient art was captured and fixed, permanently pinned down in a form which has more in common with the chronicles of Tudor history than the shared living experience of transitory theatrical performance. Literary editors and critics from Alexander Pope to the present, have examined Shakespeare's plays in terms of the printed text, and earlier this century those history books were brought into closer affiliation with the plays when a group of scholars agreed on a highly influential theory for not only reading the plays in sequence but also interpreting them as a linked series.

During the second world war the Cambridge academic, E.M.W. Tillyard, no doubt anxious that peace and stability would soon be restored, re-examined those printed play-texts in conjunction with Tudor historiography and came up with a theory based on order, an 'Elizabethan world picture' which he saw reflected in those past works of a bygone, golden age. In *Shakespeare's History Plays*, published in 1944, Tillyard further claimed that 'Shakespeare conceived his second tetralogy as one great unit', and that 'Disregarding the two isolated plays [*King John* and *Henry VIII*], we can say further that the two tetralogies make a single unit' (1980: p. 234 & p. 147). This overview won the support of many subsequent scholars,[4] who also examined the texts producing various readings to endorse the notion that the history plays were a linked and integrated series, revealing a broad and complex panorama of national life, unified and balanced into a coherent aesthetic 'order' mirroring the political order of the Elizabethan state. Like the current trend for drama documentaries, the drama, which was created partly from facts, when reassembled to emulate past lives, moved closer to a type of historical 'faction'.

Until the 1950s theatrical performances of the history plays, motivated by the conventions of the 'live' stage (two to three hour individual performances, their success or failure depending on audience response), remained disaggregated; the popularity of individual plays such as *Henry V* and *Richard III* nurtured, in much the same way as their

cinematic equivalents, by the opportunity they afforded to star performers to impress the audience with their fine acting abilities. Furthermore, as Richard David has observed, 'The man in the street goes to the theatre for a play, not a political treatise' and he (or she) 'is hardly prepared to stomach a trilogy, much less an "octology"' (1953: p. 129). But by the mid-century, as lines of communication lengthened and multiplied (railways and radio, telephones, telexes and television), linear sequential interpretations also penetrated performance. In 1951 Anthony Quayle directed the summer season of history plays at Stratford-upon-Avon, setting a precedent for the history 'series' in performance with the *Richard II* to *Henry V* 'tetralogy' performed from March to July in historical sequence, the programme for Richard II boldly consolidating contemporary literary theory, claiming that: 'It is generally agreed that the four plays of this season's historical cycle form a tetralogy and were planned by Shakespeare as one great play'. Added to this, Quayle's own remarks concerning the 'ignorance' he associates with the previous theatrical mode of presenting the plays in isolation, suggest that the sequential interpretation, developed in the loftier heights of academia, is somehow enlightening:

> … it seemed to us that the great epic theme of the Histories had become obscured through years of presenting the plays singly.

> … Successful theatrical practice over a great number of years had stealthily built a mountain of misrepresentation and surrounded it with a fog of ignorance.
> (Wilson and Worsley, 1952: pp. xviii-ix)

Not surprisingly, Richard David, reviewing the plays, commented that 'Everything in Anthony Quayle's production was focused on continuity, on the connexions and the likenesses between the plays, and their differences were studiously toned down' (1953: p. 129). But whereas theatre relied on a minority of extremely dedicated spectators to purchase all four tickets across the season, television had a ready made audience and established successes with both 'serials' and 'series', so the next step was easily made from theatrical tetralogy to television's first epic octology *An Age of Kings* (BBC 1960), produced by Peter Dews and directed by Michael Hays. The eight discrete plays, reassembled into fifteen 60-90 minute, weekly instalments, were now transformed into a continuous, all embracing metanarrative of English medieval history and brought within the reach of a large percentage of the population via the television screen. Once the sequential formula was established future televised performances followed suit, the BBC's Michael Barry enlisting The Royal Shakespeare Company directors – Peter Hall and John Barton in 1964, to produce a three part series of the first tetralogy (an adaptation of the RSC's *Henry VI*, *Edward IV* and *Richard III*), in which Shakespeare's three *Henry VI* plays and *Richard III*, were, like the Dews/Hays production, chronologically reordered, suitably cut, modified and renamed *The Wars of the Roses* (BBC 1964).

This infiltration of historical and printed modes into the drama was taken a stage further when video recordings added permanence and repeatability to television productions. When the ambitious televised series of Shakespeare's complete works was in the making

– *The BBC Television Shakespeare* (BBC/Time-Life 1978–85), these considerations were of particular significance, the original producer, Cedric Messina, explaining that: 'The guiding principle… is to make the plays, in permanent form, accessible to audiences throughout the world' (1978: p. 8), so that the spectator 'can go to the screen and see the whole panorama of the historical plays, leading one into another' (Andrews, 1979: p. 137). To tighten those sequential links between one production (or video recording) and the next, flashbacks to the previous 'episodes' silently open each play, e.g. *Henry IV* Part Two beginning with two clips from *Richard II* – Richard handing the crown to Bolingbroke and Richard's murder, followed by two clips from *Henry IV Part One* – Henry IV at prayer and the mortal combat between Prince Hal and Hotspur. Returning the plays to the popular oral/visual medium of film provides an opportunity for liberation from the fixity of the printed text, a move successfully achieved in certain cinematic versions of Shakespeare's plays, such as Akira Kurosawa's *Throne of Blood* (1957), and Peter Hall's *A Midsummer Night's Dream* (1968)[5]. The medium of television, being 'the only really "national" theatre' (Hawkes, 1973: p. 231) would also appear to offer unique opportunities for a democratic recovery of Shakespeare, a reappropriation of jealously-guarded fortresses of high culture for the popular audience. But the enchaining metanarrative structure imposed by television on the history plays succeeds rather in closing off possibilities for radical interpretation. Furthermore, as Messina rightly observed, video recordings are, like printing, a 'permanent form', and permanence lends authority to that enchaining metanarrative, authority which is easily confused with definitive 'truth' and further closure. To appreciate the way that subtle re-ordering so effectively denies alternative interpretations, we need to examine the narrative structure itself.

The components of any narrative may be divided into 'story' and 'discourse'. 'Story' covers *what* is depicted (characters, settings, happenings etc.) and the 'discourse' is *how* those components are presented, the means by which the story is communicated to the reader/spectator.[6] The selection and ordering of events within the narrative (the plotting) is part of the discourse, being how the reader/spectator is made aware of what happens. The plot may follow a resolved, causal pattern – one event leading to the next, or it may be one of revelation in which the function of the discourse is not to supply answers/resolutions, but merely to reveal a particular state of affairs. When the history plays are interpreted collectively each play becomes a 'story' component (a group of characters and events) in a wider narrative. If these are then arranged chronologically, the temporal linking produces a strong sense of unravelling in terms of cause and effect, in other words a resolved plot; whereas if they are randomly arranged the causal element diminishes and connections appear in other ways. Resolved plots follow a linear structure, being predominantly a chain of events; revealed plots, a characteristic of much 'modernist' fiction, are more amorphous and do not propel the reader/spectator forward towards a final closure but invite her/his participation in the work. The editors and directors who rearrange the plays in linear chronology are therefore manipulating a resolved meaning by the very structure they impose upon the diverse components, a structure which denies the comparative freedom of a revealed plot and with it the possibility of radical interpretation. Alan

Sinfield points out how a belief in 'order', can even unite quite different interpretations, as was the case with the Barton/Hall production *The Wars of the Roses*, in which the apparently opposing views of Tillyard and Jan Kott (*Shakespeare our Contemporary*, 1967) become 'two sides of the same conservative coin' (Dollimore and Sinfield, 1985: p. 131). Hall said that his direction was guided by a belief in Tillyard's 'Elizabethan World Picture': 'All Shakespeare's thinking, whether religious, political or moral, is based on complete acceptance of this concept of order'; yet his equal conviction that 'Shakespeare always knew that man in action is basically an animal' (quoted by Sinfield, Dollimore and Sinfield, 1985: pp. 160 & 162), supports Kott's view of 'a cruel social order in which the vassals and superiors are in conflict with each other, the kingdom is ruled like a farm, and falls prey to the strongest' (Kott, 1967: p. 25). As Sinfield observes, the combination of these views is 'powerfully conservative' in so far as it 'offers no hope for humanity and no analysis of the sources and structures of injustice' (Dollimore and Sinfield, 1985: p. 162). In spite of Kott's repudiation of Tillyard's view, his image of history as the 'implacable roller' which 'crushes everybody and everything' (Kott, 1967: p. 39), leaves no hope for escape from the causal chain.

The structural linearity imposed by editors and producers in support of their political/ideological convictions, is certainly compatible with the plays in printed format, but it is far less significant in oral/visual art forms. Traditional oral narratives (still evident in ballads, fairy-tales, nursery rhymes, myths and legends) depend on human memory for retention and are therefore structured, like poetry, around balanced patterns, repetitions, antithesis, and thematic links.[1] These connections do not merely move along a horizontal line of causal enchainment; there are vertical links, reversals and circular rotations. It is worth noting here that certain play titles: *The Life and Death of King John* and *The Life of Henry the Fifth*, suggest that 'life' itself is the guiding principle here and within the plays 'life' is repeatedly described in circular patterns: '... life did ride upon a dial's point, Still ending at the arrival of an hour' (*Henry IV Part One* 5.2. 83-4). Considering the history plays collectively within an oral network, vertical parallels may certainly be drawn between kings of the same name, such as Richard III and Richard II, and perhaps it is more than a coincidence that the plays *Richard III* and *Richard II* were both printed in quarto in the same year — 1597. These kings then invite comparison, the sinful Richard III, a debased, but skilful schemer, offsetting the weak, yet saintly Richard II, as regal as pride and piety permits, each thus achieving definition by contrast with the other. Similarly, and more overtly, the rebel Jack Cade in *The First part of the Contention*, is actually compared, within the play to the hero king Henry V:

> Is Cade the son of Henry the Fifth
> That thus you do exclaim you'll go with him?
> Will he conduct you through the heart of France
> And make the meanest of you earls and dukes?
> (4.8. 189-192)

Once identified on a parallel scale, further equations begin to emerge. For example, Jack Cade denounces literacy in favour of orality:

Away! Burn all the records of the realm. My mouth shall be the Parliament
of England.
(4.7. 12-14)

Although Henry V is far from illiterate, he not only admits his inadequacy when it comes
to rhetoric, but forcefully justifies his own plain speech:

> I am glad thou canst speak no better English, for if thou couldst, thou wouldst
> find me such a plain king that thou wouldst think I had sold my farm to buy my
> crown ...

> ... before God, Kate, I cannot ... gasp out my eloquence ...

> I speak to thee plain soldier ... take a fellow of plain and uncoined constancy, for
> he perforce must do thee right, because he hath not the gift to woo in other
> places ...
> (*Henry V* 5.2. 122-156)

In this speech alone the linking of 'king', 'soldier' and 'fellow' are made by repetition of
the epithet 'plain'. The parallels drawn between the rebel Cade and Henry V seriously
question the theory that, to the Elizabethans, Henry Monmouth was 'the ideal represen-
tative of order and security' (Wilson and Worsley, 1952: p. 22). Instead the effect is one
of levelling, a view more obviously conveyed in the quarto play of *Henry V*: 'The Chronicle
History of Henry the fift, With his battell fought at *Agin Court* in *France*. Together with
Auntient Pistoll' (1600), where Henry is less of a hero in the epic and historicist mode, but
more a gentle gamester:

> For when cruelty and lenitie play for a Kingdome,
> The gentlest gamester is the sooner winner.
> (Holderness & Loughrey, 1993: p. 60)

In this play the distinct plebeianising and carnivalisation of the monarch effectively sets
monarch and man face to face in a ritual enactment of that myth of equality which under-
lies the comic romance motif of 'the king disguised' (see Anne Barton, 1975); and here
the orgiastic festival of violence, celebrated on the field of Agincourt, aligns Henry very
closely with the man from Eastcheap – Pistoll:

> *Kin*... What new alarum is this?
> Bid every soldier kill his prisoner.
> *Pist*. Couple gorge.
> (Holderness & Loughrey, 1993: p. 73)

Notably, Pistoll's name, like that of Jack Cade, is also given a place of prominence in the
play's title.

Of course a strong case for interpreting the histories as linked sequences is the presence of the word 'part' in certain original titles, but even here the various parts do not necessarily follow in temporal sequence. The first *Henry IV* play, originally entitled: *The History of Henry the Fourth* (Stationer's Register 1598), includes various episodes depicting Henry IV's son, Prince Hal: his involvement in wayward dalliances at Eastcheap and Gad's Hill; the battle of Shrewsbury in which he replaces Hotspur as the chivalric hero; and finally his reformation as, in the closing scenes, he takes up his regal position to climb with his brother 'to the highest of the field' (5.4.159), before being united with his father 'To fight with Glendower and the Earl of March' (5.5.40). On the Elizabethan stage, this clearly proved a popular play, not least due to the creation of the fictitious character Falstaff, who brings a riot of carnival colour to the events depicted, so much so that, as legend has it, the queen herself requested to see another play showing Falstaff in love (Wells and Taylor, 1988: p. 483). After Falstaff's second appearance in the non historical play *The Merry Wives of Windsor* (where the women are allowed to get the better of him), he was again returned to the stage for a second involvement with the prince. However, *The Second Part of Henry the Fourth* does not pick up from where the earlier play left off. Instead it returns to the battle of Shrewsbury via the allegorical figure 'Rumour', who reminds the audience, in a fine piece of double talk, not to believe what they may have heard: 'From Rumour's tongues / They bring smooth comforts false, worse than true wrongs' (Induction, 39-40). The audience soon learns that Hal is not, as the first play had led us to believe, reformed, but is still cavorting around with his low-life comrades. This play goes on to repeat a similar pattern of events to those previously enacted – Hal up to no good in the tavern; Hal proving his royal worth, and finally Hal once more taking up his regal position, this final point of departure having indeed moved on a year or so to effect the death of Henry IV so that Hal may be crowned and this time make a more positive rejection of his unruly friend Falstaff. The second part considered in this way does not roll on from the first, but doubles back, attempting to repeat that earlier successful performance.

This repetitive technique is successfully employed in numerous television 'series' where a main character, or group of characters repeat similar 'adventures' in each successive programme, as for example in *Lovejoy, Miss Marple* and *Batman*. But the pattern was certainly used in oral myths and legends, such as the adventures of Robin Hood and the tales of King Arthur. Non sequential structuring still shaped manuscript or early printed collections of stories and Murray Roston cites the widely read *Legenda Aurea* by Jacabus de Voraigne (c.1297) as an example of a collection of saints stories which 'lack any co-ordinating thread or rational order other than their shared didactic purpose' (1987: p. 203). Alternatively a collection of stories, such as Chaucer's *The Canterbury Tales* (c.1387), could use a particular scene/setting – the road to Canterbury, as an organising framework. This contextual structuring was similarly used in the visual arts of the early Renaissance. The sculptor, Ghiberti, united his 'continuous narration' (episodes of a story that are disparate in time and place shown as though occurring simultaneously) of Jacob and Esau (*Gates of Paradise* 1452, Florence) by means of an architectural perspective – an arched loggia (Avery, 1970: pp. 51-2). In terms of two or three part narratives, such as the Henry plays,

it is illuminating to compare them with other grouped visual representations such as diptych or triptych paintings.[8] The *Wilton Diptych* (c.1400), previously at Wilton House – home of the Earl of Pembroke, to whom the 'First Folio' was dedicated, comprises two separate images: an earthly grouping of the monarch (Richard II) and saints (St John, St Edward the Confessor and St Edmund) and a spiritual revelation of the Virgin, Christ child and a host of angels. The frames are not chronologically linked, this is not a case of Richard's arrival in heaven; they share neither the same scale nor the same space/setting, but are brought into conjunction thematically as a celebration of Richard's piety. In another more complex example of pictorial narrative – Piero della Francesca's *Legend of the True Cross* (1452–1466, S. Francesco chapel, Arezzo), it has been suggested that the Renaissance fascination with mathematics[9] could supply the linking formula for the random composition of the ten scenes which make up this fresco narrative; a cycle which 'abounds with such echoes and reflections – thematic, liturgical, and formal – in a dense network that crosses horizontally, vertically, and diagonally' so that 'the chronological thread of the story, its succession in history, becomes lost in this web'; this apparently mysterious arrangement is unlocked by applying a formula based on a Pythagorean number theory (Perry Brooks, 1992). As these examples demonstrate the co-ordinating links which can serve to unite components in a narrative are far more diverse than the historicist obsession with temporal causality, an ordering which clings to a sense of 'natural' clock time as opposed to the more psychological, thematic, theological or scientific linking.

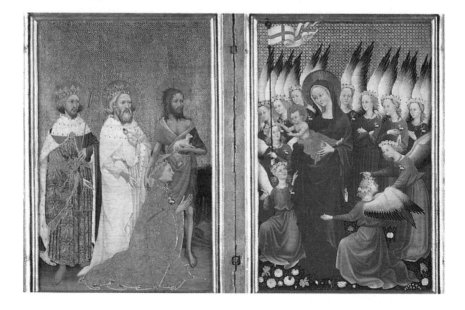

St. John, St. Edward the Confessor and St. Edmund recommend Richard II to the Christ Child.
The Wilton Diptych. Circa 1400.
London. Reproduced courtesy of the Trustees of the National Gallery.

The effortless acceptances of apparent 'naturalism' in historical ordering is itself enhanced by television, accustomed as we are to the 'natural' presentation of current news programmes (tomorrow's history), documentaries, chat shows etc. Jonathan Miller, who succeeded Cedric Messina as producer of *The BBC Television Shakespeare* plays, accepted this as the basis for his 'naturalistic' approach, maintaining that 'as soon as you put Shakespeare on that box where … people are accustomed to seeing naturalistic events presented, you are more or less obliged to present the thing as naturally as you can' (Hallinan, 1981: p. 134). Naturalistic settings, 'authentic' medieval costumes and a moving camera which roams in and out of the scenes, are amongst the devices employed to create the illusion of reality: and perhaps the most powerful convention of all for encouraging the sense of naturalness in terms of temporal continuity, and one adopted by all producers of the combined performances of the plays on television, is the use of the same actors for characters who appear in different plays, 'ageing' them in accordance with the imaginary passage of time. Reviewing *An Age of Kings*, Milton Crane noted how 'Robert Hardy's Prince Hal, grew visibly through *Henry IV* toward the magnificence of *Henry V*' (1961: p. 326). One notable exception within these overall naturalistic productions is Jane Howell's treatment of the first tetralogy for *The BBC Television Shakespeare*. Aware of the multiplicity of potential meanings, Howell refused to accept Miller's insistence on naturalism. Using a bare stage with minimal, emblematic props and scenery, a group of actors operating as an *ensemble*, doubling parts to prevent the illusionary identification of actor with character, Howell managed to high-light the 'artificiality' of her productions. However, even when the viewer is made patently aware that this is 'but a play', these attempts at a radical interpretation are still held within the restricting chain of temporal causality, conveying that orthodox 'providential' view which begins with a crime against God's judgement — the deposition of a rightful king (Richard II), followed by a series of bloody battles until the Tudor king (Henry VII) is lawfully restored.

What these epic productions are doing, under cover of an apparently 'natural' ordering of time, is channelling the viewer to accept implicitly a deliberate construct designed to convey a particular interpretation, an interpretation which, far from being the definitive course of history, is no more than a singular point of view from a specific ideological stand point. The singularity of that interpretation is evident in the very fact that events are seen in succession, one at a time; whereas interpretations from multiple viewpoints overlap, occur simultaneously or conflict. The ideologies informing that singular view are traditionalist / politically conservative, hence that unbroken chain of historical causation which denies radical change, digression or individual initiative. In establishing authority for that view television offers more than the opportunity for a naturalistic presentation.

Television, specifically the BBC, developed from radio, sound preceding pictures; whereas cinema's roots are in photography which became 'moving pictures' before sound was finally incorporated. Pictures may 'move the soul of the beholder' (Alberti, 1966: p. 77), but language is the means by which knowledge is transmitted. Where cinema continues

to function, like theatre, primarily as a source of entertainment, television (together with radio) fulfils a wider role in society, as a major means of communication and is arguably the most important medium for disseminating information about the outside world, bringing news and views directly into the home. The annual television licence fee is in part justified by this 'public service'. Regulations governing both the BBC and the IBA reveal their pursuit of 'public service broadcasting': 'to provide radio and television services for the dissemination of information, education and entertainment' and to ensure and maintain programme quality and standards (BBC's Royal Charter and IBA Act, 1973, Kuhn, 1985: p. 15). Unfortunately, 'the public' are not all satisfied by the same values and since broadcasting is a heavily selected interpretation of art and events, the question is whose interests are actually being served by the system? This was a point specifically raised during the Falklands war when television reports, attempting to remain impartial, were criticized by Margaret Thatcher for that very impartiality:

> Many people are very concerned indeed that the case for our British forces is not being put over fully and effectively. I understand that there are times when it seems that we and the Argentines are being treated almost as equals ...
> (Kuhn, 1985: p. 36)

The 'epic' interpretation of Shakespeare's history plays satisfies the interests of the culturally and politically conservative. Backed by traditional academia, it supports the mythical ideal of Shakespeare as the most celebrated of English authors – poet and dramatist, capable of conceiving and creating a national epic as did the great writers of ancient Greece and Rome – Homer and Virgil. Furthermore, it suggests that Shakespeare endorsed the ideologies of the Elizabethan ruling elite, or at the very least saw no alternatives; it subsequently denies the opportunity to peel back that glossy Elizabethan film and hear the voices of discontent that were already being raised and which culminated in civil war only twenty six years after Shakespeare's death. The basis for this argument, the 'providential theory', is of course retrospective in outlook, looking back to an older social order, justifying hereditary privilege and opposing change. Jonathan Miller, discussing *The BBC Television Shakespeare,* makes exactly this point when he maintains that Shakespeare was 'looking backwards over the chaos of the previous century during the Wars of the Roses ... And he comes down on the side of an orderly society ruled by an efficient sovereign' (1981: p. 145). The political outcome of these interpretations is to gild the pillars of state authority with cultural authority. The overall conservativism of the ambitious BBC/Time-Life productions may be seen as partly economic – satisfying the constraints of commercial underwriting – the series being in part financed by high-level, American, private enterprise for commercial gain, and partly the conservative cultural views of the original producer – Cedric Messina's emphasis on 'high-quality', 'durability', 'great' directors and 'classical' actors etc. Seen in this context it becomes clear that, where television may lend authority to the metanarrative structure, the medium itself does not dictate this view of Shakespeare's history plays, but rather the ideologies of those responsible for their production.

As Raymond Williams observed, the very nature of broadcasting in terms of organization, is one of 'sequence' or 'flow' (1974: pp. 88-90), this sense of continuous transmission is recognised instinctively when we talk about 'watching television' rather than watching a particular unit within that 'flow'. When plays are slotted into this continuum, rhythm and duration take on new significance. Hence the de-composition of the metanarrative into convenient parts, most notably the fifteen parts of *An Age of Kings*, and the compression created by cutting, in order to fit the events into hourly, ninety minute or two hour slots. Peter Saccio points out how in the BBC/Time-Life productions, the rhythm is altered, stretching out time by splitting scenes – for example in *Richard II* when the colloquy of Northumberland, Willoughby and Ross is depicted in a different location from the death of Gaunt (Act 2, scene 1), and condensing the passage of time via camera dissolves – occurring five times during Richard's prison-soliloquy. These compressions and decompressions of narrative time, made possible by filming techniques, create, in these productions, more space for history 'to peep through the interstices' (Bulman and Coursen, 1988: pp. 209-10). In this instance the nature of the medium has been used to satisfy the historicist interpretation, but it could equally be utilized to very different ends. The television viewer is for example, perfectly adapted to receiving a stream of fragmented, totally unrelated, presentations within the flow of transmission. A typical evening's viewing (without changing channels) moves from news to a satire on the day's news, to a documentary about Ireland, to a sitcom, then a 'behind the scenes' view of news-making, followed by one of a detective series, then a psychological thriller film (Monday 20 March 1995, 7.00 p.m. – 12.35 a.m., Channel 4); all this further fragmented by the intervention of grouped, disaggregated commercials. To avoid the commercials, viewers can, and do, switch over to pick up a fragment from a programme on one of the other channels. As a collection of disparate units the combination of these programmes resembles a 'revealed' rather than a 'resolved' mode of plotting.

When Shakespeare's plays were first transposed onto silent film they too were short 'extracts' – Beerbohm Tree's *tableaux vivants* from *King John* (1899) and the shipwreck scene from *The Tempest* (Tree/Urban 1903). These experimental films were predominantly 'visualisations' from Shakespeare, and were therefore much closer to pictorial art. In terms of historical drama, Tree's pioneering work continues to reverberate in the disaggregated approach and strong visual emphasis in cinematic productions of Shakespeare's histories, but it is a far cry from television's mode of presentation. Television, backed by video, now impregnates the oral/visual mode with both the authority and the permanence of print, whilst the 'factual' element within the plays encourages an easy acceptance of naturalistic and chronologically ordered presentations. From a post-modern perspective, in which art is recognised as artifice, it is important to see the picture within the frame. When Shakespeare's history plays are arranged to resemble 'real life', the danger is that the framing hand, manipulating those events towards their resolution, seems to be, as Stephen Dedalus explained, 'like the god of creation, … invisible, refined out of existence' (Joyce, 1960: p. 215), an idea far removed from the overt artificiality of the Elizabethan theatre. Television drama is as much a contrived construct as live theatre and

in a society which is increasingly returning to visual/oral modes of communication, television does offer an opportunity to represent pre-print art forms in a way which could open up interpretative possibilities. Instead of channelling the viewer blindly down a particular ideological alley, television could reveal further potential in Shakespeare's plays via their original order, which was 'Most out of order'.

NOTES

1. Our preference is to use original titles, but for the reader's convenience we have here employed those in more general use.
2. e.g. Leah Marcus, 1988; and Gary Taylor, 1989.
3. Wells and Taylor, 1988, return the plays to their order of composition. This edition used for quotations from Shakespeare.
4. Notably Lily Campbell, 1947; J. Dover Wilson, 1952; G. Wilson Knight, 1944.
5. This argument developed in Holderness, 1985.
6. See Seymour Chatman, 1978.
7. See Walter Ong, 1988, on oral structures.
8. Comparison between diptychs and the two parts of *Henry IV* also made by Sherman H. Hawkins, 1982.
9. See Michael Baxandall, 1988.

BIBLIOGRAPHY

Alberti, L.B. (2nd ed. 1966) (tr. Spencer, J.R.) *On Painting*. New Haven; London: Yale University Press.
Andrews, J.F. (1979) 'Cedric Messina Discusses *The Shakespeare Plays*', in *Shakespeare Quarterly*, Vol. 30, No. 2, pp. 134–7.
Avery, C. (1970) *Florentine Renaissance Sculpture*. John Murray.
Barton, A. (1975) 'The King Disguised: Shakespeare's *Henry V* and the comic history'. In Price, J. G. (ed.), *The Triple Bond*. University Park: Pennsylvania State Press.
Baxandall, M. (2nd ed. 1988) *Painting and Experience in Fifteenth Century Italy*. Oxford: – Oxford University Press.
Brooks, P. (1992) *Piero della Francesca*: The Arezzo Frescoes. Rizzoli International Publishing.
Bulman, J.C. and H.R Coursen (eds.) (1988) *Shakespeare on Television*. Hanover, N.H.; London: University Press of New England.
Campbell, L.B. (1947) *Shakespeare's Histories: Mirrors of Elizabethan Policy*. Huntingdon Library.
Chatman, S. (1978) *Story and Discourse: Narrative Structure in Fiction and Film*. Ithaca, NY.: Cornell University Press.

Crane, M. (1962) 'Shakespeare on Television'. *Shakespeare Quarterly*, Vol. 12, pp. 323-7.

David, R. (1953) 'Shakespeare's History Plays: Epic or Drama?'. Shakespeare Survey No. 6. Cambridge: Cambridge University Press. pp. 129–39.

Dollimore, J. and A. Sinfield (eds.) (1985) *Political Shakespeare*. Manchester: Manchester University Press.

Hallinan, T. (1981) 'Jonathan Miller on The Shakespeare Plays'. *Shakespeare Quarterly*, Vol. 32, pp. 134–45.

Hawkes, T. (1977) *Shakespeare's Talking Animals*. London: Edward Arnold.

Hawkins, S. H. (1982) '*Henry IV*: The Structural Problem Revisited'. *Shakespeare Quarterly* Vol. 33, pp. 278–301.

Holderness, G. (1985) 'Radical Potentiality and Institutional Closure: Shakespeare in Film and Television'. In Dollimore, J. and A. Sinfield (eds.), *Political Shakespeare*, Manchester: Manchester University Press.

Joyce, J. (1960) *A Portrait of the Artist as a Young Man*. Harmondsworth: Penguin.

Kott, J. (1967) *Shakespeare Our Contemporary*. London: Methuen.

Knight, G. W. (1944) *The Olive and the Sword*. Oxford: Oxford University Press.

Kuhn, R. (ed.) (1985) *The Politics of Broadcasting*. London: Croom Helm.

Marcus, L. (1988) *Puzzling Shakespeare: Local Reading and its Discontents* Berkely University Press.

Messina, C. (1970) 'Preface' to *The BBC TV Shakespeare: Richard II*. London: BBC.

Ong, W. (1988) *Orality and Literacy: the Technologizing of the World*. London: Routledge.

Roston, M. (1987) *Renaissance Perspectives in Literature and the Visual Arts*. Princeton, N.J.; Guildford: Princeton University Press.

Taylor, G. (1989) *Reinventing Shakespeare: A Cultural History*. London: Weidenfeld and Nicholson.

Tillyard, E.M.W. (1980) *Shakespeare's History Plays* (first pub. 1944). London: Chatto and Windus.

Wells, S. and G. Taylor (eds.) (1988) *The Oxford Shakespeare: The Complete Works*. Oxford: Oxford University Press.

Wilson, J.D. and T.C. Worsley (1952) *Shakespeare's Histories at Stratford*. London: Max Reinhardt.

MYTHS OF CREATION: THEATRE ON *THE SOUTH BANK SHOW*

BOB MILLINGTON

TV Arts documentaries play an important role re-presenting aspects of theatre culture to the general public, reaching far beyond the tiny section of the community that actually attends the theatre. In this essay I intend to examine just what images and impressions of theatre are circulated in the most well-known and influential of these programmes on British television, London Weekend Television's *The South Bank Show*.[1] First launched in 1978, the programme stands today as one of the longest running series on ITV (Channel 3), and is now the only generic Arts documentary to hold a regular slot on a popular channel. Over the course of time LWT's self-styled 'flagship Arts strand'[2] has gained a considerable reputation for its eclectic and accessible approach to the contemporary Arts scene.[3] At the time of writing, the programme is still fronted by its original presenter/editor, Melvyn Bragg, and continues (if somewhat precariously) to hold onto its 'cocoa-time' slot on Sunday nights for half of the year.[4]

Though the featured art form changes from one week to the next, *The South Bank Show* always starts off in exactly the same way. Each week we begin quite literally with a 'creative touch'. Those disembodied hands, detail 'borrowed' from Michelangelo's *The Creation of Adam*, provide the archetypal emblem to encapsulate the programmes artistic concerns. God's index finger reaches out to Adam's – not here to create Man – but to celebrate 'creativeness' in the Arts. Repeated so many times over the years, Michelangelo's hands, have supplied the programme with a recognisable trademark. In the playful postmodernism of the current opening-titles sequence the 'creative touch' is repeated no fewer than five times for emphasis, and it sets in motion a parade of artists and artifacts from Shakespeare to David Hockney's *The Swimming Pool*.

In the rapid flow of allusions it is very easy to overlook that what we are being offered is a definite way of looking at 'creativeness'. The 'artist', Adam, is shown as an individual alone, 'inspired from above', in that blue 'flash of inspiration' that follows his contact with the divine. The specific content of each programme episode generally endorses the same romantic view of Art, and artists' profiles characteristically privilege individual inspiration

at the expense of the various social transactions that must be undertaken before the work can reach its public. The substantial distortion of image that occurs when this individualistic model of 'creativeness' is applied to the world of theatre, which relies on group effort and collaboration for its realisation, should be only too apparent.

Discussion of the 'creative touch' has served to introduce the Media Studies perspective that informs this essay, based on the idea that representations actively make sense of the social world rather than simply reflect it.[5] The process of constructing representations – privileging some images and omitting others – normally disposes power in favour of the dominant social groups. The semiologist, Roland Barthes, adopted the term 'myth' to describe the way images naturalise these dominant power relations as self-evident 'truths', that 'go-without-saying'.[6] The myth-making potential of television is unsurpassed in this respect. As we sit in our armchairs to watch *The South Bank Show* and bask in the natural and apparently unmediated flow of information about the Arts we are simply unconscious that a value position is being offered for us to adopt. So dominant, indeed, is this individualistic myth of creation in western society – re-told so many times by a culture that dedicates itself to 'free individuals' – that it is hard to imagine that any other way of thinking about art and 'creativeness' exists.

While the 'myth of creation' provides *The South Bank Show* with its organising system, the content for specific episodes is drawn from the existing agenda of the Arts establishment – the well-known names and assumptions that circulate in media and press reviews, publishing, and academic criticism – and which the up-market and well-educated audience, who are attracted to the programme, have come to expect. As elsewhere in television, dominant values are upheld. There can, indeed, be very little space for innovation and radicalism in a programme that sits so strategically as 'quality television' on a commercial channel. Unsurprisingly, therefore, the producers strive to find an accessible middle ground and, by placing emphasis on personalities rather than issues, 'to make programmes that are intelligent without being off-putting'.[7] This kind of controlled stimulation is perfectly matched to the realisation of LWT's aims as a television company: to provide both public service broadcasting and still more importantly to operate at a profit.

The existence of an Arts programme on a commercial channel stems primarily from LWT's statutory obligation to provide public service programming, which not only entertains but also educates and informs viewers. From the earliest days of television, Arts programmes have assumed special importance in fulfilling this task. Of considerable consequence to this essay is the way that the public service approach to Arts TV brings with it a set of idealist assumptions about the spiritual value of Art, that is closely associated with the rise of English as an academic subject.[8] In *The South Bank Show* literary values are very prominent as exemplified, for instance, in the stance of Melvyn Bragg[9] – and they shape the programme's handling of theatre not just in the foregrounding of the playwright in the scheme of things, but in separating drama from other areas of social and political life in the pursuit of its eternal human truths.

If public service ideals provide *The South Bank Show* with its critical approach to theatre the choice of subject matter hinges much more on material considerations. The survival and growth of LWT depends on its profitability as a commercial company and achieving sufficient audience ratings to interest advertisers. To maximise the ratings it is clear that the programme must feature the most celebrated theatre practitioners' names – the on-going success stories of the mainstream British theatre. Even so, with theatre celebrities such as Willy Russell and Vanessa Redgrave achieving only 1.7 and 0.87 million viewers respectively, it is clear how even these famous names are failing to attract regular ITV viewers and are only really appealing to the specialist Arts audience. So, to broaden its reach, the programme frequently turns away from high culture towards the popular arts and examines areas such as television, film, stand-up comedy, and popular music. In this way profiles on popular entertainers, such as John Cleese and Dawn French (which at 5.6 and 5.8 million viewers achieved the highest-ever ratings for the programme) are used to 'subsidise' the lower ratings that are achieved with the programme's high-culture output, and maintain its continuing viability as a C3 programme.[10] Whilst diversity and populism arguably contribute two of *The South Bank Show*'s most progressive features, it is worth noting that these stem as much from commercial considerations as they do from the democratic convictions of its producers.

Apart from Music, Theatre has been the most frequently featured art form on the pro-gramme over the years. Out of just over 450 episodes, Theatre (expanded to include pop-ular comedy and television) has been an important consideration in about 90 of them. Specific programmes have included profiles on leading writers such as Christopher Hampton, Trevor Griffiths and Edward Albee; on actors such as Anthony Hopkins, Judi Dench and Ian McKellan, on directors like Peter Brook, Peter Hall and John Barton, and on Theatre companies such as The Royal Shakespeare Company, Hull Truck and The Black Theatre Co-operative. Disappointingly few women practitioners have featured on the programme. For whatever reason, *The South Bank Show* has taken little interest in the emergent trend for women playwrights.[11] This is a significant omission for a programme whose commitment to theatre writers has otherwise been strong.

In relation though to those areas of theatre which are regularly featured on *The South Bank Show*, three clear preferences emerge: Firstly, the programme's championing of male writers (25 programmes); secondly, its considerable interest in theatre practitioners whose work spans several media (not the least because of the greater availability of film and television extracts for inclusion in the programme); and thirdly, its desire to elevate forms of popular culture to the level of art. The first two of these tendencies are exempli-fied in the profile that was produced on Willy Russell that we will examine below. While the last preference lies beyond the scope of this essay, it is interesting, to note, neverthe-less, the extent to which popular culture finds its way into the Russell profile and helps to widen the programme's appeal.

Analysis of one episode of such a long-running series cannot, of course, lay claim to be dealing with the programme's representation of theatre as a whole, but it does serve to exemplify the dominant literary trend of much of this output. Above all, the case study provides the opportunity to explore in more detail the logic with which the programme is put together, and especially the reliance on the myth of individual inspiration discussed earlier.

The profile of Willy Russell (19/9/93) in many ways typifies *The South Bank Show's* approach to theatre, not the least in its privileging the role of the writer in the production process. The preponderance of playwrights on the programme not only upholds the dominant values of the literary theatre it may also be more convenient for programme makers. Projects that centre on scripts and writers are almost certainly easier to focus in production than those engaging the unpredictable dynamics of group theatre and performance.

Russell's professional career – spanning fringe and mainstream theatre, television, film, musicals and folk music – is ideal for the populist trajectory of the programme and the blurring of distinctions between the popular arts and high culture that it favours. Early in the programme the issue of the accessibility of the arts is, indeed, explicitly addressed. Russell comments, 'I actually hate Art that is used to intimidate people ... to make them feel it is not for them'. His remarks, of course, encourage the non-specialist viewer to stay with the programme.

In the course of the 52 minute transmission the programme covered the following major topics:

1. The celebration of the tenth anniversary of *Blood Brothers* in a West End theatre.
2. Russell's insistence that the arts be accessible.
3. The writer's working class roots in Liverpool: including his failure in school, his work as a ladies' hair-dresser, his involvement as a song-writer/performer on the folk circuit, and his eventual escape into second-chance education where he first took up serious playwriting.
4. *Educating Rita*, the writing method and autobiographical links.
5. Learning the writer's craft: Russell's role as a teacher on a creative writing course and his own apprenticeship at the Liverpool Everyman Theatre.
6. The creation of *Shirley Valentine*, the writer's working methods and analysis of the major theme of escape.
7. Work in progress on Russell's novel.
8. Return to *Blood Brothers* with Russell accompanying Barbara Dickson singing 'Easy Terms' for end-credits.

As with all the interview-based *South Bank Shows* these separate segments are fused into a coherent whole utilising three basic modes of address. These are *exposition, interview* and *illustration*.

Willy Russell in character as Shirley Valentine, on *The South Bank Show.*
Reproduced courtesy of London Weekend Television.

Exposition relates to the direct relaying of information. It is most apparent at the beginning of the programme when Melvyn Bragg, presenting directly to camera, introduces the week's profile and 'signposts' programme content. The recognisable presence of Bragg renews a promise to viewers established in earlier episodes, that the programme will be 'Intelligent but not off-putting'. From then on the exposition is held back and the viewer is encouraged to become immersed in the world of the artist. In the second half of the programme exposition is intermittently resumed in the form of short voice-overs to tie together the remaining narrative strands.

Interview is the key mode of address used in the programme. It supplies all the information, reflection and comment that the artist provides as well as the snatches of two-way discussion that occur in the episodes where Bragg himself is actively involved. Interview is also used to provide the testimony of the 'expert witnesses', that are brought in to elucidate aspects of the writer's work. In the Willy Russell profile the testimony is supplied by Alan Bleasdale, a fellow Liverpudlian writer, and the directors John McGrath and Alan Dossor who gave him his first professional engagement at the Everyman Theatre.

The interview mode is quite intricate. We become engaged in the writer's ideas, thoughts and personality through the extracts of conversation and comment offered from a continuous interview between Russell and Bragg, which has been deliberately staged for our benefit. In the editing process, much of this is omitted, for reasons of economy and effect,

including most of the interviewer's questions that have prompted particular comments. This artificial convention, which goes unnoticed by us, endows the programme with considerable manipulative powers to lift remarks out of context in 'real time' and re-organise them into an ordered, but wholly constructed argument that suits the programme' interests.

Illustration is used to complement the interviews, supplying all the audio-visual information associated with the profile. It lets us confirm for ourselves, that what is being spoken about is true. The Russell portrait uses still photographs, archive footage, song performance, special dramatisations as well as clips from TV plays and films to create this sense of veracity. The cross-cutting that occurs in editing between illustration and interview provides the chief mechanism for maintaining the programme's continuity and apparently seamless flow. With the average length of uninterrupted sequence being in the order of forty seconds the rate of programme flow is considerable, a device which in itself helps to retain the attention of viewers.

The combination of exposition, interview and illustration, create the impression that we have been shown 'the whole truth' about the writer's world instead of a carefully organised way of making sense of it. So, in a very real sense, the programme can be said to be speaking through the 'Willy Russell' figure it has constructed, telling viewers the kind of story it wants them to hear. What it offers them, of course, is a variant of the myth of inspirational creation, established at the beginning of this essay, framed around the idea of the author's 'unique genius'.

The myth-making begins with an examination of the exceptional qualities of the writer as a young man, the attributes which enable him to transcend his 'lowly' working-class origins and achieve better things in Art. The exploration of Russell's biography, in the interview, quickly establishes both his creative promise as a folk-song writer and his determination to better himself through education rather than remain 'trapped' as a ladies' hairdresser for the rest of his life. Every few minutes, of course, viewers are allowed to sample Russell's art for themselves in the form of the illustrative play clips they are offered. The body of work establishes the consistency and distinctiveness of the writer's 'vision', an impression which is further reinforced by the way plays are endowed with value in discussion. Russell's artistry does not just reside in his playwriting and his performance skills are eminently televisual. Therefore every opportunity is taken to show him singing or acting, and to establish the idea of his 'talent in diversity'. Throughout the entire programme Russell's presence dominates the image. Whether the writer is shown mounting the stage to collect a drama award, travelling to the West End theatre in a taxi, framed in lingering close-up 'thinking aloud', or lit dramatically singing a song, no opportunity is missed to emphasise the idea of his 'unique creativeness' and reveal the 'author in power'.

Instead of establishing and elucidating aspects of the artistic process by letting us see what actually goes on 'behind the scenes', the images rather serve to mystify the writer's role and skills. As a 'unique genius' he is isolated from others in the process of making drama,

and even the craft of writing is explained in only the most generalised terms of 'living the character' and 'getting the story right'. Creativity, especially, is placed outside explanation and is a matter of the artist's inspiration, as Russell vividly describes:

> One afternoon Rita walked onto the page it's the only way I can describe it. I don't want to be mystical about it or anything, but this girl walked on, and she was talking to somebody I didn't quite know who … I didn't know what the setting was, what the environment was, but I don't ask myself those questions if a character starts speaking. If a character starts to take over and lead and is so alive that he or she is providing the words and I'm merely following them with the pen … or word-processor I just follow it.

This is not to deny the genuineness of Russell's account of the experience of writing when it is an intuitive process and going well. However, in the general course of things, a writer would naturally set such an experience against the 'bad days' when writing is more laborious and mechanical. The whole point is that the programme is not interested in balance. All it wants to hear about is something that supports the idea of artistic uniqueness, which Russell readily supplies and which consequently is placed in the centre of the profile as further evidence of his 'extraordinary' creative powers.

In the recounting of the myth it is clear that theatre is merely ancillary. It is (mis)represented as an instrument of individual expression – an unproblematic and transparent medium for the realisation of the writer's unique vision. There is no interest taken in engaging and exploring aspects of the production process that requires creative individuals to collaborate and negotiate interpretation as members of a team. Nor is there any attempt made to place the writer in a chain of command that includes directors and actors. Indeed, the only other professional we are 'shown' Russell associating with is Barbara Dickson – for the singing of the final song. This is quite surprising for much production effort actually went into recording interviews and rehearsals with actors for the programme, including a day-long shoot with Julie Walters rehearsing *Educating Rita*. None of this footage was used, presumably because it was not so effective as other available illustrations, such as the dramatisation where Russell acts the role of Shirley Valentine. Here, most conveniently, author and character merge on screen to reinforce the autobiographical explanation of the plays that we have been offered – that the fictional characters are all figments of his own real life and psyche.

To forge the necessary link between Russell's life and his art in the interview, Bragg adopts the traditional literary approach of 'authorship'. Two autobiographical themes – the urge for self-betterment and the desire to escape – are selected and used as 'keys' to 'unlock' the hidden meaning of the plays for viewers. The on-going consistency of theme and vision that Bragg establishes across the body of major works provides the evidence upon which he constitutes Russell's artistic reputation. Authorship lends itself well to *The South Bank Show*'s commitment to public service. As the cultural dominant, it is wholly natu-

ralised in the process of promoting, consuming and evaluating theatre arts. The information that is handed on here to viewers is exactly what they have come to think they 'need to know' before they can 'fully' appreciate the art. Interestingly in the course of the programme, Russell raises some doubts about whether this privileged information is strictly necessary to understand his work.

Whatever the value of authorship in determining the literary quality of plays, it contributes little, of course, to an understanding of the way they function in the theatre. In his efforts to end the cult of the author and to open up texts to the skills of the reader, Roland Barthes observed that, 'to give a text an author is to impose a limit on that text, to furnish it with a final signified, to close the writing'.[12] His observation highlights the kind of problem that is encountered in Drama study where the pursuit of the author and his supposed 'intentions' closes down viable interpretations of the script, and marginalises the importance of the group and theatre context in the production of the 'final signified' – the play in performance itself.

At this point in the essay it is worth considering just how a more theatre-centred profile of Willy Russell might have been offered on *The South Bank Show*. To achieve this alternative profile it would be necessary, as Janet Wolff proposes in her account of art as social production, to replace 'the traditional notion of the artist as creator with one of the artist as producer' and recognise 'the nature of artistic work as located production'.[13] The effect of this would be to situate the writer in the process of production, and to place less emphasis on inspiration and more on the idea of interpretation. Though the writer as the play's originator is the first person in the production chain to fix meaning this is subject to constant re-definition in the rehearsal process.

The idea of offering an alternative means of profiling the writer is not as far-fetched as it may seem at first, for in the making of any television documentary there will be numerous other ways of putting the programme together, out of the large quantity of production sequences that are shot and that are then discarded in editing. It is probable that a proportion of the footage needed for the alternative profile would have been already available. The alternative profile would not attempt to be so wide-ranging, but would focus solely on the musical, *Blood Brothers* which remains relatively undeveloped in the programme as transmitted. The tenth anniversary party for the musical, bringing back many of the original contributors, would provide an opportunity to collect interview material to present a retrospective on the making of the show.

The interviews would seek to establish how the necessary alterations came to be made to transform a Seventies small-scale touring play for Children's Theatre, into a major West End musical play in the Eighties. Hopefully too, something of the character of the artistic collaboration would emerge, bringing with it an appreciation of the complex set of power relations that exists in the theatre between the writer, the director, the actors, the producer, and the designer etc. The myth that would be adopted for the alternative pro-

gramme would be the more democratic one, of Russell and the production team 'rising to the challenge' as they overcame the various artistic problems that were encountered in mounting the show. This mythical structure (beloved of programmes like BBC's *Challenge Anneka*) was also used in *The South Bank Show* on the making of The Bristol Old Vic Theatre's *The Bristol Blitz* (20/11/88), which in a some provides the prototype for the alternative profile.

At the centre of a theatre-based study there must be consideration of the way ideas on the page are rendered into theatrical form. One way of doing this would be to consider the way characters are interpreted on stage by comparing, for instance, different approaches of two actresses to the leading role. This could lead into a more general examination of the way an appropriate production style evolves. In the case of *Blood Brothers* this would certainly involve consideration of the influence of genre on Russell's work and the discussion of the conventions of the popular musical play that were established at the Liverpool Everyman Theatre during his important formative years, and from which the musical derived its ultimate form. Such matters are just touched on in the finished programme, in the interview with John McGrath.[14] It is worth pausing here briefly to consider just why so much emphasis is placed on the importance of Russell's adolescence in the transmitted programme and so little on the influence of his artistic milieu when he was learning his craft. To the authorly critic, of course, the more a writer is seen to be a member of a school and is influenced by fellow artists, the more it detracts from the idea of his artistic uniqueness.

A major area of omission in the transmitted programme is production economics. The making of theatre is not simply a matter of generating creative ideas, but also involves the mustering and managing of the necessary finance to pay for the human and technical resources that are needed. Aesthetic choices at all levels of the production are constrained by the budget that has been made available to pay them. Hence the production catch-phrase in these times of financial retrenchment, that 'the economy is the aesthetic'. In each of the plays that is discussed on the programme Russell has successfully matched his production resources to the changing economic circumstances of the theatre. One reason why *Shirley Valentine* has become what Bragg describes as the writer's 'best-loved play' is that, being a one-woman play, it is also extremely cheap to stage and has, as a result, been readily taken up by many theatres as a low-risk venture.

The alternative profile of *Blood Brothers* would provide a good opportunity to examine some of the financial implications of putting on a West End musical and establish the entrepreneurial skills that are increasingly demanded of successful writers in getting their work staged. The shift towards money need not necessarily make *The South Bank Show* less accessible to its audience. Indeed, the programme has already offered a fascinating profile of Cameron Mackintosh (2/10/90), the theatrical impresario and producer of the international 'blockbuster' musicals *Cats, Les Misérables* and *Miss Saigon*, that foregrounded the importance of production finance. As far as I am aware this initiative has

not yet been repeated, and production finance is otherwise firmly separated from the artistic considerations discussed in other theatre profiles. In the literary approach to Drama, of course, great Art transcends its immediate social context and is above 'vulgar' economics.

In this essay I have argued that theatre is a social art and that an adequate representation of the medium on television must go beyond the consideration of the creativity of individuals and engage the complex set of social and economic relations that occurs in the transfer of ideas from the page to the stage. The alternative profile that was proposed, whilst retaining the writer as a major point of focus, attempted to make sense of theatre as a social process, a site for collaboration and negotiation in response to specific production constraints.

In contrast to this, *The South Bank Show*, as was seen in the profile of Willy Russell, characteristically constructs a literary theatre that is the vehicle for the ideas of individual writers. While the programme has done much to promote the new drama over the years, the undue emphasis it continues to place on the power of the dramatist not only over-simplifies the complexity of the production process, but overestimates the opportunities that now actually exist for creative expression. In 1978, when the programme was first launched, the myth of creation celebrated the emergence of a new wave of theatre writers who were able to benefit from a golden age of Arts subsidy and expansion. At this time the myth carried special force because it was grounded in a basic reality and spoke of its own moment.

But in the 1990s the context is very different and the myth operates more retrospectively. It continues to attempt to reassure us that all is yet well in the theatre by directing our attention to the on-going success of the increasingly grey-haired super-celebrities from the same golden age. The chance of members of a new generation of dramatists ever finding their way on to some future *South Bank Show* is remote, for the theatre institutions and infra-structure that supported new writers and plays in Britain have all but evaporated away. The Liverpool Everyman Theatre, which enabled Willy Russell to launch his career, provides an interesting case in point here. For within a month of the transmission of *The South Bank Show* on the writer, the theatre was forced to close down through lack of funding. The example is not an isolated one.

Myth is oblivious to such nice ironies for, according to Barthes, 'it abolishes the complexity of all human acts'.[15] The eternal truths it substitutes about human creativity serve to mask over the current crisis in the contemporary theatre. The contemplation of such depressing matters is, of course, the last thing that even the most devoted theatrephile wants to do at cocoa time on a Sunday night, and on this basis perhaps *The South Bank Show* may be excused its altogether more uplifting myths of individual achievement. In the last analysis, even a distorted representation of live theatre on a popular television channel would appear to be better than no representation at all.

NOTES

1. The influence of the programme is felt still more widely, through sales abroad to European and North American Cable Networks.
2. LWT production publicity.
3. Since 1978 the programme has won over 55 national and international awards. These have added considerably to LWT's international prestige as a production company.
4. The programme has a high media profile and Melvyn Bragg's ongoing fight to retain the 10.45 slot for it has been the subject of press attention over the years. See, for instance, Andrew Culf 'Changing Tides For The Arts Flagship', *The Guardian* 3/10/95.
5. See, for instance, Dyer R. (1985) 'Taking Popular Television Seriously', in Lusted, D. & Drummond, P. (eds.) *TV and Schooling*, BFI Education, pp. 41-46.
6. Barthes R. (1957) (tr.1972) 'Myth Today' in *Mythologies*, Jonathan Cape, pp. 117-174.
7. Nigel Wattis, the programme's executive producer in interview with the author 05/12/94.
8. See Masterman L. (ed.) (1986) *Television Mythologies*, Comedia 'Introduction', pp. 1-8.
9. Bragg is a practising novelist who has also served as Chair of the Literature panel of the Arts Council of Great Britain 1977–1980. His attitudes exemplify those of a whole generation of broadcasters, influenced at university and beyond, by the hegemony of English as an academic subject.
10 The programme's audience fluctuates between about 10 per cent and 50 per cent of the viewers who are actually watching television at this time. On average advertisers are satisfied with the programme's performance, not the least because of the high numbers of affluent viewers (from Social groups A and B) who are included in this audience.
11. Only a handful of women writers and theatre practitioners have been profiled on the programme. They are the writers Verity Bargate and Linda La Plante, and the performers Vanessa Redgrave, Judi Dench, Dawn French and Thora Hird. This considerable under-representation would seem to support the argument that the British theatre establishment is misogynistic, as discussed in Michelene Wandor (1989) *Look Back in Gender*, Methuen.
12. Barthes R. (1968) (tr. 1977) 'The Death of the Author' in *Image, Music, Text*, Fontana, p. 147).
13. Wolff J. (1981) *The Social Production of Art*, Macmillan, p. 137.
14. The significance of the popular musical play that evolved at the

Everyman in the Sixties is discussed in McGrath J. (1981) *A Good Night Out*, Methuen, pp. 52-53.

15. Barthes R. (1957) (tr. 1972) *Mythologies*, Jonathan Cape, p. 156.

PRODUCING PERFORMANCE: AN INTERVIEW WITH SIMON CURTIS

JEREMY RIDGMAN

Simon Curtis has been Producer of Performance, *the BBC's series of productions of theatre plays, since it began in 1991. Jeremy Ridgman spoke with him about the development of the series and his views on televised drama.*

J.R. Could we start by looking at the evolution of *Performance* as a series. It began in November 1991 and seems to be the first consistent set of televised stage plays since *Play of the Month* in the 1970s.

S.C. At the end of the eighties, the Drama Department at the BBC was determined to become a film department and there were powerful people there who thought that studio drama was over. I met with Alan Yentob while I was still working at the Royal Court and he felt that wasn't true: he believed that within the huge menu of drama that the BBC offered – I don't know how many hours it is – there was still a place for five or six quality productions of theatre plays. This was picked up by John Birt, who felt that this sort of material made the BBC distinctive and that its audience, although comparatively small, was very appreciative. And it meant that everyone in the country had the opportunity to watch a play like *A Doll's House* or *Roots* or *Shadow of a Gunman*. I was quite intrigued. I wanted to get into television and I think they saw me as someone from the theatre community who might have a vision of how the strand, as they call it, could develop.

It's not quite true that there hadn't been anything since *Play of the Month:* there had been *Theatre Night*, which had been rather more

haphazard. I tried to think how I would approach the idea and began looking at plays that I thought would work interestingly in the studio, where the emphasis was very much on quality writing and the psychology of characters. And then I approached directors, writers and actors I admired, many of whom had a pet project they wanted to do. And what you are offering an actor is the chance to be in one of the world's great plays. The whole job only takes a few weeks to do – in London and mostly with other great actors. And for those actors who tend to do mostly film work but wished they did theatre work, this was a way of doing a theatre job without having to give six months of their lives.

So it became apparent fairly rapidly that we were able to secure the best actors in the world; and that caught on. We went against conventional wisdom. In the year that Jeremy Irons won the best actor Oscar, he was prepared to do a *Performance*; Kenneth Branagh's appearance in *The Shadow of a Gunman* was his first time back at the BBC for a decade, and when Bob Hoskins did *The Changeling* it was the first time he had worked in England for ten years or something.

But not only were we going after those big names. The new young actors have all had a part. Juliet Stevenson played Nora before she became a big television star as she is now; Jane Horrocks, Hugh Grant, Juliet Aubrey … a lot of the interesting people we got on their way up and I'm proud of that.

J.R. What sort of rehearsal time are you able to offer actors?

S.C. They get the same sort of rehearsal time they get in the theatre, about four or five weeks. This would be fairly luxurious compared with the conditions they might be offered in other television drama. Most serial drama doesn't have formal rehearsal periods at all but, of course, the comparison isn't quite fair: everyone working on *EastEnders*, for example, knows their character, whereas here you are starting from scratch.

J.R. Does working in a studio, rather than shipping people off to a location, allow for a more actor-centred process?

S.C. I think so: though it can be frustratingly technical in the studio. We are devoting four or five weeks to acting rehearsals, rather than camera rehearsal, but it is to your peril as a director if you don't take on board those technical aspects during those early rehearsals.

J.R. The title of the series seems to foreground the work of the actor and suggests that watching actors at work in theatre pieces might be one of the main attractions for the audience.

S.C. Yes, but my feeling is that in the studio, on video-tape, what works best is just capturing those faces, those close-ups. The plays that rely on big *coups de théâtre*, big ensemble pieces, are very hard to pull off. But the minutiae of human behaviour is often better achieved here than in the theatre.

J.R. Does that recognition motivate your choice of dramatic material?

S.C. Quite a lot. There is quite a lot of variation in our repertoire. We had tremendous success right from the start in rescuing Rodney Ackland's play *Absolute Hell*, after which we went after what we would call 'lost masterpieces' for a while, like Rattigan's *After the Dance*. But I soon realised this was very hard to pull off because in fact the plays are very often the stars. So I tend now to go to well-made plays or famous plays that we can do interestingly, with a surprising piece of casting or in a new version or something. Finally, you're better off doing *The Deep Blue Sea* or *The Widowing of Mrs Holroyd* – well-known plays.

J.R. Do you consciously try to establish a balance in the repertoire within a season?

S.C. I suppose that I do think of it as a season, but I'm not sure the audience do. I believe that audiences think 'What's on TV tonight? I'll give that a chance'. I don't think they strategise. I think, my God, we're expecting these people to watch these plays five weeks in a row. I'm still not convinced that is the best way of doing it: it might be better if they were spread out through the year.

J.R. But when you are talking about a season, you're thinking about it being like a repertory company's output: over a particular year there would be a contemporary play, a Shakespeare, a costume drama and so on?

S.C. I think more in terms of a balance. I certainly don't think 'What's the new play we're doing this year'.

J.R. And any thematic cross-references are purely coincidental? I read recently a quotation from the critic Felix Barker, writing about *Roots*

when it was first performed in 1959, who referred to Beatie as a modern-day, proletarian Nora. It would seem to justify your decision to programme *Roots* back to back with *A Doll's House*.

S.C. Yes. It's interesting to think how many plays we've done about women or which were strongly female … though its probably just that they were good plays. They were always political in a way; about someone struggling with their life. But then most plays are about that. I look for plays where you can learn about a human being in a context. A critic did say about *A Doll's House* 'This is the most riveting drama I've ever seen on TV'. I mean, there was that kind of level of direct response to the work. The most watched *Performance* ever has been *The Widowing of Mrs Holroyd*. Now it might have been something to do with the casting of Colin Firth or Zoë Wanamaker. But it's interesting, because even by the standards of *Performance* it is a very slow, dark play. Maybe it's because the psychological drama was so intense.

J.R. Both are very immediate pieces of drama in that sense; unlike, say, *Tales from Hollywood*, which is more distanced from the conventions of television drama.

S.C. That's right. And what I've learnt is that those more immediate, emotional, claustrophobic plays are the ones that do best for us. There's no doubt that those gutwrenching, emotional dramas are the ones that most succeed and get the strongest reaction. And I have consciously gone in that direction: it's no coincidence that we have gone towards those plays with a very high emotional temperature.

J.R. This idea of a television production as a version of the play is an interesting one. How specific have you been in using the transposition from one medium to another as a way of confronting the text experimentally? Patrick Marber's radical translation and reworking of *Miss Julie* as *After Miss Julie* in 1995, where the entire action is shifted to election night in 1945, seems to be an example of the sort of dramaturgical experiment you might see on the stage of the Royal Court or in the Cottesloe but which you might not expect to find on television.

S.C. Yes. But why should television be less adventurous about that sort of work than theatre? A play like *Miss Julie* can survive anything. Marber had an instinct that there was something more contemporary in the play and the idea of the 1945 election gave him a sort of springboard

into the play. And it was much more alive, much less suppressed than productions of *Miss Julie* I've seen recently. Such an approach actually liberates the play.

The play was on our list of chamber plays that we wanted to do. It was Michael Hastings who, as script editor, suggested that Patrick Marber look at it; it was Patrick who had the idea that it would work on that particular night in July 1945. It is also the night that *Absolute Hell* is set on.

J.R. In that sense, both plays end up working intertextually with a particular body of television dramas – *Country, Licking Hitler, The Imitation Game* – that were set around that critical moment with the end of the second world war and the return of the Attlee Labour government.

S.C. Exactly. Angus Calder's *The People's War* was a great source.

At the other end of the spectrum, there was also some feeling at the BBC that it had been too long since they had done any Shakespeare. So, we did *Measure for Measure* in 1994 and then *Henry IV* in 1995. What seems important when we do plays like that or *The Changeling*, is to go in and edit them. With the BBC Shakespeares, the guidelines were that you had to do the whole play or do them as written, which was rather deadening. David Thacker had a really fresh, bold vision of *Measure for Measure* and if you read the script of his adaptation it reads almost like a modern film. I felt the same about *The Changeling*, that at the heart of the play, in the central triangle, there was a fantastic psychological drama. John Caird did a similar thing, I think, with *Henry IV.* I think it helps the play reach more people.

J.R. How many people does it reach?

S.C. It's between one and two million. Which is an awful lot of people, when you think of 1.7 million people watching *A Doll's House* on a Saturday night. It's terribly small in terms of popular television drama but in terms of that sort of statistic, it's quite impressive. And I have to say that the BBC have never got onto me about that. Everyone, including the Controllers of BBC2, Alan Yentob and Michael Jackson, have always been incredibly supportive of the series.

J.R. A figure like 1.7 million would be equivalent to over two thousand full houses at the National or in the West End, a six year run at least; by those standards it would constitute a major revival.

You have also recently gone to early television plays, with Dennis Potter's *Message for Posterity*, which had been wiped, and Paddy Chayefsky's 1954 piece, *The Mother*.

S.C. Yes. That was really because I stumbled on the Chayefsky and I just thought it would be liberating to do a play that was actually written for the television studio, as opposed to cramming a theatre play in, as well as it being a wonderful piece of writing. It also seemed a good idea to explore one of the less famous Potter's. But we haven't pursued that: we have stuck to theatre plays. More recently we have been going after quite short theatre plays, simply because they are somehow easier to digest: Harold Pinter's own production of *Landscape*, *Shadow of a Gunman* and *Miss Julie*.

J.R. How do you choose your directors?

S.C. If there is one thing *Performance* has done extraordinarily well, it has been in giving important theatre directors their first chance to work with a camera; Deborah Warner, Katie Mitchell, David Thacker, Howard Davies, Gregory Mosher, John Caird. It is a phenomenal list. It causes problems, because you are helping them to learn their way through a new medium but they also bring a freshness and work with the actors very well, so there is a lot to be gained. We have also worked with David Jones and Christopher Morahan and Richard Eyre, who bring a wealth of television experience.

J.R. Do your designers come from theatre?

S.C. Some, like Bob Crowley or Hildegard Bechtler are from the theatre: and someone like Crowley brings vision and a sense of scale which adds a great deal. But mostly we use BBC designers who are hungry to do the work: to create a whole environment in a studio is a very exciting job for people who spend a lot of their time redressing real locations.

J.R. Before taking up your job on *Performance*, you were a freelance director but you also worked for some time during the eighties at the Royal Court, where you were very much involved with new writing. What particularly, in terms of your own background in theatre made you want to move into television in this particular way?

S.C. Ironically, in the theatre, I was interested in new writing, rather than dashing classic revivals, which most of my peers are much better at

than me. As a theatre-goer, I still principally only go to new writing. So there was still something of a shift of mind set when I came to do classic drama. And that's why I was keen to bring in *Top Girls* or *The Trials of Oz*. I have worked with the best writers ever on *Performance* – John Osborne, Harold Pinter, David Mamet, Caryl Churchill, Christopher Hampton … That's very exciting. But new writing on television seemed very impressive to me and I like TV: I grew up watching TV and I like the fact that it can reach every nook and cranny of the country, as opposed to one room in Sloane Square. If you are interested in new writing you can't survive in the theatre, unless you are the one or two people who are making a lot of money from it.

J.R. What do you say to the accusation that television as an industry profits from theatre, without putting anything back?

S.C. I am very attuned to theatre people's snobbery about television and television people's resentment of theatre; but actually, now it's very much two way traffic. I don't know of any theatre director who doesn't want to be a big movie director and isn't prepared to use TV as a step in that direction. And then you think of Anthony Page and Judi Dench going on to do *Absolute Hell* again at the National Theatre, where both the play and her performance were very well received. I'm quite proud that we are not always following the theatre.

Not only does theatre love to have people who are famous from television in their casts, but actors are trained much more in television now than they used to be: they are not trained in the same way by the theatre. Writers too are emerging in other ways now: they're not just coming from the theatre.

J.R. Judi Dench would seem to be an example of someone whose reputation is just as solid in popular television as in the so-called high art of theatre.

S.C. Actors can't just exist in the theatre. Nor do they want to. Gambon was back in the theatre recently for the first time in six or seven years.

J.R. How do you decide which plays you are going to direct yourself? Is it a matter of personal choice or the schedule for the year?

S.C. It depends. A director works better if they have a passion for a

particular play, a concept or idea. I really, really loved the Chayefsky play and I had always really wanted to do it. I had always thought that *The Changeling* would make an interesting television production. I had done *Roots* before. And so on …

J.R. *Roots* seems to be a very interesting case. It would be defined by many as an archetypally naturalistic play. But if you go back to John Dexter's original production and read his ideas and his comments on Jocelyn Herbert's design, it seems that he is suggesting that it is not raw naturalism that he is after: it's a form of realism but at the same time there's a degree of distance and poetry, particularly in the production idea of the space around the domestic set. But to bring that play into television seems to bring all sorts of problems about people's preconceived ideas of naturalism, their familiarity with naturalism.

S.C. It is true that naturalism works better in the studio. And it is much easier in the theatre to do a stylised set – with real elements but which isn't fully representing a real room. In TV it is much harder to pull that off. But it is tricky, because the dialogue in *Roots* is not naturalistic: that's also very poetic. One of the main reasons for redirecting the play for television was that since we had staged it in the Cottesloe in 1988, Pam Ferris had become a huge television star, mainly through *The Darling Buds of May*. And her performance as Mrs Bryant on stage had really handled that poetry and, as I believe I heard Arnold Wesker say, had been the best ever. So it seemed the right moment to have another crack at it.

J.F. Is there a sense in which *Performance*, by looking at those fifties and early sixties plays by Pinter, Osborne and Wesker, is trying to look again at the roots of that critical movement in post-war drama?

S.C. I think that 20th century plays which are much more naturalistic and psychological work better on television: It's much easier to pull them off than older plays, basically. And they also have great leading parts. Interestingly, when you reassess some of those plays they are incredibly wordy. But I do come from the Royal Court and that legacy is very important to me personally. I never liked the idea of the ownership of those plays – that you could never do *No Man's Land* again because Sir John and Sir Ralph were so wonderful. The play lives on.

J.R. Does it concern you that a television production may eventually become a document of the play in performance, setting it in stone for posterity?

S.C. I can't help that. That happens to be the form we work in. We make as many mistakes as they do in the theatre and have successes the way they do in the theatre. There's a myth that in doing this kind of work you can't fail. Well you absolutely can. If we couldn't fail then by definition the RSC could never fail with a play by Shakespeare, and they do. We don't always get it right, but that's called art. We just try to be as canny as possible. Some productions are always going to come together better than others.

J.R. When you are doing a play by a living writer, how closely do you involve the writer in the production process?

S.C. I love that side of things. There have been times when you would go up to the rehearsal rooms in Acton and there would be the likes of David Mamet, Caryl Churchill, Christopher Hampton or Harold Pinter participating in the production. Hampton worked very closely with Howard Davis to reinvent *Tales From Hollywood* for a stylised, studio production. Rodney Ackland came to the studio shortly before he died. It was very moving with *Roots* to have Wesker in rehearsals and bringing photographs of the actual family the play was based on. At one point, someone said 'How did they make ice-cream in the fifties?'. And he just rang the woman that one of the characters was based on from the rehearsal room and found out the recipe. Mostly the writers are thrilled when we do their plays.

J.R. Have you ever considered not working with the studio or do you see the constraints of the studio as a positive virtue?

S.C. That was certainly the way we defined it at first and made it distinctive. But I think we are moving away from that and are looking more towards film, opening them up. We may need to go into co-pro-duction for that: we can't afford to make that ourselves. And that will bring in other considerations. We have recently done 'My Night with Reg' on film, in the studio; and 'Broken Glass' on film and mostly in a studio. It becomes harder and harder to convince the artistic community that video-tape is worth making any more. And, of course, there is more chance of future exploitation of stuff on film. When we first did *Performance*, people were just grateful for it: now it's taken for granted. The series began just before the return to the big classic serial. So in a way we were ahead of the game. For that reason, when we started, people were particularly excited. In subsequent years the rightful attention that *Middlemarch, Martin Chuzzlewit* and *Pride and Prejudice* have

received has tended to overshadow *Performance*, mostly because with a single play it is harder to ignite the imagination of the nation.

J.R. How does the work sell overseas?

S.C. Quite well. The Public Broadcasting System in America has shown some of them. But they are unpredictable. I think they should have taken *Absolute Hell*. They had a great success with Juliet Stevenson in *A Doll's House*. The Chayefsky was phenomenally successful in America, but here it was shown on the night of the first National Lottery draw and was virtually ignored.

'My Night With Reg'. *Performance* (1997, BBC 2).
l–r: Joe Duttine (Eric), Kenneth Macdonald (Bennie), David Bamber (Guy), Roger Frost (Bernie).
Photo: BFI Stills, Posters and Designs, courtesy of BBC Television.

NOTES ON CONTRIBUTORS

John Adams is Director of Film and Television Studies in the Department of Drama (Theatre, Film, Television) at the University of Bristol. He has taught history, theory and critical approaches to film and television for some twenty years, specialising in the development of practical methodologies. He has published articles on film and television iconography, and works professionally as a writer, producer and director. Current research projects centre on early screen performance and on landscape iconography in American and European film since 1950.

Carol Banks is a PhD student and Research Assistant at the University of Hertfordshire. Her research focuses on Shakespeare and gender, and visual and textual theory. Her publications include articles on textual theory and she is currently working with Graham Holderness on a new book *Shakespeare's History Plays*.

Simon Curtis began his career at the Royal Court Theatre, where he was Deputy Director and where his productions included Jim Cartwright's *Road*. He has also directed at the National Theatre, the Lincoln Center, New York and the Steppenwolf Theater, Chicago. In 1990 he became Executive Producer of *Performance* at the BBC. He has also directed for the series: *The Changeling* with Bob Hoskins, Elizabeth McGovern and Hugh Grant; *Old Times* with John Malkovich and Kate Nelligan; and Paddy Chayefsky's *The Mother* with Anne Bancroft. For the BBC he has also directed David Edgar's *Buying a Landslide* and produced David Hare's *The Absence of War*.

Richard Eyre was Artistic Director of the Royal National Theatre from 1988 to 1997. He was previously Associate Director and Director of Productions at the Lyceum Theatre, Edinburgh, Artistic Director at the Nottingham Playhouse and Producer of the BBC *Play for Today* series. He has directed new work by many leading playwrights, as well as numerous classics, and has produced and directed films for television, including *Tumbledown*, *The Insurance Man* and *The Ploughman's Lunch*. He has also directed television adaptations of David Hare's *The Absence of War* and Tennessee Williams'

INDEX